In case of loss, please return to:

As a reward: $ _____

GOOD50X70 ANTHOLOGY THE SOCIAL COMMUNICATION PROJECT

A project by
Pasquale Volpe

In collaboration with
Gabriella Morelli

Edited by
Franco Achilli

Produced by
Associazione Culturale Good Design

www.good50x70.org

CONTENTS
by Franco Achilli

The *Good50x70 Anthology* collects and displays the work submitted to the Cultural Association Good Design competitions from 2007 to 2012 in one volume with the combined features of a catalogue and an anthology.

All the posters selected by the juries over 5 years are presented here, along with the original briefs from the non-profit organizations and generous written contributions from high regarded commentators. Different voices engaged in exploring the meaning of the initiative, harnessing the tools of the profession and the thrill of participation.

The commitment and energy ignited by *Good50x70* have spread beyond it. A whole community of practice, thousands of graphic designers, artists and creative people from around the world, have involved themselves in a talented act of engagement for a good cause, allowing the project to gain international visibility and widespread awards.

Moleskine believes in this endeavour. There are shared ideals: passion, brilliance, competence and ease in the contemporary milieu, and a recognition of the individual and combined powers of manual creativity, technological excellence and social thoughtfulness.

We are proud to be the publishers of this project and to create a volume that preserves this first phase of the life of *Good50x70* at a turning point, at the very moment when the initiative is evolving in a new direction, entrusting itself exclusively to digital interaction through the World Wide Web.

Other opportunities for cooperation, unique to this new dimension, will come.

Roberto Di Puma
Director of Product Design and Publishing - Moleskine SpA

FIVE YEARS: GOOD50X70 REACHES ADULTHOOD

While it is true that in many cases images speak louder than words, those presented in these pages distil a potential energy which it would be wise to put to some use as soon as possible, allowing these works to fulfil the purpose for which they were designed.

Or perhaps even go beyond that purpose: a poster's concept can be turned into the key image for a broader social campaign, with the design being used as a screen for a smartphone, a tablet, or any other analogue or digital medium which lends itself to the idea.

Thus, the debate on the life and death of the poster in our times would appear to be pointless. Now that this experience has drawn to a close, Good50x70's commitment remains that of keeping its original promises and ensuring that the meeting point which has been created over five years of collaboration between graphic designers and organizations becomes a reality, one that's ongoing, efficient and always open to those who need it.

The *Good50x70* online archive is no longer just a repertory of attractive visual responses; it is now a fertile gallery of messages and information, a rich and remarkably large seam of ideas, creative suggestions and expressive forms. These could be beneficial to NGOs and charities, public bodies and associations, as well as graphic designers all over the world, because they will find there a beating heart and an encouraging blueprint for them to continue in their commitment to social and public sector communication.

The complete database of *Good50x70* (which contains not just the winners, but all the posters sent in over the years) now becomes a permanent receptacle; it is ready to incorporate projects from other similar initiatives, entire collections on the theme, or individual contributions from designer-volunteers and schools. These are further reasons why *Good50x70* has become so important for graphic design and why it is increasingly rich in meaning and significance for all: it is now a place for sharing creative and sector-specific interests, a meeting place where people and projects can connect.

After five years of activity, *Good50x70* can be satisfied with having built a vessel containing thousands of ideas; with having allowed the creative community (and especially younger designers) to encounter some of the world's best graphic designers, who have been asked to select the entries each year. Through this vast participation, *Good50x70* has been able to enjoy international experiences which have breathed new life into graphic design's role not just as an aesthetic/expressive discipline, but also as a social and cultural contribution.

Raising issues, opening up contradictions, exploring languages and creativity in order to use their tools to make an impact on contemporary society: *Good50x70* has paved the way, and it thanks the graphic designers, jurors, organizations, schools and institutions, sponsors and members of staff who have allowed such a basic idea (that of solidarity) to be shared and supported by a world as complex and sensitive as that of social communication today.

A GOOD STORY FOR INTERNATIONAL GRAPHIC DESIGN

When it came to analysing and summarizing five awe-inspiring years of *Good50x70* for this book, it became clear that I would have to take a step back in order to adopt a detached viewpoint: over the years, thanks to my friendship with Pasquale Volpe, I have had the pleasure of observing a large number of results, signals and trends which have emerged from the event, but what prevails above all is the incredible dynamism demonstrated by those who devised *Good50x70* and who have dedicated such energy and truly contagious passion to it.

Over the years, *Good50x70* has become not just a remarkable array of signs, artefacts, messages, travelling exhibitions, international workshops and people, but also a polymorphous collection of visual expressions and cultures: the idea of a graphic-creative contest has evolved from being a creative competition to being a broader appeal for participation. Primarily, it has made a first-rate cultural contribution, in a very large, geographically diversified social context which nevertheless has its own eclectic expressive dimension, and has successfully raised the bar for creative standards and for the idea of "engagement" in social communication today.

The *Good50x70* Cultural Association, which was set up specifically for the occasion, has allowed *Good50x70* to become a perfectly tuned engine that produces optimum results year after year: a mechanism in perpetual movement, thanks to the work of the volunteers and students recruited from design schools.

The initiative has also been incredibly popular with the public, through 82 exhibitions set up across the continents and deliberately shown in the street, rather than in galleries or spaces open to professionals only: thus poster graphics have once again started talking in the streets, with their messages and colourful jollity. The exhibition staged in Milan's Via Dante in 2010 was, moreover, the world's largest ever exhibition on social graphic design, in terms of surface area and number of visitors. For each of the five editions of *Good50x70*, each of which attracted large numbers of entrants and, with the fourth edition, a prestigious reward – namely the President of the Italian Republic's *Medaglia di Rappresentanza* – many comments and reflections have already been written (often in the form of praise, analyses and advice for the following year, always bolstered by contributions from world-famous authorities on the subject): this volume draws together summaries of the opinions given by the eminent jury members for each edition. Time and again, the few but encouraging criticisms raised about the formal quality of the projects and their predictable sameness/standardization found, however, that they had to admit defeat when faced with the sheer extent of participation. A fluid international graphic design movement, which voluntarily pulled together, managed to produce a collective voice each time its "intellectual" responsibility was called upon. So it's nice to think that this was simply a burst of positivity, during such a worrying time for human life on planet Earth.

With merit and continuity, efficient organization, transparency and steadfastness, *Good50x70* made a name for itself as one of the most important events for young graphic designers the world over. It is a useful occasion, not just due to the works created for organizations involved in social communication, but also as a radar for the production of that vibrant cultural and visual contradiction which is the poster (when done well, of course).

Perhaps at this point it would be beneficial to offer not so much an assessment of the event, but some general considerations on its constituent elements, so as to fully grasp the dimension of the response to *Good50x70* and the significance of graphic designers having taken part in such a broad-ranging social communication project.

THE POSTER: A NOBLE PIECE OF PAPER

On more than one occasion, when commenting upon the various editions of *Good50x70*, some of the jury members raised a question which, in rhetorical terms, remains the pillar of this whole initiative: what point is there in designing a poster nowadays? Admittedly, a change of scene has taken place with the irreversible spread of new digital media and the dwindling physical space for traditional posters, leading naturally to a decrease in their output and distribution; nevertheless, the experts' responses also put the accent on the *designer*, for whom the poster is a sufficiently large size, making it ideal for his or her two-dimensional work. It offers the space for a creative interpretation, the opportunity for multiple reproduction, and for simultaneous distribution in different locations, outside the designer's strict control.

Nowadays, designers are called upon less and less by qualified clients to make posters, other than those for election campaigns or commercial promotions, for example. Indeed, due to the cost of production and billposting, and the misinterpreted promise of many more new contacts, museums and theatres, cultural festivals and concerts, institutions and private clients have cut their investments not just in printed posters but in other promotional objects too, in favour of the digital channel, of sending out newsletters and save-the-dates. The reassuring savings this offers compared with traditional print media has allowed them to increase their investments in digital activities; however, not only is the end result never guaranteed, it is also quite different. It certainly dissipates the event's historic value, as it eliminates the graphic object, which is not just an announcement but, when it is all over, turns into a memento.

It is a fact that today, the surface of graphic design has shrunk, so that the chance to design a poster (suddenly, a large format to get our hands on!) is always welcomed by graphic designers as an unexpected creative adventure, a return to the historic forms of their profession: that is why poster graphic design contests always attract so many entries.

Indeed, posters are one of the first, elementary mediums onto which graphics students are taught to transfer their ideas, languages, lettering and the rudiments of semiology. They experiment with pagination theories and techniques, and fine-tune the layout until it is ready to print; what's more, there are fewer complications with regard to foliation, colour bleeds and layout guides, unlike designing a book or magazine, and there are no limits imposed by the number of characters of a text that's already been finalized. What better, then, than a poster competition to reawaken, with simplicity, the talent of graphic designers and communicators?

Not to mention the enticing chance to offer their ideas up for a noble cause, such as that of social communication: this is the graphic of the Good Samaritan, and it doesn't get much better than that.

Presumably, the poster has always been, and almost always is, the source of an intrinsic, intimate, potential satisfaction for the *designer*: in essence it is a delicate creative moment which must combine, like a chemical compound, aesthetic balance and the capacity for summarizing; during which designers must gather and eventually put into practice the advice of their teachers (and mentors, whether or not they are ideal), sometimes referencing the work of the greatest designers, having responsibly resisted the temptation to forcibly introduce an idea which they've had up their sleeves for years and which must necessarily be used for this last, great, inalienable occasion.

In short, this is a great chance at creative freedom. That empty field to be filled (50x70 cm, 70x100 cm or even larger) is always a fascinating challenge, wherever it ends up (quite literally: with results that are relevant enough to be displayed in an exhibition, on the street or on the sheeting of a building site, the poster never loses its meaning and value, even if the place it is posted changes).

A detailed analysis of the reasoning and requests of the brief; careful consideration of the initial conditions (*what is the budget and time frame available for me to honestly reach my objective?*); close formal adherence to the client's profile, to avoid aesthetic or lexical misunderstandings: designing a poster is certainly not simple, but it's not that complicated either. It is always an exciting thing to do.

How often have enthusiasm and creative verve shattered when they come up against the fundamental rules taught on graphic design courses ("*Remember that the poster must be understood by a passer-by on the move and that you won't get more than three to five seconds to make your visual bait work*", "*Don't forget the lesson of the Japanese flag: strong element in the centre, maximum contrast with the background, clean space around the element of attraction*", "*The poster is a piece of paper stuck up with glue, it's not a painting or a video clip, so simplify, simplify, and simplify again, because you have to make yourself understood in an instant!*") before seeking a mediation between such theory and the mad impulse to break the rules?

THE QUESTION OF CLIENTS AND THE SUSPICIONS OVER DESIGN AS A "STYLISTIC EXERCISE"

Graphic designers' promises are generally delivered to a "client": in other words, someone willing to pay a fee or at least acknowledge a specific skill when it comes to asking the "designer" to transfer content, images and information into a form that is attractive, well-organized, distinctive and effective for their specific communication channel or context. In advertising, this relationship has always been taken for granted as one of the foundations of professional practice between the creative structure and the client; so much so that it is cultivated and conducted by specialists in doing the "dirty work", such as the account managers, who save art directors a lot of trouble and bad moods.

Meanwhile, graphic designers have always believed that contact and discussion with their client is culturally and professionally beneficial, and they always tackle the theme from a somewhat "ideological" perspective, sometimes with great difficulty, because every job involves exploration down a complicated tunnel.
It is in the very nature of graphic design and its ideal destiny (namely that it should last over time, thus leaving an influential imprint in society for as long as possible) that the highest value of design is expressed: the poster, like a book or road signage system, seeks its own "useful" dimension for the good of society; seeks to be something that is not ephemeral and can always be applied to a specific purpose.

Despite everything, advertising still produces campaigns using printed posters (which, however, are always larger than those used in graphic design, which rarely manages to exceed 140x200 cm); but its intrinsic "culturally subversive" potential, which is capable of stimulating sociocultural contradictions in the public, is expressed when it iconographically smashes sexual taboos, or picks up on provocative forms of spoken language; and in other cases, when it manages to break away from the forced layout of a TV commercial frame.

Graphic design posters rise above the marginal position of the whole discipline to become noble and influential when they tackle themes that advertising posters never touch upon: this happens when the project is intended to promote a cultural festival, an opera, a social initiative, or even when it expresses a genuine language of protest or civil dissent.
In this case, the poster is already "close" to its viewers at the moment of creation; it works because it is rooted in the cultural background of the same audience it is aimed at: for graphic design, both the speed at which meanings are conveyed (in terms of semantics and language) and its environmental congruity (symbols, worlds, iconic elements that are evocative and recognizable by its viewers) become a great advantage.

The same iconographic or stylistic choices, the techniques and words used in posters, simplify the relationship with those they are intended to attract, making it immediately possible to read, assimilate and share the message: posters use expressions which are authentic and thus credible within their own environment and historical and cultural time. Their presence changes the way that the surrounding area and visual environment are perceived: those pieces of paper (placed in more or less strategic spots, in a random or prearranged order), as they evolve into symbols and archetypes for a cultural and social turning point, will endure over time as a value, perceived and assimilated by the communities or audiences for which they were designed.

Let us think, for example, of the Bauhaus posters made using innovative Gestalt graphics; the breakdown of the graphic field with the Russian avant-garde; the lettering and modern role of the camera obscura in posters by the Ulm School; the cheerful, engaging graphics of the Cuban revolution; or the figurative silk-screen prints by the Atelier Populaire during May '68 in France: that method of producing graphic design and street posters influenced the aesthetic culture of communication for an entire century.

From Weimar (1919) to Paris (1968), it was also demonstrated that the idea and creative talent always had to be combined with the ability to skilfully use printing and distribution techniques: the typography workshop of the Bauhaus, like the silk-screen print workshops in the occupied classrooms at the Sorbonne or at the Institute for Cuban Cinema in Havana, encouraged experimentation using the technical and economic resources available. This scenario led talents to emerge which later became famous, or conversely remained totally unknown once the experience was over, but which objectively contributed with the same value and passion to the history of twentieth-century graphic design with some absolute masterpieces.

In all the cases I've mentioned, to which I can now add *Good50x70* (2007-2011), the goal was to communicate values of engagement, sharing ideals, civil awareness and a sense of change, and to communicate sentiments of solidarity in cultural or social crisis situations: and the medium chosen to do so was none other than the poster, the most subversive medium of all.

Good50x70 perfectly grasped that permanent spirit of tension in graphic designers: so it is misleading, and rather churlish, to consider *Good50x70* as a one-off vanity exercise, a training ground for people to let off steam regardless of whether or not they were genuinely emotionally and ethically engaged in the major issues raised by the briefs given by the organizations invited. I believe that graphic designers have an instinctive desire to put themselves to the test, always: and the poster is an inviting swimming pool which entices them to jump in, sometimes performing excellent dives, and sometimes succeeding only partially or not at all.

Year after year, *Good50x70* has seen hundreds of good and ordinary projects, tens of excellent, outstanding posters, and numerous small and large masterpieces. Thousands of other entries have, over the years, been rejected by the juries at the preliminary stage and so were never published, but in my humble opinion, those too were a "legitimate part" of the potential energy of *Good50x70*. Indeed, a lot of graphic designers put themselves to the test and had the chance to try, to manage to get themselves noticed (and why not), and to offer their work as part of a social campaign somewhere in the world; an even more important aspect, as Massimo Vignelli pointed out in his article for the 2011 edition, is that so many designers managed to compete on the same theme as other colleagues with whom they otherwise would never had had the chance to come into contact.

Year after year, the *Good50x70* catalogues have always been a wonderful platform for exchanging ideas and points of view. One might think that, ultimately, the "true" clients were not the international organizations who launched their briefs through *Good50x70*, but the design field itself: in the end, the finalists' posters were selected not by the client but by other, more authoritative graphic designers (such as Massimo Vignelli, Alain Le Quernec and Armando Milani to name but a few) who, together with the competitors, have thus defined elements of the quality standard of social communication in recent years. So for graphic designers, as we have already mentioned, a fundamental agent in the progress of their projects is the client: in *Good50x70*, this is somehow an entity which is not exactly virtual, but is, however, intangible; moreover, the reasons for this are obvious, but can nevertheless place an objective and not insignificant limitation on the designer's approach and, perhaps, on the final result too. The lack of that professional relationship (which consists of an exchange of knowledge and respect for roles, and often conflict or temporary misunderstandings) changes the designer's point of view, denying him (at least partially) the value of a very important interaction.

However, it is equally true that for *Good50x70*, the diverse selection of themes submitted by the clients (namely the organizations) triggered a surprisingly large response and that, most likely, the flaw of not having direct contact with the "client" – and the consequent risk of the final entries not having been truly perfected – was eventually made up for by the high number of entries, so that choosing the most suitable interpretation among them was never very difficult.

I would like to point out – acknowledging a few correct observations on *Good50x70*, in more than one case from the jurors themselves – that in some ways the competition could have been seen as a stylistic exercise, a creative training ground for particularly sensitive designers to get to grips with themes which appealed to their personal interests. This was another possible risk, but the conditions of *Good50x70* were always clearly stated: taking part in this platform for projects meant sharing the final results of one's work, and what counted – for the organizers, the charities, NGOs and the juries involved – was the creative contribution to the theme, the dynamism and hard work expressed by thousands of graphic designers around the world on a topic of cultural and social urgency, quite apart from their personal credentials in terms of volunteer work or campaigning. On the controversial question of its being a "stylistic exercise", we can agree that some of the entries veered slightly off course: at first glance, some of the themes may have appeared extremely succulent and inviting for graphic designers everywhere, and the praiseworthy purpose of the initiative may have allowed a sort of authorial self-indulgence in the form of stylistic excess in some cases.

In other cases, there is an evident use of references and stylistic elements, as there was a rather frequent use – especially in the first few editions, but much less so in the last ones – of gory dramatizations (pools or splatters of blood in more than one poster, with the aim of making it all *really, really dramatic*) and a veritable menagerie of sexual organs and condoms so as to direct references to the blight of AIDS or of exploitation through prostitution. These interpretative approaches are rather simplistic, often ingenuous, sometimes even boring and unattractive, of course, but they still reflect the effort that went into them. On the other hand, historically speaking, a certain tragic–apocalyptic element has always provided inspiration for social communication posters (especially in the ecologist and pacifist movements of the 60s and 70s). This is a semantic shortcut that attempts to get to the point and generate a sense of guilt in the public, rather than raise consciousness; often, the result is that the object of the message is overly emphasized: depicting the problem as grotesque or even as a threat beyond the comprehension of normal people prevents the problem from being actually understood.

"SWI

TCH

to HE

ART

VI

EW"

ORIGINAL IDEAS AND GOOD50X70

Many of the ideas submitted to *Good50x70* reflect a fundamental simplicity (in both design and semantic terms and – dare I say – also technically, given that none of the participants had any idea how their work would eventually be printed by the end client: indeed, the rules required them to deliver a digital layout, not the final print-ready version); but this risk was irrelevant, given that there was a jury on the receiving end which had the expertise to measure the intrinsic value of the posters entered.

What's more, the designers were all aware that their freedom of interpretation would be met with a freedom of evaluation on the jury's part: indeed, none of the latter would be fooled by rehashed solutions, banal reprocessing using Photoshop, or by the slick professional look of stock photos; in choosing the "best" in graphic design, the jury members (all graphic designers themselves) always opted for a simplicity of ideas, for the least standardized and perhaps most authentic ones, sometimes less well-packaged, but those that expressed a "meaning" and a fast, relevant message. What's more, thanks to the selection committee, the quality of *Good50x70* has not just remained steadily high over the years, but has actually improved with each edition, and has allowed the works to be presented in a large number of exhibitions which have toured the world.

Looking back over the images selected over the past five years, the trickiest decisions have always been those concerning the originality and the method with which the entrants tackled the themes given: the most original creative work – and generally this includes designers in the younger age group – suffers from the technical handicap of not being capable of immediately condensing an idea into a visual summary; very often, a good idea fails to cross the threshold of an impressive presentation. Given that the designer has relied upon technical skill, rather than experience, the idea ends up seeming merely well presented.

In a few other cases, it was pointed out that many entries recycled solutions that had been "done before" in the past. But that's precisely what authoritative juries are for, selecting – and rejecting – unoriginal projects so as to ensure that the final selection is as high-quality as possible.

However, we should take into account that the majority of the designers, as mentioned above, belong to the younger age group: so the risk of them producing something "done before" is higher, but there are a couple of reasons why we should not question their good faith:

1. For some time now, graphic design schools have abandoned the good habit of conducting an in-depth course on the history of graphics; I am sure that being thoroughly educated about what has been "done before" (through up-to-date, well-managed academic libraries and by supplying students with compulsory annotated reading lists) would save designers and clients from naive and embarrassing repetitions.

2. Nowadays it is much easier than before to find similar designs, or even identical creative solutions. The Internet is on hand to prevent mistakes and irreparable damage (for our clients and for our own professional reputation). Very often, designers' good faith is based on the method of design they learnt at college, and the professional results reflect the graphic designer's academic career and training (in terms of intellectual background, methodological approach and their teachers' presentation and teaching skills). Identical training produces similar results, not just for scattered clusters of graphic designers, but for the thousands of design graduates who enter the profession each year. Constantly monitoring the work of others and keeping up to date is easier nowadays, and should become an ongoing professional habit.

For example, how many logos look alike because their creators studied under the same teachers, or as students devoured Gestalt theory or entire chapters of Rudolf Arnheim's books on visual perception, or Adrian Frutiger's wise theories on signs and symbols? The same can happen with posters too, of course, and often occurs with book covers around the world. It is hardly a tragedy, but we should seek to prevent similarity – however regrettable – becoming a setback in the (one hopes) continuous progress of visual culture. Older generations of graphic designers should help by encouraging younger professionals to continue their experimentation, research and open debate, not just blame them and grumble because they have left behind the "good rules" of the past, as though such rules were unbreakable methodological dogmas.

GOING BEYOND GRAPHIC DESIGN STANDARDS: THE TRUE VALUE OF GOOD50X70 IS INCLUSIVE DESIGN

Good50x70 has been expressed through the sense of a "Big Occasion", namely within a mutually interesting context for both designers and the organizations who set the themes, in which small masterpieces and less eye-opening ideas freely coexist, almost overturning the concept of the relationship between designer and client. Over the years, thousands of ideas (usable or otherwise – the choice was there!) have become available and have contributed to the gradual, unstoppable spread of information and knowledge on the major themes affecting the state of our world.

Messages created using various different styles, impacts and iconic language (a sort of ready-to-wear graphic design archive) are now on hand, ready to help real and potential clients in search of graphics, and many more who will probably become aware of this precious portfolio in the future.

Ironically, many of those clients (charities, NGOs, institutions and social volunteering organizations) do not currently know that they can have access to this vast, open goldmine. Their main daily activity (fundraising) and their mission to reach their goals can, however, be improved and be communicated more forcefully thanks to the contribution of *Good50x70*.

This is something which goes beyond graphics, and which at last shifts the presence and influence of graphic design into a much larger cultural field, so that it can become ever more useful and accessible than it has been so far.

Good50x70 now has to work on the most delicate phase: promoting the vast archive that it has put together, and which is destined to grow over time, thus turning a collection of ideas into a useful collective legacy.

Five editions of *Good50x70* have launched major *global themes* (from environmental protection to civil rights, from socio-economic themes in poorer countries to the abolition of child labour), and *local themes* (tigers' risk of extinction, or public reaction to the pervasiveness of the Mafia, for example); and the latter also drew a response from entrants all over the world: I believe that this shows once again how graphic design is often seen (and reflected in society) as a fully-fledged form of literature capable of tackling "distant" issues even when the designer has a cultural background that may not necessarily derive from that specific context, which is imaginary but no less virtuous by being so, as it is well-documented and never meaningless. The distance of the observer, the difference in cultural background and chosen method of interpretation (whether consciously expert or spontaneous) have always been interesting factors with their own expressive impact, which often made such entries stand out from the rest.

Many of the designs gathered by *Good50x70* come from extreme social, cultural and geographical contexts; it is only when they shy away from the usual, conventional technical solutions that they manage to be surprising and efficacious. In almost every edition, several creatives from the Middle East area stood out for their remarkably high standard of style, which was quite out of the ordinary. *Good50x70* was this, too: a vast review of the many figures that populate international graphic design; a contest which, in addition to being spurred on by an altruistic spirit, turned attention back to certain graphic design "enclaves" which are surprisingly high quality and generally gain less exposure on the international scene of the graphic design establishment. *Good50x70*'s skilled use of the web and its accomplished management of the platform in real time, taking great care over managing its contacts, helped make the project the success it was. The anthology you are reading is not just evidence of a remarkable project, but also a new source of ideas; it is nothing short of an atlas of engaged, responsible graphic design.

THE POSTER IS DEAD, LONG LIVE THE POSTER?

The poster has been declared dead countless times, but the medium has always been cheerfully resuscitated whenever a historic or cultural watershed moment has required a high-impact, distinctive, comprehensible echo. Paradoxically, in a world in which physical space is being gradually eliminated in favour of digital solutions, this humble visual medium seems to have reappeared wherever necessary, to extend the influence of messages through its expressive creativity and format. I would go so far as to say that the poster has once again become very inventive and culturally "disruptive" precisely because there are no longer that many places for it to be displayed.

Every now and then, experts gather or write articles and conduct lengthy debates discussing the end of the poster, but surprisingly up one pops on a wall, as though to announce its robust, hearty state of health. Even now, making a good poster requires just a few quality ingredients, and I believe that the issue of cost (of production and then billposting) is a feeble excuse used by posters' detractors. In fact, it reveals how an element of visual culture has deteriorated: that which attributed the printed object its rightful place in material life, and which gave it the task of preserving the memory of our actions. All things told, a poster is a cultural, social and political trace which remains eloquent: it is a container for information, but can also be a punch in the stomach, as fast and powerful as an uppercut thrown out against consciences which may be inert or indecisive, distracted or waiting for a confrontation. It's a piece of paper, but one that's full of energy: it has the potential to tell a story in an instant, and force us to connect ideas, opinions and reality. It gets you to take a position, by moving you or provoking you.

This is why I believe that the poster is alive and well, and we should realize that there is still a point in letting it pack its communicative punch through good graphics.

5 YEARS OF THE PROJECT
8 CHARITIES
930 POSTERS
9870 ENTRANTS
82 EXHIBITIONS
27 MEMBERS OF THE JURY
81 COUNTRIES INVOLVED

FIVE YEARS OF GRAPHIC DESIGN, FIVE YEARS OF COMMITMENT

Five years of *Good50x70* have meant, for many designers all over the world, something more than a yearly graphic design event. For all these years, *Good50x70* has also been an opportunity for the international community to debate some themes of crucial importance for life on Earth, from civil rights battles to environmental protection.

Thousands of projects have sought to contribute to the collective outlook, and at the same time have become an open legacy which is available to anyone in the world who might need it to amplify their voice or make their social communication even more hard-hitting.

The ideas and social commitment of the graphic designers have in many cases offered a fresh perspective on drastic situations which, however, require other forms of support if they are to be tackled and resolved, such as through local and global funding strategies, or political and economic intervention on a global scale by the governments and nations who are working for the progress of humanity. Graphic design isn't enough, of course. Graphic design cannot solve the weighty subject matter of social communication, but it can help people to understand the extent of problems, to draw people closer, and create awareness by inspiring them to get involved. Whenever it manages that, it's always "good graphic design"; when its creators leave behind aesthetic self-satisfaction, it becomes virtually perfect. When "good graphics" introduces new standards and experiments with new visual languages, and with passion, it turns into something that is excellent and encouraging for the entire discipline, because it turns it into an influential, useful cultural tool.

The role of *Good50x70* cannot go beyond this collective responsibility: the extent of discussion, exchange of ideas, participation and message-spreading has been broad and tangible, far beyond the expectations of the organizers themselves. Travelling exhibitions and workshops have given *Good50x70*, and therefore all those who have taken part over the years, that spirit of involvement and sharing which has allowed a large, voluntary, totally unprecedented graphic design movement to take shape.

This is, however, still primarily a book about five years of graphic design. It is a testimony which gathers together the works which the juries judged to be the best and most outstanding throughout the various competitions.

And while behind every excellent graphic design project there is always an excellent designer, we can be certain that behind a *Good50x70* project, there is not just a graphic designer, but a good person too.

25

2007

MASSIMO VIGNELLI

New York, USA

[…] The real problem, if there is one at all, is that in some sense the poster as a means of communication has lost its main vehicle, namely the wall. The medium itself has been diminished by the strength of so many other types of media, and has been relegated to the role of a bulky oversized letter: too large for the home, too small for the city.

[…] Nowadays, other media are stronger and more effective: in just one second, a documentary can move more people than a poster ever will. Yes, an image can achieve a lot, make a deep impression, but why on a wall?

Why not on my computer screen, for example, or on a printed page? What is there that's more widespread than this medium?

[…] It's been said that the simplistic solutions seen on many posters could be due to the use of the computer and all the seductive options that the computer offers. I'm not sure that this is a problem. It could be one, in the hands of an amateur, but the computer is a great help if it's in the right hands, no more and no less than a pencil or a paintbrush once were.

Massimo

ALAIN LE QUERNEC

Quimper, France

[…] I grew up with the idea that a poster was "action", that a poster was strength, that a poster was life. Today, the world has changed and we must acknowledge that most of what is passed off as posters nowadays is just dead paper, and the anatomy of that death is what we call "culture" or "art".

[…] The art of the poster survives, even though it's no longer needed, because its nature is that of a minimalist art form, in terms of both text and image. This art must continue to be taught to students, even though they may never make a real poster in their lifetime. It's a good way of structuring one's thoughts.

[…] The themes of this competition – AIDS, global warming and so on – which were chosen to give colour to this display of graphics with a conscience, actually demonstrate just how powerless designers have become. What is the point of a poster which is deprived of its natural environment, and hence its power? A good idea is one that works, and is circulated. A cartoon in a newspaper, a big magazine cover, both of these can be more effective means of communication than a poster, in the "real world".

Alain

TIMO
BERRY

Helsinki, Finland

Nowadays, creatives are merely "hired hands" who adapt and change according to their clients' requirements. Keeping one's backbone in a field like this is a challenge. I'd like to thank the organizers of *Good50x70* for having bucked this trend, and I am honoured to take part in this well co-ordinated, interesting and, more importantly still, "good" project.

The sheer number of entries was incredible, proving that the design world has an ethic which is greater than that defined by clients' commissions.

The themes were complex. Making a poster that conveys the right message without being boring or flat is quite difficult, but harder still is communicating social themes without preaching. The jury members were able to see not just a lot of effort, but great ideas and good design too. The best posters stood out from the rest, and their designers should be proud of their work. I hope that the ultimate goal of this project – to take these images onto the streets – becomes a reality, as it deserves to.

Timo

YOSSI
LEMEL

Tel Aviv, Israel

The poster will never die. It will never change; it will always manage to convey a message in the street. A poster should be like a diamond: it must be immediately recognizable, but also full of layers of meaning. A poster should also be international: it must be understood from Mexico to China. The immediate reaction has to be one that takes place in both the stomach and the brain.

How to create a good poster on a social issue:

1. Get yourself involved; you need passion.
2. Love what you design.
3. Learn everything you can about the theme you have to work on; do your research.
4. Simplify things. The simpler it is, the more people will be able to understand it. In most cases, you'll need "blood, sweat and tears" to create the simplest things.
5. Everything begins and ends with a good concept.
6. The best combination is copy and an image that mutually support each other, so as to triple their impact.
7. Try to think with no limits.
8. Try to be bold.
9. You must be original.
10. Try to get a reaction, to surprise people, first of all yourself.

Yossi

LUBA
LUKOVA

New York, USA

"Are you a good designer?"

A journalist recently asked me if I thought I was a good designer. I think that the answer I gave is relevant to a project as necessary as *Good50x70*:

"I've always thought that other people, not me, should decide whether I'm good at what I do. Very often, we creatives think that the general public don't appreciate our profession enough. That is probably true, but it is the fault of the design world itself, not of normal people who don't care enough about beautiful compositions, trendy typography or superficial provocativeness. What those people need from art and communication are works that inspire emotions and leave an impression, and make them think. That's never been a simple task. But works like that trigger a change in the public's opinion of graphic design. People who have never given a second thought to creativity will start noticing it and feeling a need for it. They might even go as far as stealing posters from a cinema lobby, or having a replica of a poster tattooed on their skin. When something like that happens with my own images, I interpret it as proof that I might even have done something good. Our audience wants to be stimulated and uplifted. That's what good creativity should do."

Luba

ARMANDO
MILANI

Milan, Italy

2,500 years ago, Confucius said that signs and symbols rule the world, not words or laws. Designers today should bear his words in mind, because their role is to turn ideas and concepts into visual communication.

Various crises have now reached global dimensions – we have been swallowed up by war, fanaticism, energy wastage, the demographic explosion, and global warming. In the light of all these problems, we must recognize that a designer has a socio-political role which goes beyond making something that is simply attractive and marketable.

The *Good50x70* project has succeeded very well in interpreting this heartfelt responsibility for the world we live in, with an outstanding number of entries comprising 1,659 posters. I have to say that, as it is open to all, the quality of the entries (bar a few cases) was not exceptional, but I believe that the value of this competition lies in the fact that it encourages people to think and, hopefully, act against the dangers facing humanity, warning us not just about our future, but about the future of our children too.

Armando

CHAZ MAVIYANE DAVIES

Harare, Zimbabwe

[…] The function of the posters in *Good50x70* is to raise awareness, inspire action, illuminate, promote or inform; and to do all that effectively, we need to be astute, well-informed and diligent in terms of approach and creativity, so as to be able to reflect the messages we want to communicate. Unfortunately, very few of the posters entered managed to achieve this. I was overwhelmed by a feeling that some people really believe that an acceptable design can be achieved by using an archive image, a vector gradient, a sound sample and a couple of Photoshop filters. Young designers especially should be very careful about how they include computer software, with its "one-click tricks", in the design process. The fact is, everyone has access to them, which explains the bland homogenization we are seeing more and more nowadays, regardless of which corner of the world it comes from – technological imperialism!

[…] Until we realize this, we'll be crawling in a desert of mediocrity towards a pixelated mirage which computers promise to those who are unwilling to grasp the ethos which is intrinsic to good communication and in design.

Chaz

LOURDES ZOLEZZI

Mexico City, Mexico

The themes of the competition refer to major social issues which are already the subject of heated international public debate: the urgent need to start saving energy to avoid global warming; AIDS in Africa; the common prejudices faced by prostitutes around the world; health care during war; and the protection of human rights in the fight against terrorism.

Good50x70 has been an opportunity to discuss the level of this debate, the strength, the potential, the clarity of ideas and their innate forcefulness. Something needs to be done, and fast, to show the situation as it really is, to denounce our shortcomings as a society, and, as always, there is a need to change our world for the better.

In this case, given that the role of the visual arts is to share and disseminate an aspect of reality laid bare, it's been a great experience being part of this new endeavour to reflect upon our collective faults as human beings.

Lourdes

Lila

Italian League
for the Fight against AIDS

AIDS

MESSAGE

BEYOND PROSTITUTION PREJUDICES.

BACKGROUND

It isn't easy to handle the prostitution issue: moralism, hypocrisy and clashing systems of ethic
continue to make any form of dialogue difficult, even today. The same arguments are still use
in every discussion, despite the great social evolution of the last century. Both blame on th
phenomenon and labelling of the victims persist.

With so much hypocrisy, institutions often decide to fight the immoral behaviour they see i
prostitution, and not the real criminals. The weakness of the tools adopted by governments to solv
the problem is evident: a high number of arrested prostitutes, but how many clients and exploiter
are either arrested or expelled?

Only by recognizing prostitution as a self-determined choice made by those who practise it an
those who use it, and respecting it as it is without making useless attempts at prohibition, ca
we make a difference in terms of rights, safety and public health. Only in this way is it possible t
fight against the slavery of women, with the consequent break-up and trial of the criminal networ
exploiting it, instead of perpetuating the current situation where those who practise the professio
at their own risk are most exposed to legal repression, rather than those who gain from it sittin
at home.

SAFE PLEASURE
BELÉN DE MARÍA GIMÉNEZ
Montevideo, Uruguay

EUROTIQUE
NICOLAS FILLOQUE
Ivry-sur-seine, France

LABYRINTH
BENITO CABANAS ELVENO
Mexico

FOR SALE
NATALIA DELGADO
Ensenada B.C, Mexico

WATCH OUT
AVIRAM MEIR
Israel

GAMES
LEONARDO ALBANESE
Foggia, Italy

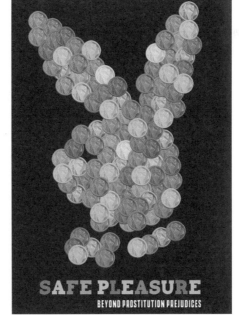

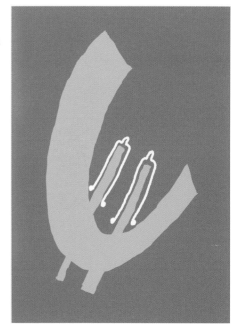

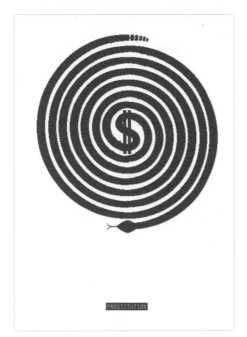

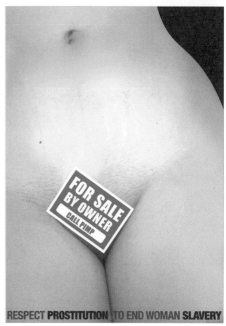

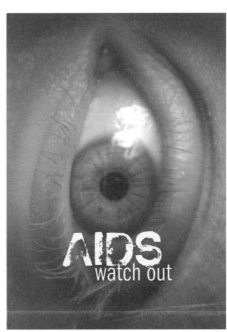

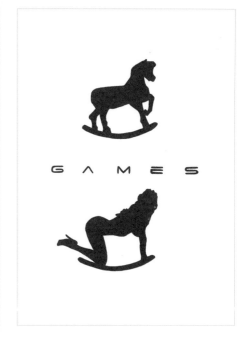

SEX WITHOUT A CONDOM
CHEN WANG
Buena Park, USA

DON'T GAMBLE WITH AIDS
ILHAMI DIKSOY
Samsun, Turkey

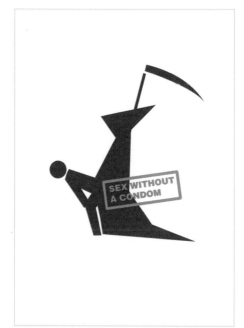

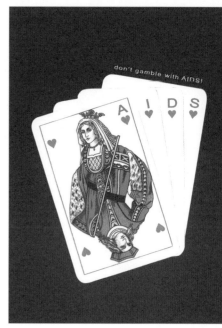

PAC-MAN
SERGEI BUCENKO
Kharkov, Ukraine

HI_V
IOANNIS FETANIS
Athens-n-Iraklio, Greece

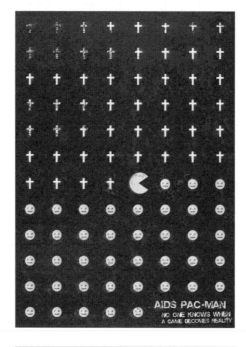

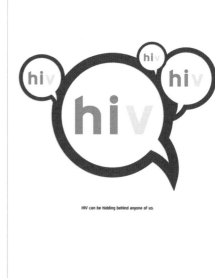

WO
PAMELA CONVERSO
Milano, Italy

HER PUSSY, MY WALLET
BARBARA LONGIARDI
Forlì, Italy

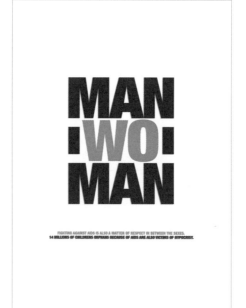

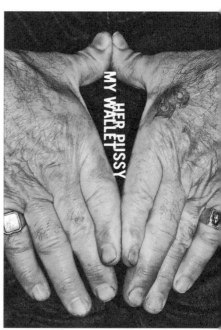

I HAVE TO SAY, I LOVE YOU!
PARISA TASHAKORI
Tehran, Iran

I LOVE
GABRIEL RIVERA
Mexico City, Mexico

A NICE PIECE OF MEAT
DIEGO PICCININNO
Barcelona, Spain

DON'T BURN YOURSELF
SAIT KESER
Samsun, Turkey

SHIFT WITH CARE
ARDAN ERGUVEN
Istanbul, Turkey

GRADUAL DEATH
MOSTAFA KALANTARI
Tehran, Iran

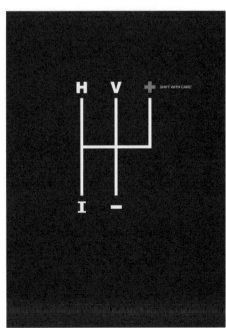 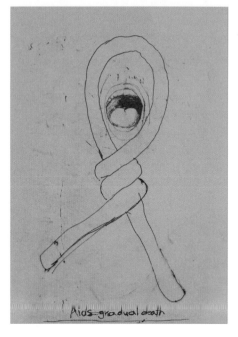

HIV
REZA SHERI
Tabriz, Iran

NO PROSTITUTION
MEZA ROMERO OBED CHAPARRITO
Puebla, Mexico

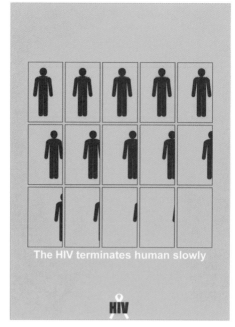

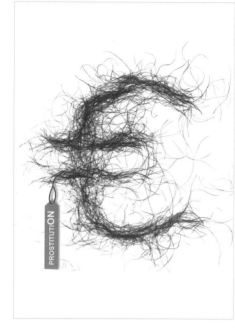

POSSIBILITY
ALI CAN METIN
Istanbul, Turkey

PROTECT YOU
ABRAHAM LAFARJA FERNÁNDEZ
Veracruz, Mexico

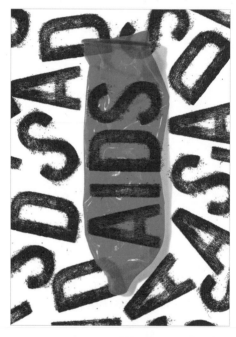

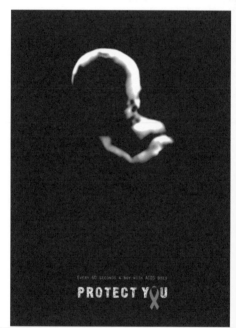

PINK?
ENRICO MOSCONI
Ancona, Italy

ALPHABET
JULI SZENTE
Budapest, Hungary

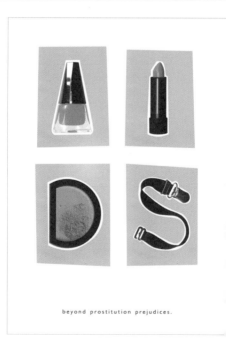

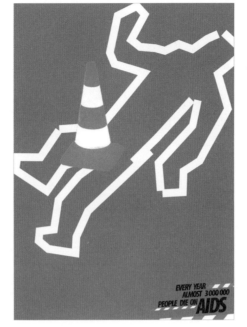

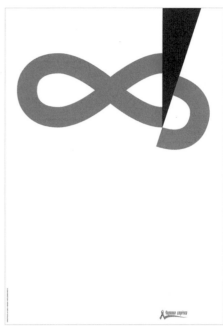

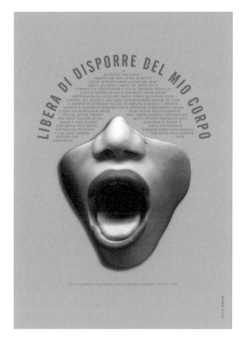

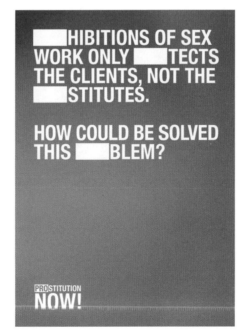

DO NOT BLAME ME FOR EVERYTHING!
HAJAR MORADIBENI
Tehran, Iran

IT'S YOUR TURN
CARINA DIAS
Vila das Aves, Portugal

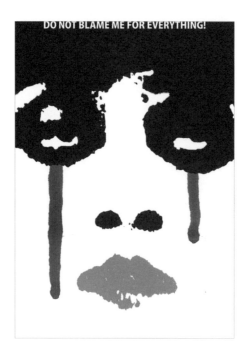

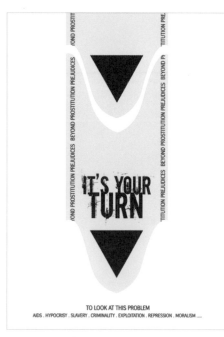

VICTIM
GABRIEL MARTINEZ
SONIA DÍAZ
Madrid, Spain

UNKNOWN
TUUKKA TUJULA
Helsinki, Finland

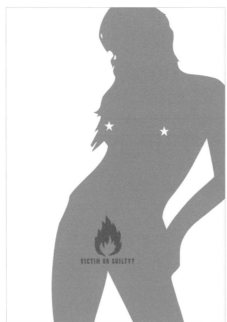

KEEP YOUR LOVE
KWANG-BOK KIM
Daejeon, Korea

AIDS, DO NOT PLAY WITH IT
YOUNG-JOON PARK
London, UK

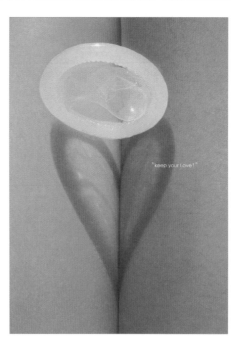

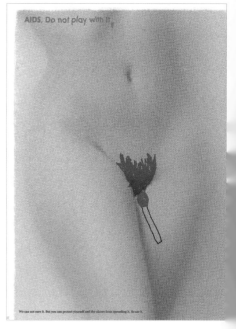

AID
MILENA VALNAROVA
Sofia, Bulgaria

THE LAWS CONCERNING PROSTITUTION
THOMAS DI PAOLO
Germany

SNOW WHITE
DO-HYUNG KIM
Seoul, Korea

PROSTITUTION LIKE A PRISON
THIBAULT BRASSART
Cambrai, France

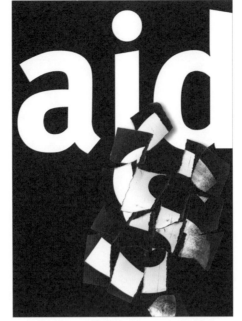
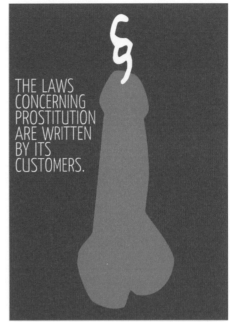
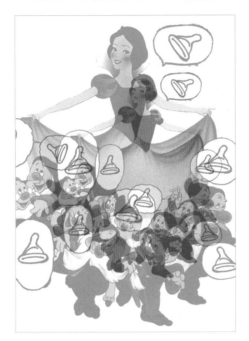

39

Greenpeace

ENVIRONMENTAL DAMAGE

MESSAGE

USING ENERGY EFFICIENCY TO FIGHT GLOBAL WARMING.

BACKGROUND

Fossil fuels are seen as the main cause for climate change. Our (over)use of them risks irrevocably destroying the fragile balance of the planet. It is difficult for all of us to "see" global warming, but the impact is increasingly evident, and it is alarming. While waiting for the energy revolution of the third millennium, which will involve the use of clean and renewable energetic sources (sun, wind, biomasses, the sea, clean hydrogen), everybody can do a lot right now to stop climate change and cut down on the emissions of climate-damaging gases — mostly CO_2 — by investing in "energy efficiency".

Energy efficiency doesn't mean saying no to the comforts of our current lifestyle but reducing the energy consumption of our appliances, buildings and industrial plants, to get the same effect but with less consumption.

Research across Europe confirms that it would be possible today to save up to 45% of electric power consumed and to cut one third of CO_2 emissions by replacing all current electrical appliances with more efficient models that are already available in the market.
Energy efficiency is the first and most important renewable source currently available, because it is the easiest to develop, with the lowest cost to society. All of us can do a lot from now to stop climate change and cut down on our own CO_2 emissions. How? By investing in energy efficiency!

NO ENERGY
ROBIN HEGARTY
Dublin, Ireland

KYOTO
MATE OLAH
Budapest, Hungary

CHANGE GLOBAL CLIMATE CHANGE
BRIAN HAYES
Robbinsdale, USA

GLOBAL WARMING
DORIT BIRKNER
Uffing, Germany

CO2
ARMEEN KAPADIA
Pune, India

GREEN WEEK
REGINA MALDONADO
Garza Garcia Nuevo Leon Mexico

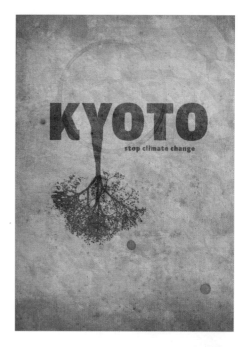

NON PERMANENT
ALEXEY KONDAKOV
Kiev, Ukraine

GLOBAL WARMING
MIKEL FAMMILIA
Azkoitia Gipuzkoa, Spain

TOASTER
THORSTEN SCHMIDT
Stuttgart, Germany

NO TITLE
ISTVÁN SZUGYICZKY
Budapest, Hungary

666°F
NIKOLAY KOVALENKO
Kyiv, Ukraine

ENVIRONMENTAL DAMAGE
JAMILE JAMSHIDI
Shiraz, Iran

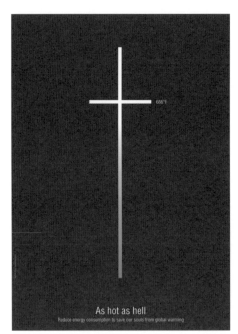 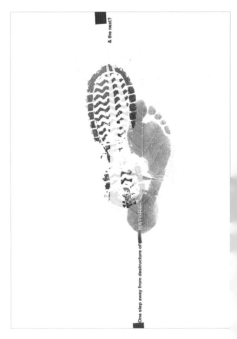

SWITCH!
ANA BARBARA ACEVES PIRA
San Pedro Garza Garcia, Mexico

EXECUTION
JULIA LUKYANCHENKO
ELENA KOSTIRINA
Rostov-na-Donu, Russia

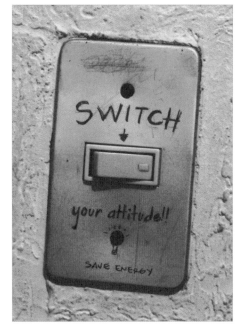
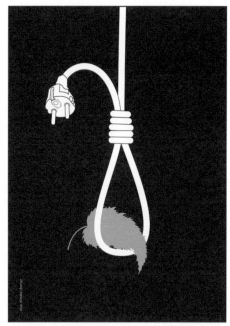

WE FOR NATURE OR NATURE FOR US?
REZA BABAJANI
Tehran, Iran

ENERGY EFFICIENCY OR DEATH
OLGA HAYON
Miami, USA

INVISIBLE KILLER
PAOLO PERONACI
Milano, Italy

THE EARTH IS THE PREY
JOSE LUIS MARTINEZ RODRIGUEZ
San Pedro Garza Garcia Nuevo Leon, Mexico

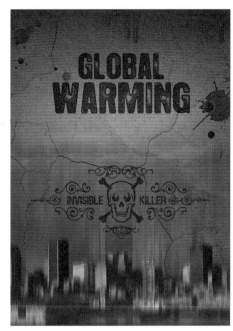

43

BACKPACK
MARTHA ANGÉLICA ROJAS PÉREZ
Culiacàn, Mexico

NATURAL ENERGY
KHEREN JUAREZ GUARDADO
Medellin, Mexico

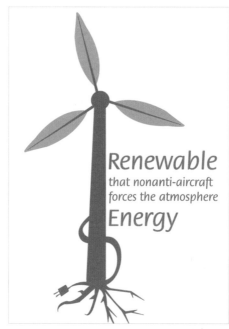

CONSERVE YOUR WATER
MARTIN FANNING
Dublin, Ireland

INFLAMMABLE
MARCO NICOTRA
Milano, Italy

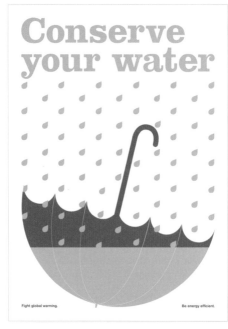

SAD GENERATION
ERKUT TERLIKSIZ
Istanbul, Turkey

COMING SOON
JOSE ARTURO GARCIA TORRES
Mexico, Mexico

44

LIGHT GLOBE
CHATRI NA RANONG
Melbourne, Australia

LITTLE THINGS
TERESA TREVINO
Garza Garcia N.L, Mexico

GLOBAL WARNING
ONUR GOKALP
Istanbul, Turkey

OPUS OF DEATH
CHEN XINGHAI
Changsha, China

THIS IS OUR ENVIRONMENT
MAYSAM KHAZAEI
Karaj, Iran

EVOLVE
SAMANTHA KOCKING
Bay Harbour Island, USA

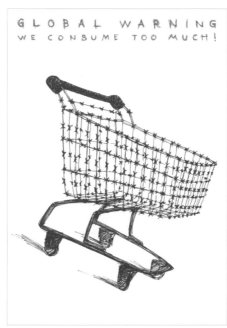

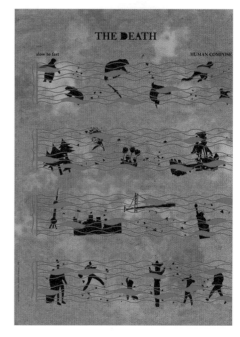

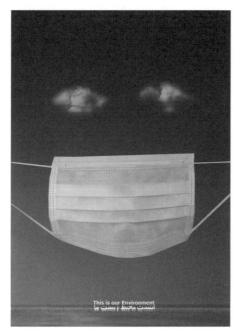

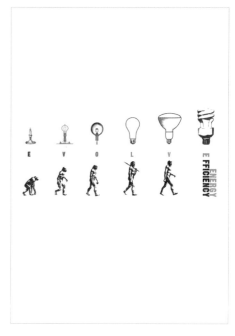

BOILING ENERGY
EGIE PERMANA
Surabaya, Indonesia

NO LASTIMES LA TIERRA
HÉCTOR IVÁN DOMÍNGUEZ PINO HETORIBIO
Puebla, Mexico

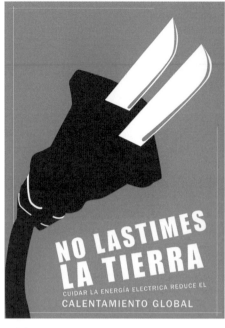

YOU'RE BURNING YOURSELF BEFORE BURNING THE NATURE
ELHAM MAHOOTCHI
Tehran, Iran

CLIMATE IS CHANGING
KATRI HERNESMAA
Suolahti, Finland

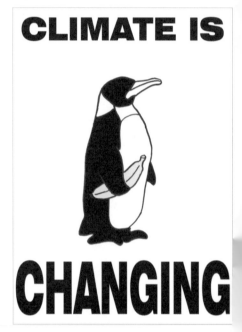

KILLING US
VICTOR HUGO CABAÑAS
Puebla, Mexico

SAVE WATER
SEUNG-HOON NAM
Seoul, Korea

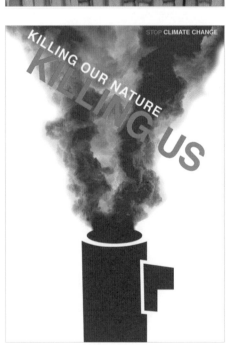
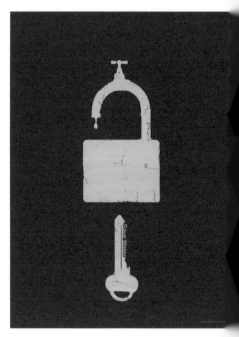

THE DIFFERENCE? EFFICIENCY
HUA JACK TOH
CHIH WEN CHAW
USA

CONSCIOUSNESS
MARIA DEL MAR REYES ABASCAL
San Pedro, Mexico

MELT DOWN
GIANNI TOZZI
London, UK

FLAME
MARTINEZ GABRIEL
DIÁZ SONIA
Madrid, Spain

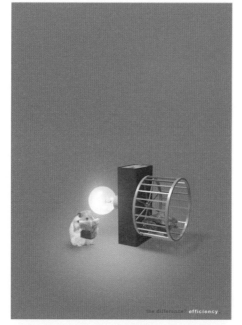

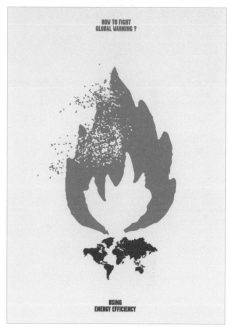

Amnesty
International

HUMAN
RIGHTS VIOLATION

MESSAGE

TERRORISM CAN'T BE DEFEATED WITH HUMAN RIGHTS VIOLATION.

BACKGROUND

Terrorism cannot be fought with arbitrary arrests, disappearances, detentions or torture.
The condition for achieving global security is respect for human rights. If the banning of torture and
mistreatment is violated, what are the chances of protecting any other human right?

Believing that torture can be justified in some circumstances means believing that the aim always
justifies the means. This line of argument is very similar to the one terrorists often use to justify
their attacks.

War on terrorism is the excuse for many governments to continue to practise, undisturbed, good
old repression. Moreover, tolerance of or indifference towards human rights violations grows when
the final aim is cited as fighting terrorism.

The only way to address this situation is to set standards prohibiting any kind of inhuman treatment.
We can't defend what we support by subverting our moral values. And we can't fight terrorism using
state terror.

HUMAN RIGHTS IN IRAN
SAJAD ASADI
Tabriz, Iran

1 MAY
TUNCHAN KALKAN
Istanbul, Turkey

IS THIS WHAT WE NEED?
SONGWEI CHEN
Lowa City, USA

GAVEL OF TERROR
VESA KUULA
Helsinki, Finland

WOMAN'S RIGHTS
SARA SOTOUDEH
Tehran, Iran

THE LAW
NIKOLAY KOVALENKO
Kyiv, Ukraine

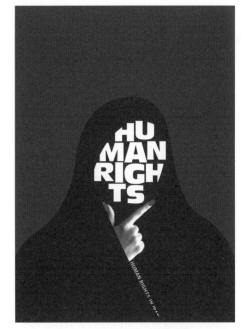

49

REALLY NOT THAT COMPLICATED
HAAVARD PEDERSEN
Milano, Italy

OUR T(ERROR)
MICHAEL CANTURI
London, UK

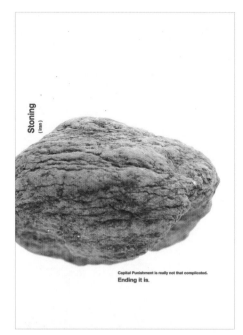

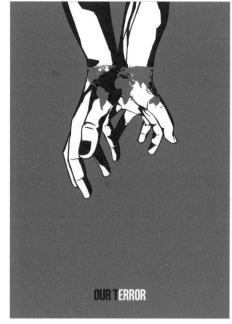

BLINDFOLD
DINO BRUCELAS
Makati, Philippines

NEVER READ
CINZIA FERRARA
ALEXANDRA DOSSI
Palermo, Italy

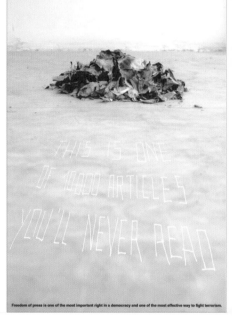

WHEN LYING ON PAPER HUMAN RIGHTS CAN HURT
SIMONE VERZA
Forlì, Italy

VIOLATIONS IMPRISON US ALL
CYNDY PATRICK
Jamaica Plain, USA

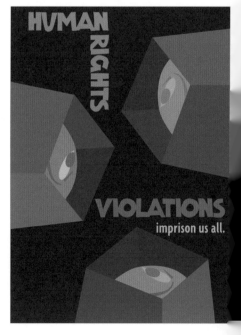

50

P_01
ABBAS PARCHAMI
Mashhad, Iran

ABOLISH TORTURE
MARLENA BUCZEK-SMITH
Wallington, USA

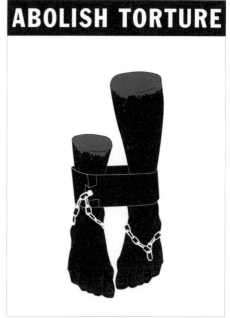

WAR WILL NEVER BE THE SEED OF PEACE
ANGELA MORELLI
Italy

WE ARE ONE
TAKANORI MATSUMOTO
Saitama, Japan

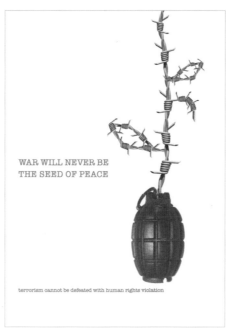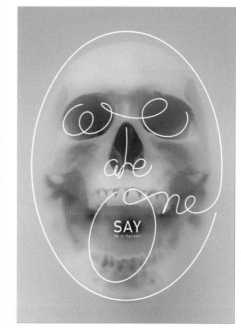

ICE CREAM / I SCREAM
MILAN JANIC
Paris, France

HUMAN RIGHTS
UUKKA TUJULA
Helsinki, Finland

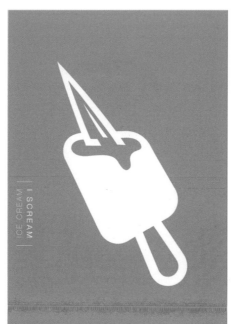

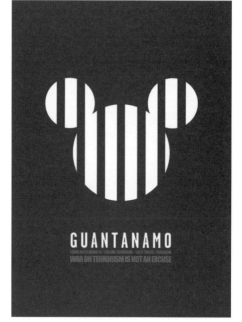
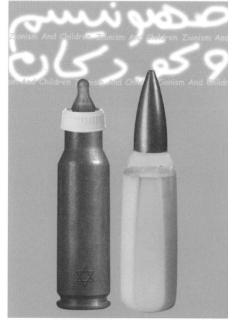

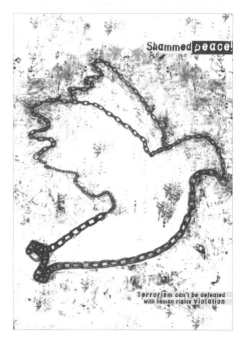
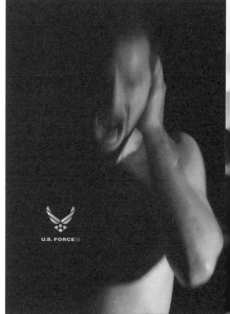

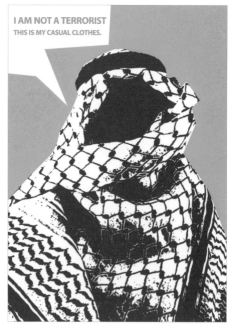

EVERYONE LOOSES
FABIO ALMEIDA
TIAGO PEREIRA
Portugal

HUMAN RIGHTS
SAEED BEHDAD
Tehran, Iran

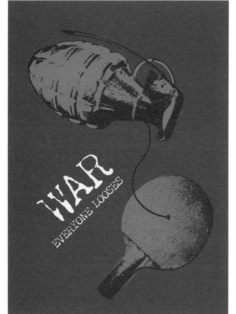 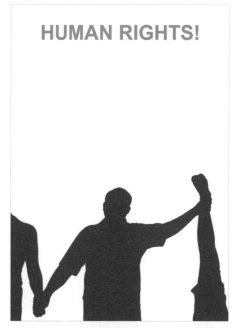

UNTITLED
FEYZI KARAER
Istanbul, Turkey

TERROR
ALIREZA HESAEAKI
Dublin, Iran

**WE CANNOT FIGHT TERRORISM
USING STATE TERROR**
JING ZHOU
Long Branch, China

HUMAN RIGHTS IN THE THIRD WORLD
TOURAJ SABERY
Tabriz, Iran

MORE (D)ANGER
HEIDI GABRIELSSON
Helsinki, Finland

GUN
MARCIN DUBINIEC
MAKSYM MATUSZEWSKI
Warszawa, Poland

STOP
ALEXANDRA VYDMANOVA
Moscow, Russia

PROTECT IT
TODOR STOILOV
Burlington, USA

MEMORY FRESH
BENITO CABANAS ELVENO
Puebla, Mexico

SPIDERMAN
ISTVÁ SZUGYICZKY
Budapest, Hungary

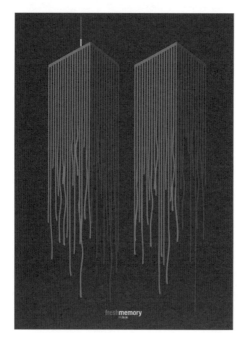

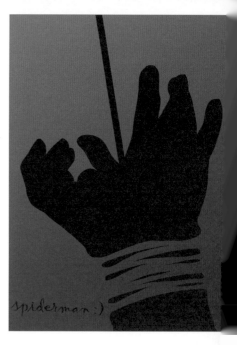

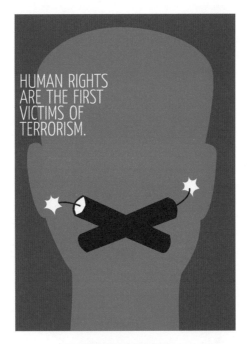

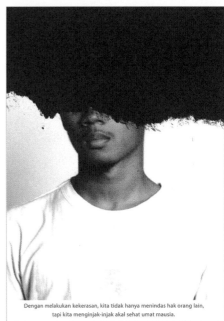

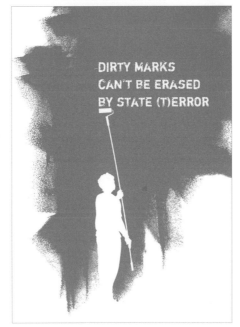

UNDERVELOPMENT

MESSAGE
CONDOMS AS THE FIRST TOOL TO FIGHT AIDS IN AFRICA.

BACKGROUND

The level of AIDS infection in Africa has reached ever more alarming proportions: every hour five people in Africa contract HIV.

Those who fight against AIDS know that this requires being active on many fronts: filling the gap that separates marginalized people in society from proper heath care; facilitating a global change in prevention and cure strategies for HIV; fighting the prejudice hitting men and especially women infected by AIDS; promoting health education and knowledge of all aspects of the disease: the infection, the physical consequences and transmission of the virus.

However, to be really effective, to eliminate other ways of virus transmission and induce real changes in behaviour, the prevention programmes must be calculated specifically on the social and cultural context where they are applied, not on global standards to be applied everywhere.

Condoms remain until now the most effective way to reduce HIV and other sexually transmitted diseases, but they aren't, and can't be, the only solution to the HIV problem in Africa.

"Until the day that people will be involved in the creation of their own health systems, we'll keep drying the floor while the tap is still dripping."
Professor Miriam Were (AMREF)

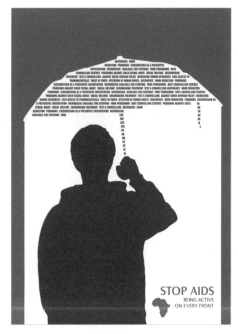

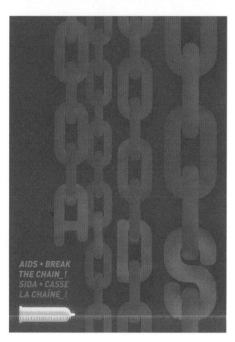

**CONDOMS AS THE FIRST TOOL TO FIGHT AIDS
IN AFRICA**
PEYMAN POURHOSEIN
Tehran, Iran

SAFE SEX
THEODORIC ERIC
Bandar Lampung, Indonesia

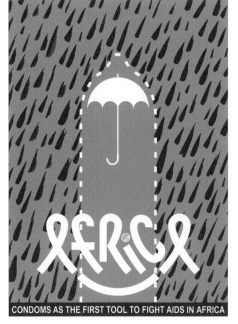

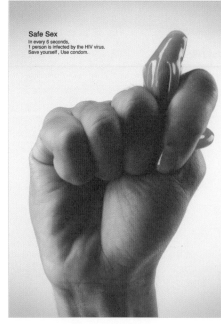

**DON'T BE BLINDED
BY SEX!**
YU-JUNG
USA

SAFETY AFRICA
MEZA ROMERO OBED CHAPARRITO
Puebla, Mexico

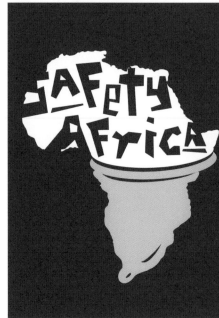

BLACK MAMBA
PIERO DI BIASE
Tolmezzo, Italy

STOP AIDS
FANG CHEN
StateCollege, USA

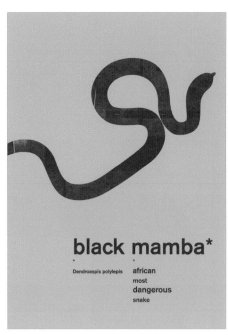

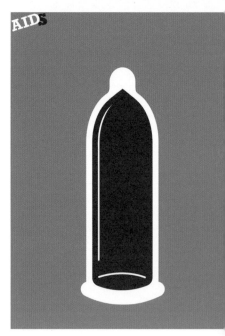

AFRICA CRYING
KATARZYNA BAK
Cerveteri, Italy

IT'S NOT MORE DIFFERENT
MARCO DUGO
Italy

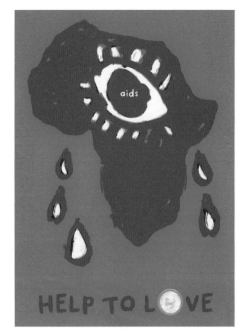

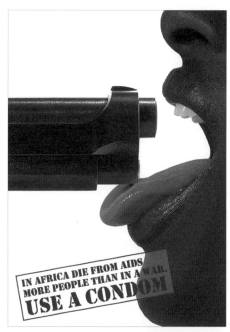

THINK FEEL LIVE
DIEGO PICCININNO
Barcelona, Spain

NO HAND TO HOLD
LINDSAY MCLEOD
Brookline, USA

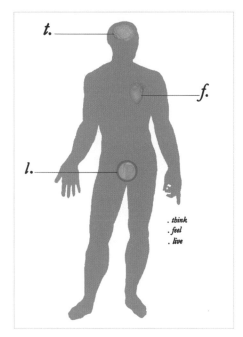

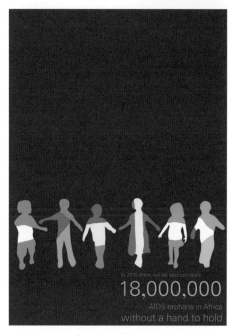

AFRICA
UBUKATA HARIKO
Tokio-to, Japan

DREAM AND THINK
JUAN CARLOS FERNANDEZ DEL VALLE
Guadalajara, Mexico

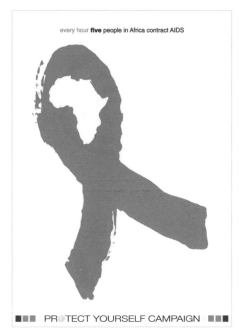

ILLITERATE
SARA SOTOUDEH
Tehran, Iran

NOI E LORO
MARCO PIROLI
Terni, Italy

PROTECT
SEBASTIAN PIECHOCKI
Szczecin, Poland

SHELTER AGAINST AIDS
KIN-HONG LEUNG
Hong Kong, China

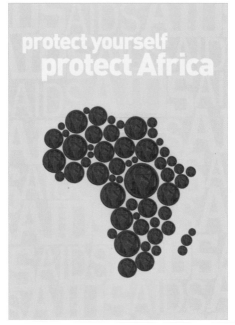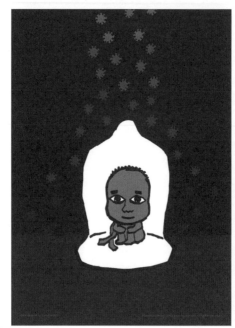

HIV
JULIANA MARTINS
Gondomar, Portugal

HURRY!
MILAN JANIC
Paris, France

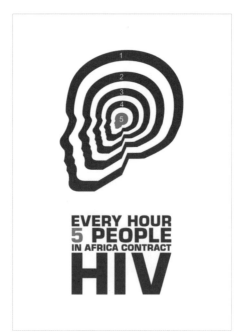

HIV STICKS
DANIELA MARIA
Monterrey, Mexico

DARKDEATH
TOLGAHAN YURTSEVEN
Eskişehir, Turkey

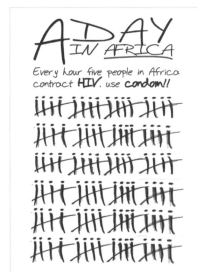

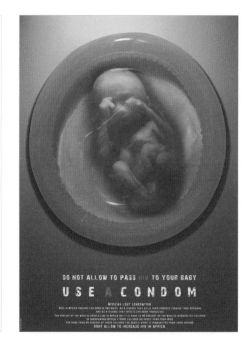

PROTECT AFRICA
GIANNI TOZZI
London, UK

TOGETHER AGAINST
BENITO CABANAS ELVENO
Puebla, Mexico

CONDOMS EXTEND LIFE LINES
PLAND (A. RIETHMÜLLER)
Senden, Germany

LIFE DEMANDS NEW AMULETS
MARIA SHIRSHOVA
Tbilisi, Georgia

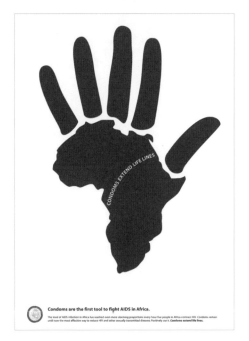

SMOKING
DO-HYUNG KIM
Seoul, Korea

PREVENT
SIMONE HASSETT
Dublin, Ireland

MUST WEAR
MYRA IRISH ENDONILA
Bacolod, Philippines

UNTITLED
GREG BENNETT
Baltimore, USA

FIGHT AIDS
TODOR STOILOV
Burlington, USA

EVERY WAR HAS ITS OWN WEAPONS
FABRIZIO FRASCA
Nova milanese, Italy

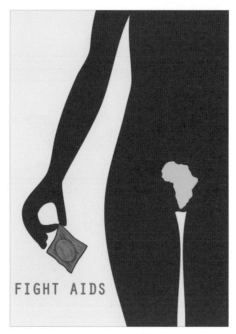
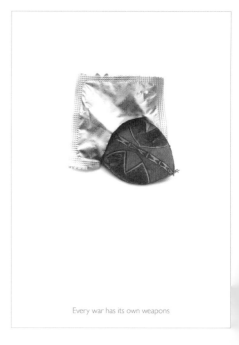

AFRICAIDS
CHARLES LEFRANCQ
Vincennes, France

SALVAGENTE
RENATO TAGLI
Cevio, Switzerland

HAPPY DICKS
NICOLAS FILLOQUE
Ivry-sur-seine, France

HANDS ON AIDS
JULIA LUKYANCHENKO
ELENA KOSTIRINA
Rostov-na-Donu, Russia

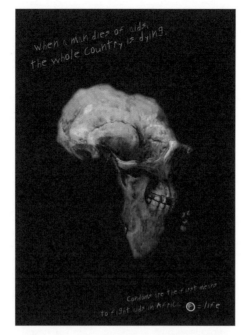

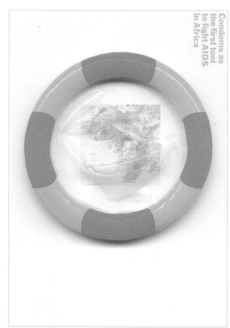

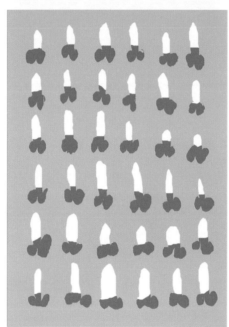

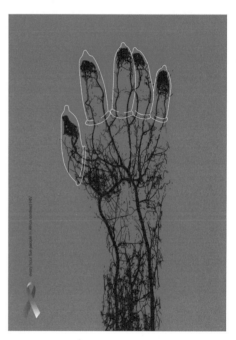

MESSAGE

HEALTH RIGHTS: FOR HIGH-QUALITY MEDICAL ASSISTANCE IN WAR ZONES.

BACKGROUND

In war zones it is crucially important to ensure high-quality medical assistance with a high grade of management and co-ordination. Humanitarian actions cannot stop at short-term needs. In war zones it is necessary to set up permanent structures, organize and train local personnel, and to reactivate health systems as much as possible, thus enabling self-sustainment for the people involved.

This means promoting a culture of health rights that has the long-term aim of being indispensable in war-afflicted countries, so that they can rise again after the conflict has ceased and civilians can go back to their lives as is their right.

As well as hospitals, we should build a new way to live together, remembering that: "All human beings are born free and have equal dignity and rights. They are endowed with reason and conscience and should act towards one another in a spirit of brotherhood."
(Article 1 of the Universal Declaration of Human Rights, proclaimed by the UN on 10 December 1948.)

WOMANS AND WAR
VAND SABERY
Tabriz, Iran

I STILL WONDER WHY WAR WHEN THERE IS PEACE
MAHDI MOHAMMADI
Fouman, Iran

WAR
MICHAELSEN ROLF
Stavaner, Norway

A SHELTER FOR THE PEACE
HADI HAMIDI
Yazd, Iran

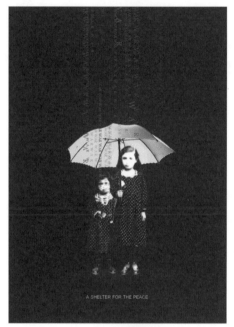

PEACE FOR MIDDLE EAST
ERSINHAN ERSIN
Ankara, Turkey

PEACE
JOANNA SKRZYPIEC
Zabrze, Poland

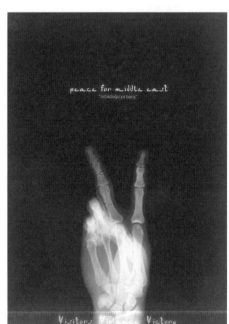

PEACE AND RECONCILIATION
RASHED MOHAMMADREZA
Tehran, Iran

Z+
BENONI CERATTI ZORZI
Porto Alegre, Brazil

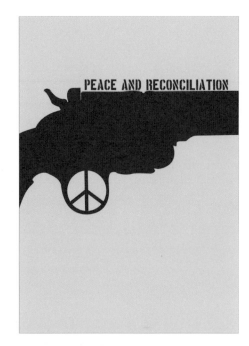

HEAL PEACE
MARIANO FAVETTO
Paris, France

HEALTH RIGHTS
DESIGN STUDIO ADHESIVE
Seixal, Portugal

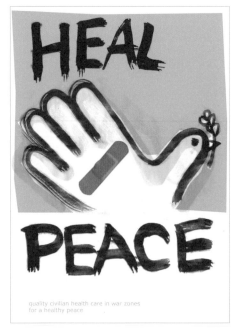

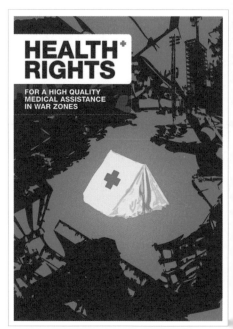

OPERATE
DENISE JUDGE
Dublin, Ireland

THEORY OF EVOLUTION
MARCO PIROLI
Terni, Italy

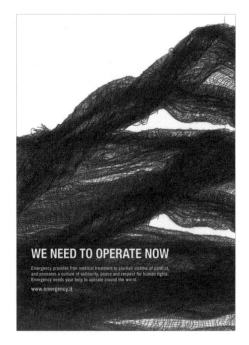

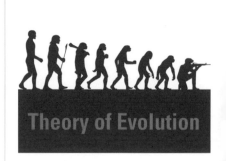

PEACE FOR HUMANITY
ASCILE KHOURY
Beirut, Lebanon

BAMBINI
PEPPE CLEMENTE
Venezia, Italy

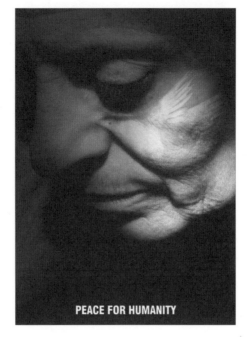

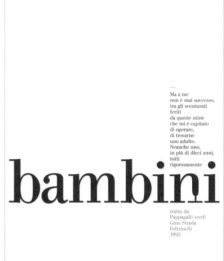

MAKE FOOD NOT WAR
FANG CHEN
State College, USA

PEACE FOR ALL
FARSHID FARDI MONFARED
Tehran, Iran

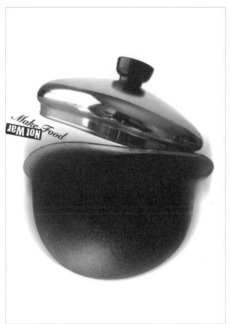

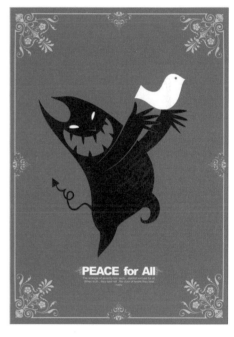

THE TRUTH
OZLEM DURMUS
Eskisehir, Turkey

WE ALL BLEED THE SAME COLOUR
CHATRI NA RANONG
Melbourne, Australia

BACK HOME
UBUKATA HARIKO
Tokio-to, Japan

WAR
SARAH SAFARZADEH
Tehran, Iran

GLORY TO MEDICAL AID
VESA KUULA
Helsinki, Finland

HEATED CONSEQUENCE
CHRIS RYLEE
Clovis, USA

PAPER AND SCISSORS
SARA SOTOUDEH
Tehran, Iran

NO TITLE
STUDIO LAUCKE
DIRK LAUCKE
Netherlands

SOS PROVIDE WEAPONS
MARIO EDUARDO ALVAREZ TORRES
Mexico

**AND BLOOD IS SPURTED
FROM QODS**
MOSTAFA KALANTARI
Tehran, Iran

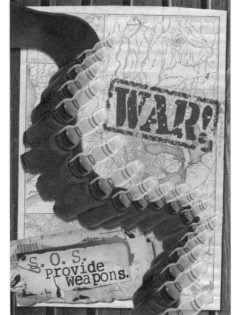 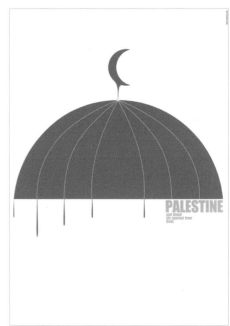

LET THEM FREE
NICOLA GRANDI
Milano, Italy

HOMO EXECUT
MILEN GELISHEV
Sofia, Bulgaria

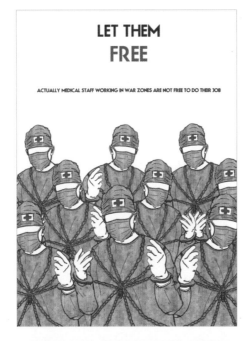 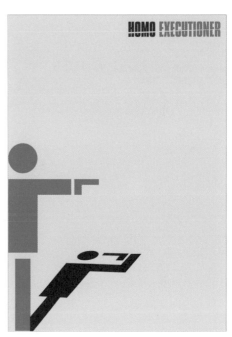

PEACE
TINOOSH KIYANI
Tehran, Iran

LIFE IN THE MIDST OF WAR
CHAD MCGOVRAN
Fresno, USA

 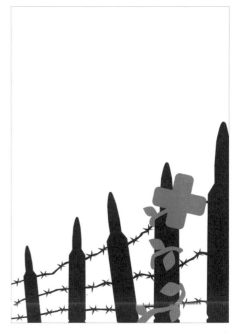

HITTING THE WRONG TARGET
HAKKI EROL
Istanbul, Turkey

WAR PEOPLE IN A WAR WORLD
FRANCESCO DONDINA
Milan, Italy

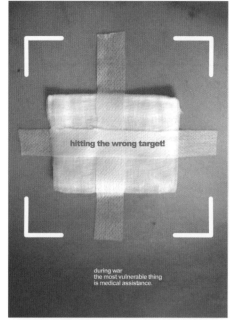

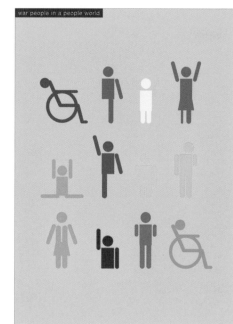

RESISTANT AND VICTORY
MASOUD NIKOOMARAM
Karaj, Iran

DON'T FORGET HIROSHIMA AND NAKASAKI
TAKANORI MATSUMOTO
Japan

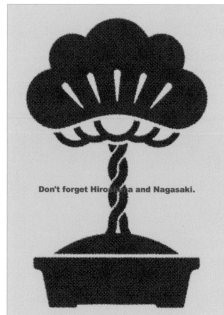

EVOLUTION
SANTIAGO OSNAYA
D.F, Mexico

LIFETIME WAR
EGIE PERMANA
Surubaya, Indonesia

WORLD ARMY
MITSUO TSUKIHARA
Nakahara-ku, Japan

RED CROSS
JOSÉ CARDOSO
Fafe, Portugal

FLYING
MEHDI FARSHIDFAR
Tehran, Iran

SCREAM IT!
DALIA COHEN
Englewood, USA

2008

2ND EDITION

MASSIMO VIGNELLI

New York, USA

In general, my comments regard the importance of the subject matter and the generic nature of the solutions.

As can be seen from the entrants' interpretations, it is difficult to avoid platitudes, and the best solutions are always those which manage to express the essence of the problem in a single image. This is a very tough task, but some of the participants have achieved it in a direct, effective way, with great intelligence, skill and forcefulness.

However, I respect and admire the determination and hard work of all the entrants as they tackled themes which are particularly difficult to present on a poster. I think that the main function of this competition is to perfect the communicative potential of the poster as a medium by honing and sharpening designers' introspective and expressive capabilities, for communication that is increasingly effective and conscientious.

I would like to congratulate the organizers of this second competition, who are unique in their serious treatment of the issues of our time.

Massimo

YOSSI LEMEL

Tel Aviv, Israel

The vast number of works that I have had to look through as a juror for the second edition of *Good50x70* shows the interest and desire of designers to have their say on social and political issues through the poster medium, and their wish to be involved in the most critical questions.

[…] However, it is becoming increasingly difficult to discover truly meaningful works; given that we are now bombarded with so many similar ideas that have been seen before, one has to try really hard to create something new. This is one of the reasons why so many designers fall into the trap of using the same old concepts in order to communicate the same old ideas, and they fail to find innovative and thrilling combinations. The secret lies in surprising and, therefore, "primitive" ideas.

The ingredients are all there, but you have to find the spark that nobody else has found before you; only then will you have a true creation. The more work there is in circulation, the more creatives have to deepen thèir research, increase their knowledge and analysis, and learn through the unexpected.

Yossi

CAO FANG

Nanjing, China

I believe that this competition, and social communication in general, are very important. A competition like this one can promote social progress. The briefs for *Good50x70* concern some of the gravest worries for the world today, problems that affect us all.

Simplicity and strength are important in visual communication, and it is not a good idea to express oneself through frightening images or absurd graphics. Creativity must be consistent and made of a unique sign. So I follow this principle: the posters must have a certain impact. Their role is to convey the pure spirit of creativity and to inform through their visual aesthetics.

I am happy to be taking part in this project, pleased about its purpose and proud to be one of the jurors. I believe that effective communication and open dialogue are a powerful force for society.

Cao

CHAZ MAVIYANE-DAVIES

Harare, Zimbabwe

While on the one hand many entries were intelligent and creative, I got the feeling that too few designers really worked specifically on the messages that the organizers are actually trying to convey.

It's very easy to generalize rather than solve problems concretely. General observations are fine, but what do they tell us in addition to what we already know? The essential information that needed to be given was what actions individuals, government or organizations need to take. That is where creativity needs to be applied, and unfortunately that was ignored by too many entrants.

Aesthetics without content is nothing.

Chaz

LEONARDO SONNOLI

Trieste, Italy

The poster continues to have a hold over us, as an object to be looked at and to be designed. This is clear from the invariably high number of entrants to the various international competitions, and the remarkable success of these exhibitions. The question to ask, if any, is regarding the usefulness of these competitions and exhibitions. Especially if, as in this case, the competition is about important themes and for posters designed ad hoc.

I believe that they are merely stylistic exercises which lead entrants to design a "beautiful poster" rather than a useful poster, and that their audience is not interested in the content but in the form. In short, it's a contest to see who can make the "coolest" poster.

Moreover, as in nearly every competition, the discussion and interface with the client is eliminated; this then removes the role of interpreter which the designer should have, and does not raise clients' awareness of the value of design. This is a chronic problem in a country where the designer's role is afforded no recognition, especially by institutions. The result which is then put on display is considered a poster exhibition, in other words it exhibits artefacts and not contents; it becomes an exhibition for graphic designers, an exhibition that's aesthetic and not ethical.

In the case of *Good50x70*, the reason why I agreed to be on the jury, despite my clearly stated contrary opinions, was precisely the organizers' – and Pasquale Volpe's in particular – willingness to discuss this and allow me to express my opinions freely.

On average, the quality is inevitably low (as in all open competitions), both in terms of representation and ideas; there is also a lack of any remarkably good entries, although in the end some excellent work can be found. [...]

However, there is an interesting aspect of the graphics, which is what still stylistically sets various geographical areas apart from each other. The most obvious example is a series of Iranian works which undoubtedly demonstrate their cultural origin, but also the influence of certain now well-known "pioneers". By contrast, there is a standardization in Western countries, which increasingly tend to swallow up bordering areas too. [...]

Leonardo

ARMANDO MILANI

Milan, Italy

This year, the number of entrants to *50x70* has nearly doubled, and I must say that the quality of the graphic design has also improved [...] This is proof of the success of this initiative. [...]

Our planet is undergoing a very critical period, precisely due to the themes tackled in *50x70,* and while designers do not have the same power as politicians, they can use their communication skills to at least encourage people to stop and think seriously.

The moment really has come for us to stop thinking about selling and start thinking about conservation. It's no longer a matter of choice; it's a necessity for our very survival.

It is particularly satisfying to note how this project has succeeded in involving creatives of all ages and from all parts of the world.

The two fundamental elements of graphic design are what to communicate, and how to do it. The objective is to improve our quality of life. [...] Nowadays we are swimming in a mass of information, often chaotic information, which is merely a reflection of reality. And I believe that this is the result of cultural chaos and of a poor use of technology, which help to spread this contradiction. I believe that it is the designer's duty to underline the difference between form and content, between vulgarity and good taste. [...]

50x70 is a pretext for getting people to think about very pressing themes, and for organizing touring exhibitions. If an idea works on a poster, it will also work on a cover or a postcard, and especially on a website, which I hope will be more and more widespread throughout the world.

Armando

TIMO BERRY

Helsinki, Finland

Judging more than 2,500 posters about condoms, dry lips and amputated feet is a hard task. Not just because of the number of posters, but because of the great extent of *taedium vitae* and passion that has gone into them. As always, it is difficult to produce communication about moral issues without being moralistic. And, naturally, most of the posters are more passionate than they are well-accomplished. [...]

Tons of effort and emotion were poured into the entries. Have I been unjust or cruel? I don't think so. I probably dedicated more time to them than they would have warranted in the middle of the street. A poster has to know what to say, and say it quickly and effectively. And the best ones do it with a bit of soul, irony, wisdom and hope, despite the distressing issues that they communicate. And did I really forget every single one of the posters in the first round? Absolutely not. Among those I rejected, there were others I looked forward to impatiently in the following stage of the contest. I'd like to congratulate the most brilliant entries which, in the few seconds we spent together, helped me to understand, share and feel something.

Posters are made for the street, as are all opinions. I'm too young to be able to remember the glory days of the poster, but I couldn't care less about this inadequacy. I (still) believe in the power of giving a visual form to society's needs. Posters are a sort of uniform for change, but only if they "dress" an action for change. [...]

Timo

BULENT ERKMEN

Istanbul, Turkey

All of these posters (or rather, poster candidates) demonstrate how people are slowly forgetting what a poster consists of. Posters are tending to become more and more similar to large newspaper ads or magazine covers.

Therefore, it is taken for granted that good copywriting is all that's needed for a good poster, presuming that the poster itself consists of an illustration of the text. I believe that to "do a good job", it's necessary to start by "making a good poster", even when the theme being presented is a social issue.

Bulent

ALAIN LE QUERNEC

Quimper, France

The thing that struck me most about the *Good50x70* project was not the number of posters sent in, nor their quality – which, incidentally, I do not consider to be excellent – but the project itself and the extent of the operation. I cannot remember anything quite like the *Good50x70* venture, especially of its size: the whole planet involved in a social graphic design project.

What I expect is that the so-called "*Good50x70* phenomenon" will grow exponentially over the next few years: the number of entries will increase, its popularity will increase, the attention surrounding it will grow. The great machine has been set in motion, and will not stop. [...]

80% of the entries I examined were unoriginal: I saw no innovative pushes towards experimentation, I saw no messages of rebellion; there were no surprises. Paradoxically, young graphic designers do not use contemporary languages. The most effective posters were undoubtedly those which came from countries where human rights have been violated due to war, dictatorships, violence, hunger, or from less developed nations. [...] My criticism is a general one, of the current state of the social poster: what I've noticed is a gap between social graphic design and real action. The purpose of social communication is to put pressure on the public. [...]
Good50x70 has the potential to begin to change things in this field of visual communication. It just needs to make sure that it takes the right steps.

Alain

WOODY PIRTLE

New Paltz, USA

[...] In a world that's ruled by the markets, it's comforting to see such a vast number of entries from designers (an army, no less!) who earn their living in the heart of the commercial arena. This monumental exhibition of social conscience has really made an impression on me. As I get old, my interests shift more from "how much money can I make" to "how much of a difference can I make". Today, the world is more at risk than at any other time in my life; this saddens me, but it also gives me a stimulus and a passion to do anything in my power to make things better. It's easy to see how many of the competition entrants share my wish to change the world.

This 2008 edition has left me with mixed emotions. I was surprised by the number of entries, and inspired by the infinite variety of conceptual approaches applied to the same subject in several briefs; I was puzzled by the unwavering fascination for technological "crutches"; disappointed by the overriding lack of "handiwork" and, in a few cases, astonished by the brilliant simplicity of both the conceptual approach and the stylistic execution.

As we celebrate the results of this year and anticipate the next, here are a few things to bear in mind:

1. Remember that a poster must quickly communicate with people who are on the move. Simplify: we all know only too well that "less is more". The observer must be able to grasp the message immediately. Next time you make a poster, put yourselves in the observer's shoes: look at it and give yourselves 5 seconds to understand its central message.
2. Next year, ensure that the English translation is grammatically correct. I rejected several entries due to the clumsy use of the English language.
3. Look beyond what is correct in your eyes. Challenge yourselves and surprise yourselves! Also, if you haven't already done so, get yourselves a copy of *The Art of Looking Sideways* by Alan Fletcher: it's a great tool for "learning to see".
4 Lastly, never give up. Learn from your successes, or failures, this year, and apply that knowledge to your future entries.

Woody

MESSAGE

SAVING A CHILD'S LIFE IS SIMPLE.

BACKGROUND

Every day, 26,000 children under the age of 5 die.
Most of these deaths are due to illnesses which are easily preventable, or other diseases which have disappeared or are easy to cure in developed countries. All we have to do to stop this situation is to provide basic medicines such as vaccinations and vitamin supplements so that children do not die from common illnesses such as measles or diarrhoea. Instead, we remain inert and do nothing.

SSSCHHH!!!
VINCENZO VALERIO FAGNANI
Munich, Germany

THE DESTINY OF A CHILD
CHIARA VAGLIANI
Cernusco sul naviglio, Italy

UNBORN FUTURE
WEE PIN NG
Paris, France

HAPPY BIRTHDAY
JOLY MELANIE
Paris, France

LIFE MEANS VITAMINS
GIANNI TOZZI
London, UK

ONE CHILD OF FIVES DIE IN THE WORLD
ABDULKERIM TURKAYA
Samsun, Turkey

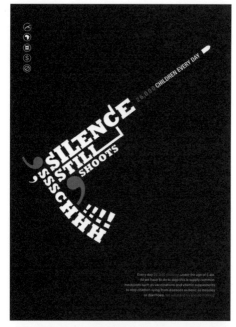

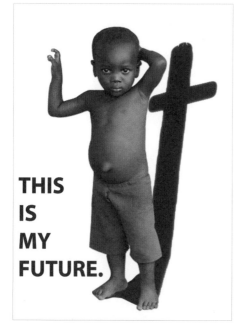

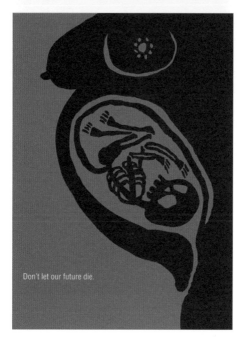

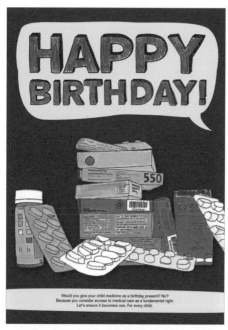

CHILD'S PLAY
PIER MADONIA
London, UK

AFRICAN FAMILY TREE
BARAN GÜNDÜZALP
EYLEM ARBAK
Istanbul, Turkey

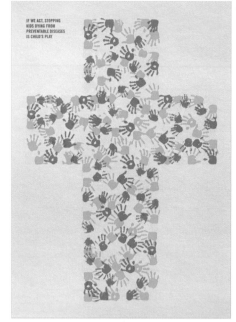

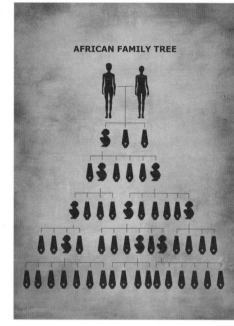

GIVE THEM OPPURTINITY
GIZELLA ANNA VARGA
Budapest, Hungary

STORK
VESA KUULA
Helsinki, Finland

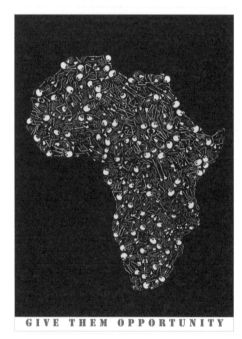

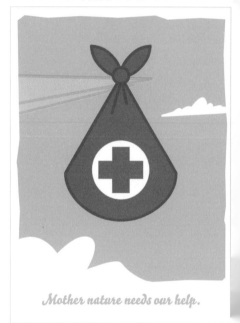

IT'S EASY TO SAVE A CHILD'S LIFE
FARID YAHAGHI
Mashhad, Iran

NO ONE'S EXCLUDED
IGOR VERDOZZI
FRANCESCO TERZAGO
STEFANO CHIES
Padova, Italy

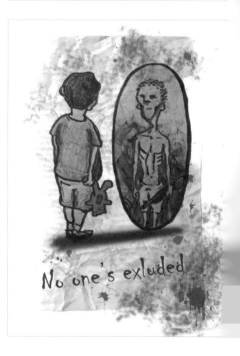

COFFIN
MAKSYM MATUSZEWSKI
MARCIN DUBINIEC
Warszawa, Poland

CHILD MORTALITY
ROCCO PISCATELLO
New York, USA

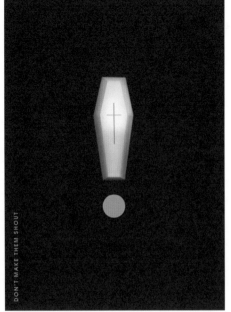

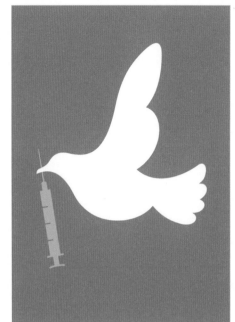

PROVE THEM WRONG
SOHRAB MOSTAFAVI KASHANI
Tehran, Iran

MEDICINES
CHARUTHA REGHUNATH
Ahmedabad, India

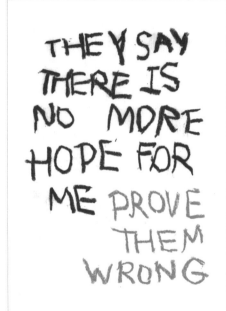

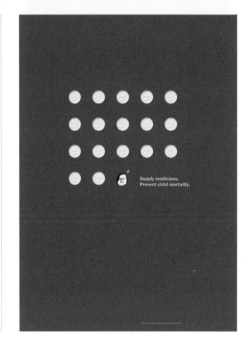

LIFE FOR CHILDREN
ALI ASGHAR PANAHI ROSHAN
Tabriz, Iran

HELLPLESS
NADAV BARKAN
Tel-Aviv, Israel

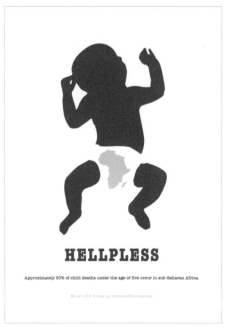

81

CHILD-PROOF
SELINA HEATHCOTE
London, UK

FIGHT CHILD MORTALITY
MADDALENA FRAGNITO DE GIORGIO
Milano, Italy

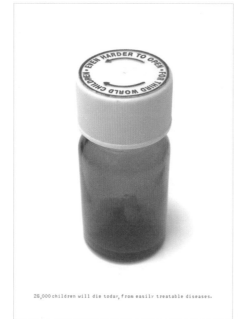

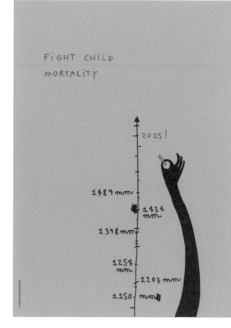

CHILD MORTALITY
BEHROOZ GORGIN
Tehran, Iran

MAKE IT FLY-AWAY!
PIERPAOLO GABALLO
Lecce, Italy

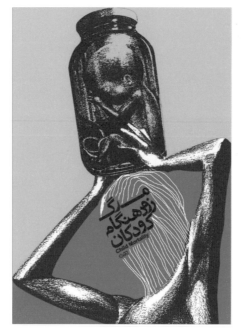

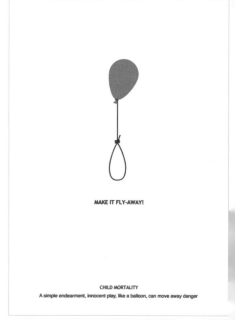

BALANCE
JANA SANDOVAL
London, UK

HUNGER
JULIANA ESTRELLA
LEANDRO OLIVEIRA
Rio de janeiro, Brazil

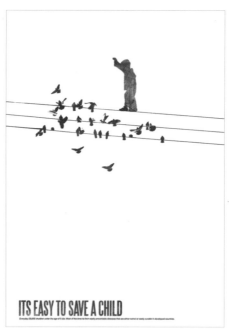

INJECTION
CAN BURAK BIZER
Maslak, Turkey

SAD LOOK
ARLEN COSTA DE PAULA PRODIGO
Uberlândia, Brazil

STOP WAR
ONISH AMINELAHI
Tehran, Iran

IT'S EASY TO SAVE A CHILD'S LIFE
FRANCO BALAN
Aosta, Italy

WE'LL GIVE HIM A FUTURE
LUANA NJKLA BUTTI
Milano, Italy

NO PROBLEM. IT'S NOT YOUR KID
ISTVÁN SZUGYICZKY
Budapest, Hungary

MESSAGE

OUR APATHY DAMAGES NOTHING BUT OUR OWN FUTURE.

BACKGROUND

We all know about global warming. Even though people think they can't do anything about it, in actual fact the actions of each individual can make a huge difference, if we all do the same thing: little things, like turning off a light or not leaving a tap running. Given that it takes more effort to do something than nothing, we never do anything. But that energy we save by turning off our computer instead of leaving it on standby can really make a difference to the future of our planet, when it's multiplied by a thousand or a million times.

And after all, our future is something that we all share.

USE BOTH SIDES
REBECA RAMÍREZ GUERRA
Monterrey, Mexico

DO YOU? RECYCLE
JUDE LANDRY
Bloomington, USA

SAVE THE TREES!
DAVID BARATH
Budapest, Hungary

SWITCH OFF GLOBAL WARMING
TAKANORI MATSUMOTO
Saitama-shi, Saitama-ken, Japan

PREPARE TO MIGRATE
HANDOKO TJUNG
Jakarta, Indonesia

... – – – ... (S.O.S)
LAUREN PERLOW
Milano, Italy

YOUR INDIFFERENCE...
GIULIA CAVAZZA
Castel Maggiore, Italy

I AM NOT RESPONSIBLE
MAJID MODIR
Stockholm, Sweden

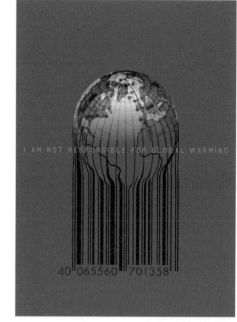

GLOBAL WARNING
OZGUR ONAL
Izmir, Turkey

GLOBAL WARNING
BIANCA BALDACCI
Milano, Italy

OZONE
PARISA TASHAKORI
Tehran, Iran

AWARENESS
FULVIO G.M. VIGNAPIANO
Latina, Italy

HARNESS THE EARTH
JUDE LANDRY
Bloomington, USA

IDEA
DANIEL OLMEDO
Guayaquil, Ecuado

RIDE A BICYCLE
JEN OHLSON
Leeds, UK

RUNNING OUT
SARA SALSINHA
Setúbal, Portugal

SUPER FINGER
MAHIR KARAÇAM
TÜLAY DEMIRCAN
Istanbul, Turkey

**PROTECT THE EARTH,
TURN OFF THE LIGHT**
MIGUEL PEIXOTO
Braga, Portugal

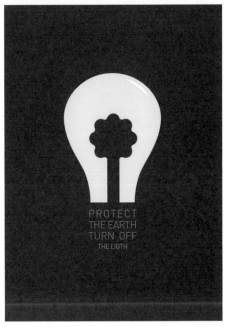

**TIME IS RUNNING, EARTH
IS DYING**
WEE PIN NG
Paris, France

SUN BULB
EDUARDO GARZA
Montarrey, Mexico

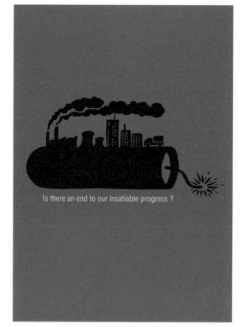

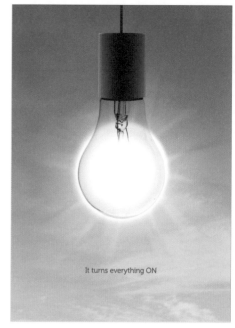

TREE
NAPIN MANDHACHITARA
Nonthaburi, Thailand

GLOBAL WARNING
LAUREN PERLOW
Milano, Italy

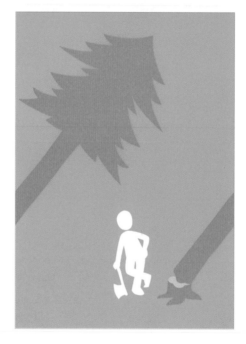

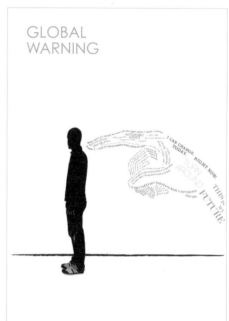

THE BLOT
JULIA LUKYANCHENKO
ELENA KOSTIRINA
Rostov-na-donu, Russia

SIMPLE MATH
JULIANA ESTRELLA
LEANDRO OLIVEIRA
Rio de Janeiro, Brazil

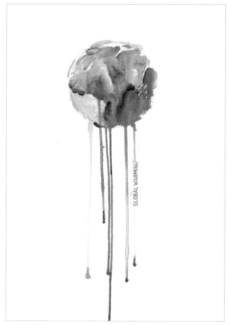

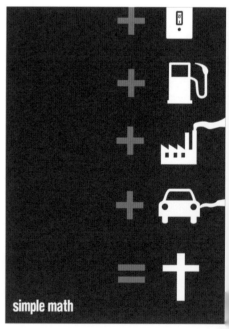

THE FASTEST WAY
MARIA EUGENIA MOSQUEDA GARZA
Guadalupe, Mexico

NEW WORLD ORDER
BURAK TIGLI
Istanbul, Turkey

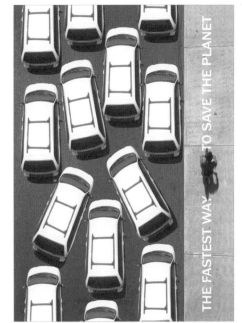

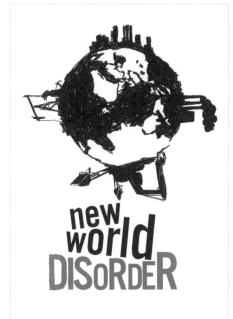

UPSIDE DOWN
KELLY HOLOHAN
Philadelphia, USA

TOES
PHIL JONES
Charlotte, USA

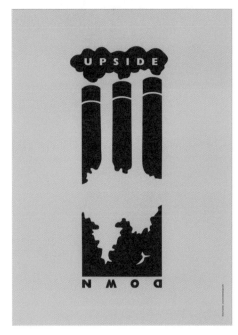

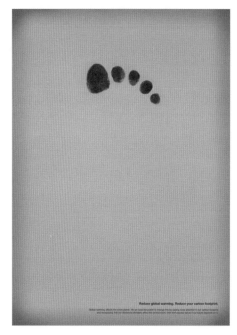

GLOBAL WARMING
SADIK SAKIN
Istanbul, Turkey

GLOBAL WARMING
ANNA MORVAY
Budakeszi, Hungary

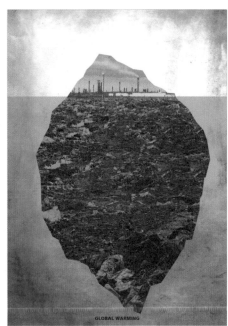

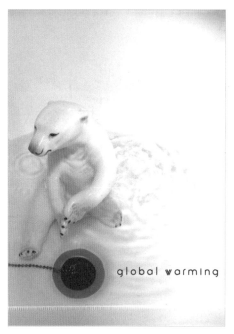

Amnesty International

HUMAN RIGHTS VIOLATION

MESSAGE

IS THE UNIVERSAL DECLARATION OF HUMAN RIGHTS WORTH THE PAPER
IT'S WRITTEN ON?

BACKGROUND

In 1948 the United Nations published the Universal Declaration of Human Rights to protect the rights of every individual in the world. That declaration was to be a "foundation for freedom, justice and peace in the world".

Sixty years on, every day almost half of the world's population suffers the violation of at least one of the 30 articles making up the declaration. More than a billion people earn one or less than one dollar per day, and the same number do not have access to clean drinking water. Meanwhile, torture, the death penalty, discrimination and violence against women and children continue to be used as instruments for social control and to maintain power. The human rights established by the declaration are often under attack by the same people who should be defending them – our governments. Why?

ACCIDENT
DARIO ANTONIO ROMANO
Laterza, Italy

STOP RACISM
BOJANA RAJICIC
Kragujevac, Serbia

UNCIVIL DIALOGUE
NAGHMEH FELOR ZABIHI
Tehran, Iran

WOMAN RIGHTS!
ONUR GÖKALP
Istanbul, Turkey

CAPTIVITY
AHMET ERDOGAN
Istanbul, Turkey

FREEDOM
NAPIN MANDHACHITARA
Nonthamburi, Thailand

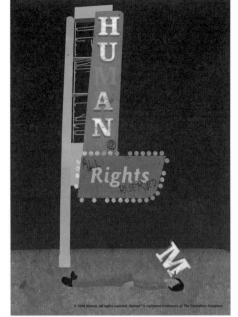

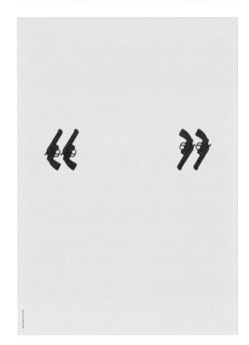

91

UNITE
FABIO GIOIA
Campobasso, Italy

TOILET PAPER
NATALIA DELGADO
Ensedana, Mexico

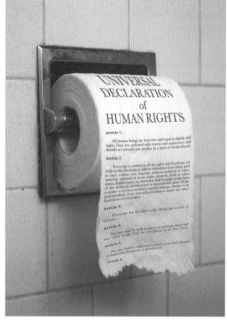

NO COMMENT
BERK SÜRÜCÜ
Izmir, Turkey

STICK IT
SARA SANTOS CASILLAS
Salamanca, Spain

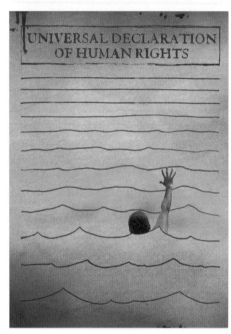

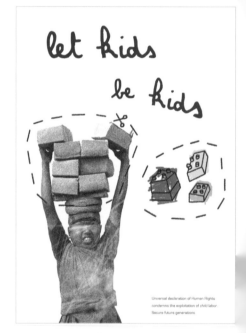

CENSOR
PAYAM ABDOLSAMADI
Tehran, Iran

SLIPKNOT
DELPHINE PÉPIN
Boulogne - Billancourt, France

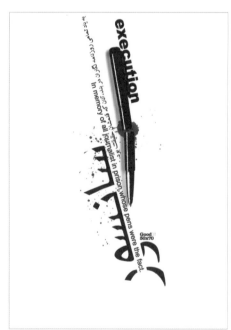

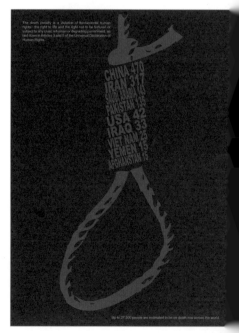

DON'T CUT EDUCATION
ONUR YAZICIGIL
West Lafayette, USA

TIBET
TOMASO MARCOLLA
Lavis, Italy

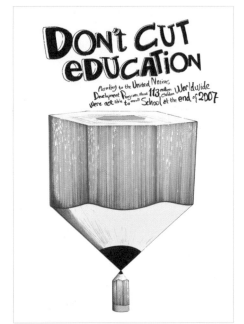

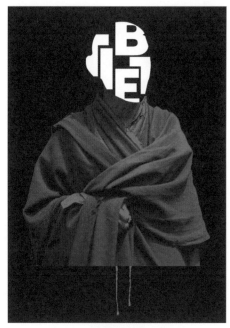

THE 60TH ANNIVERSARY
TEIJA KELLOSALO
Linz, Austria

FOOTBALL UNITES, RACISM DIVIDES
CHRISTOPHER MBAMBA
Harare, Zimbabwe

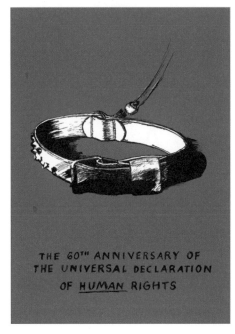

FEAR
KATRIN SCHWEIGERT
Birmingham, UK

BEIJING
ISTVÁN SZUGYICZKY
Budapest, Hungary

BLINDED RIGHTS
BAHADOR SHOJAPOUR
Newport Beach, USA

98 %
TANIA DIAS
Corroios, Portugal

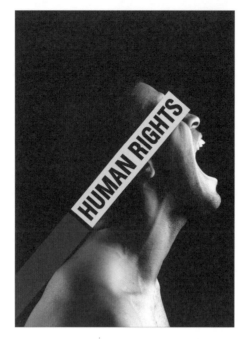
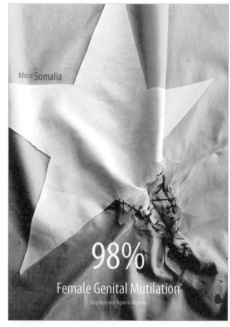

HUMAN RIGHTS, RIGHT?
ALICJA LIDIA SOKALSKA
Munich, Germany

THE SHREDDER
JASON KELLY
London, UK

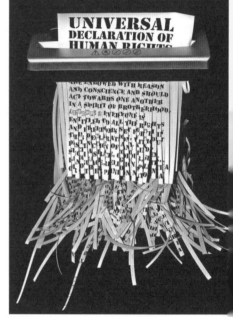

HANDICAPED
MARION BAREIL
Ville d'avray, France

**IS THE UNIVERSAL DECLARATION OF HUMAN RIGHTS
WORTH THE PAPER IT'S WRITTEN ON?**
FRANCO BALAN
Aosta, Italy

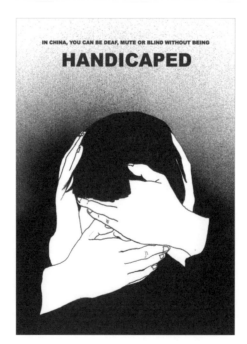
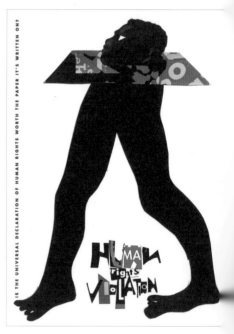

94

SONIC POLLUTION;
TO COUNTLESS ADDRESSEE
RASOOL KAMALI
Esfahan, Iran

HAPPEN NOW
ATSUSHI NAKAZAWA
Osaka, Japan

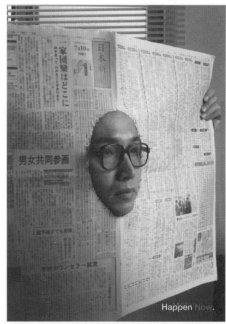

IMPRESSION
GILDA BORGNINI
Lugano, Switzerland

EKIN
CHONGLAI ANG
Singapore

DEBRIS
LARA MAGALHÃES
Porto, Portugal

INDIFFERENCE
LISA MARIE SEEGERS
Atlanta, USA

HUNTING

MESSAGE

NOBODY GAINS FROM WHALING.

BACKGROUND

The IWC, the international whaling commission, has the task of conserving whale stocks, and is currently the world's principle body for the protection of whales. Its role has been undermined by Japanese whalers who bought votes within the IWC to reintroduce commercial whaling.

When the IWC approved the St Kitts declaration in favour of whaling, two thirds of the countries who voted their approval had received financial help from Japan.

The fishing ministry has an annual budget of 50 million US dollars specifically to promote commercial whaling. The claim that whale meat is in demand in Japan is farcical, given that only 5% of the population eat it regularly, and 69% are openly opposed to it. This is the moment for the rest of the world to take a stand and protect these endangered species.

WHALE MIGRATION
MARCO VINICIO GARRIDO
Monterrey, Mexico

BRUTAL APPETITE
ROZINA VAVETSI
Holargos, Greece

SAVE WHALES
LUCA FASOLI
Verona, Italy

JUST FOR BREATHE!
BEHROOZ GORGIN
Tehran, Iran

SEA OF BLOOD
SÉBASTIEN WIEGANT
Marly-le-roi, France

WHALES ARE LIFE
NATALIA DELGADO
Ensenada, Mexico

A SIMPLE SIGN
MATE OLAH
Budapest, Hungary

JAPANESE ARE CRAZY CATS WHO EAT WHALES
WEIFENG LIANG
Guangzhou, China

WHALE HUNTING IN JAPAN
ANNA RADNÓTHY
Budapest, Hungary

WHALES KILLER
WEIFENG LIANG
Guangzhou, China

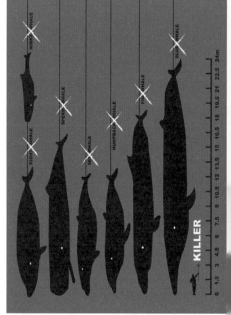

WHAT IS THE NEXT GAIN?
CEM KARA
Cevizu, Turkey

STOP COMMERCIAL WHALING
CÉDRIC QUISSOLA
Villejuif, France

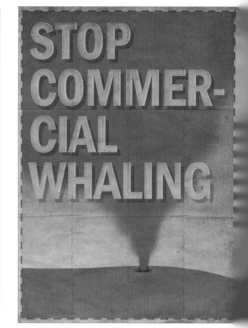

CULT OF WAR
TOMASO PERINO
Nuoro, Italy

HUNTING KILL LIFE
RICCARDO GIACOMIN
Samarate, Italy

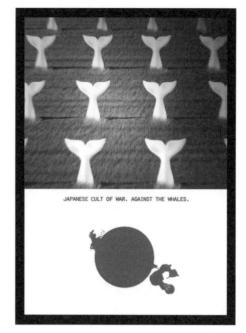

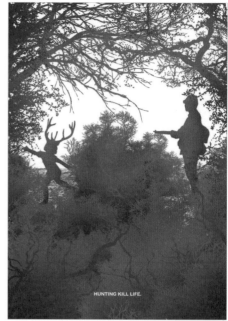

NOBODY PROFITS FROM WHALING
LENKA GAJZUROVA
Toronto, Canada

STOP WHALING
JING ZHOU
Long Branch, USA

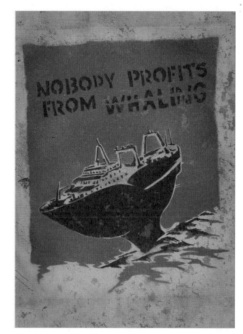

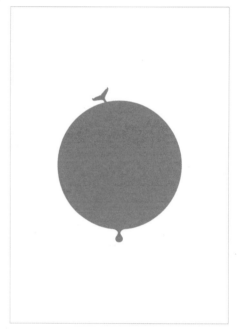

STOP EATING
GUAN HONG YEOH
Shanghai, China

LA FIN D'UNE GRANDE ESPÈCE
LÉO CARBONNET
Lille, France

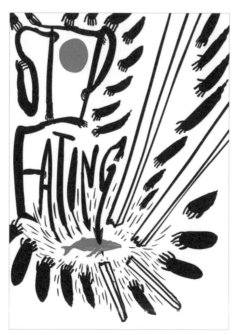

NO MORE WHALING
HÉCTOR IVÁN DOMÍNGUEZ PINO HECTORIBIO
Puebla, Mexico

BEAUTY ISN'T AS INNOCENT AS IT SEEMS
AYÇIN TURAN
Izmir, Turkey

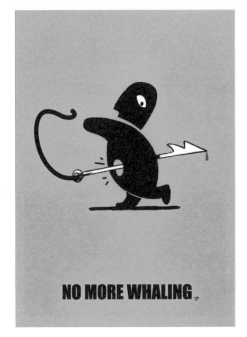

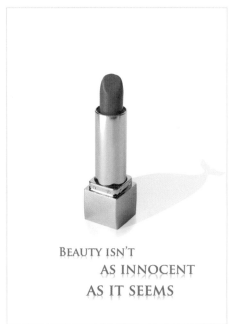

RED WHALE
ALI CAN METIN
Istanbul, Turkey

STOP WHALE HUNT
MARCIN WAWRZASZEK
Szczecin, Poland

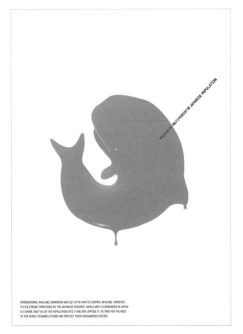

DON'T DO A WHALE LIKE NESSIE
MITSUO TSUKIHARA
Nakahara, Japan

GREEDY HUMAN BEING!
ONUR GÖKALP
Istanbul, Turkey

THE FOOD CHAIN
ADELE IVONA
Putignano, Italy

STOP
ISTVÁN SZUGYICZKY
Budapest, Hungary

THE ANIMAL IS INSIDE
ILARIA DEL MONTE
Montescaglioso, Italy

NO ONE GAINS FROM WHALING
MARTIN FANNING
London, UK

JAPAN LURES A WHALE INTO DEATH
TAKANORI MATSUMOTO
Saitama, Japan

JAPANESE SNACK
CRISTÓBAL RODRÍGUEZ OCEGUERA
Puebla, Mexico

Lila
Italian League
for the Fight against AIDS

SEXUALLY
TRANSMITTED DISEASES

MESSAGE

NOT USING A CONDOM DOESN'T MAKE YOU GROWN-UP OR COOL.

BACKGROUND

Condoms protect you from sexually transmitted diseases; they are cheap, and it takes just a second to put one on. But too many people, rather than use them, prefer to risk their lives. It's easy to assume that not putting a condom on is a courageous or strong gesture; but the only person you're hurting is yourself and the person you go to bed with. The fact is, most people who are HIV positive and unaware of it are heterosexual and from a developed nation.

But before they find out, it's already too late. We must raise awareness about the stupidity of not wearing a condom, among all social groups, and not just those most affected.

BEST FRIEND
ZIGMUNDS LAPSA
Riga, Latvia

LOVE
PRAVIN SEVAK
Kalamazoo, USA

MAKE LOVE NOT DEATH
FANG CHEN
State College, USA

SIZE
SILVIO LORUSSO
Altamura, Italy

LIFETIME WARRANTY
BARAN GUNDUZALP
Istanbul, Turkey

CONDOM
NESLIHAN KIR
Samsun, Turkey

LIFEGUARD
ALI TOMAK
Samsun, Turke

WHAT ABOUT NEXT?
SELCUK OZIS
London, UK

IT CAN BE A LIFEGUARD
SENIH CAVUSOGLU
Famagusta, Cyprus

1000 JEOPARDIES
RAMBOD NOROUZI VALA
Tehran, Iran

FASHION
SERGI RUCABADO
Barcelona, Spain

PROTECT YOURSELF
RYAN RUSSELL
State College, USA

STDEATHS
MILENA MORA D'AMBROSIO
San José, Costa Rica

DO NOT DISTURB
MRIDUSMITA NATH
Ahmedabad, India

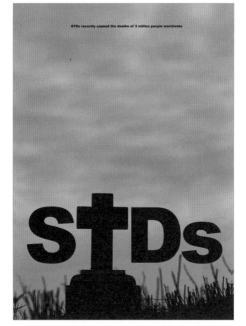

USE YOUR HEAD – WEAR A CONDOM!
JOE SCORSONE
ALICE DRUEDING
Jenkintown, USA

**TEST YOUR PARTNER BEFORE YOU MAKE
THE FINAL DECISION**
PARISA TASHAKORI
Tehran, Iran

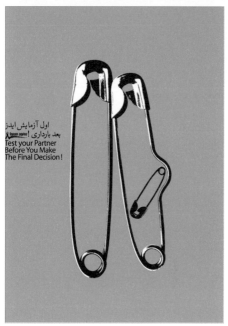

OPEN UP YOUR EYES…
MARY LEAKEY
Harare, Zimbabwe

KEEP IT TO YOURSELF
POLONCA PETERCA
Ljubljana, Slovenia

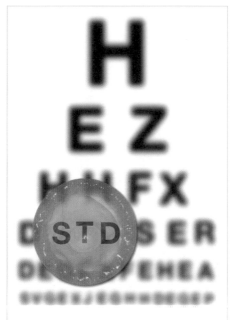

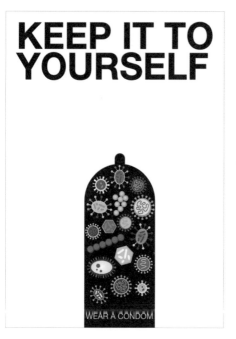

NO TITLE
ERSINHAN ERSIN
Ankara, Turkey

AIDS
ONUR GÖKALP
Istanbul, Turkey

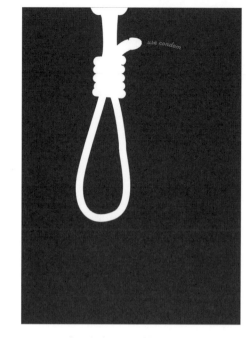

WITH WITHOUT
MORENO DE LAURI
MARIANNA GUERRA
ROSSELLA GUGLIARA
PAOLA LO CAMPO
MATILDE MASOTTI
MARCO PUGLIESE
Foggia, Italy

STRAY BULLETS
DINO BRUCELAS
Makati, Philippines

LOVE YOURSELF
TABER CALDERON
New York, USA

ANGEL
EMIR ERSAHIN
Istanbul, Turkey

USE CONDOM
AMIR ENAMI
Tehran, Iran

NO CONDOM?
MARIO ISRAEL PRADO JIMÉNEZ
Mexico City, Mexico

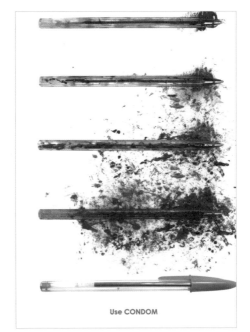

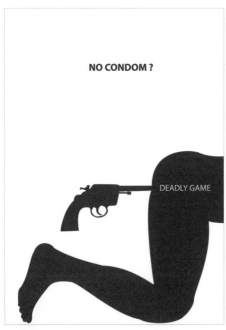

STOP AIDS
DAVID BARATH
Budapest, Hungary

PLAY SAFELY
NATHAN LOMBARDI
Newtown, USA

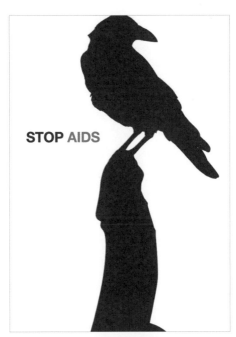

THE MOST VALUABLE COMMITMENT
KENNY LI KOON YIN
Hong Kong, Hong Kong

EASY WAYS
HADI HAMIDI
Yazd, Iran

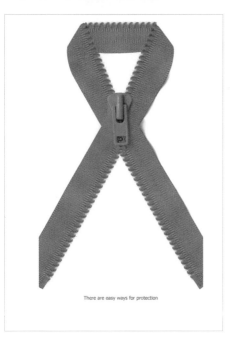

107

Emergency WAR VICTIMS

MESSAGE
IT TAKES MORE THAN A PLASTER TO CURE A WAR.

BACKGROUND
It is evident how important it is to urgently provide medical assistance in war zones. But all too often, this is limited to short-term aid during the conflict, which finishes as soon as the war is over.

In war zones and areas of extreme poverty, EMERGENCY aims to leave long-lasting infrastructures in its wake, allowing stricken communities to regenerate and prosper in the long run, even after short-term measures have come to an end. EMERGENCY provides highly specialized, high-quality health care to civil victims of war, of landmines and of poverty, in three areas: surgery, medicine and rehabilitation.

The right to medical assistance should not just be limited to the West. Through the creation of permanent structures and staff training, we are able to help communities get back on their feet after conflict.

MAKE LOVE NOT WAR
DAVID BARATH
Budapest, Hungary

WAR AND PEACE
MAHDI KHALILPOUR
Karaj, Iran

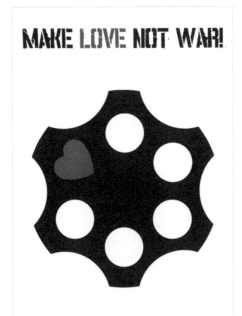
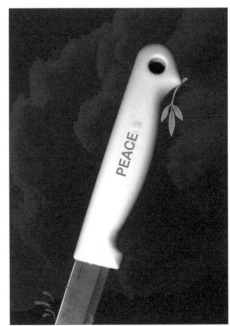

RELIGIOUS WAR IS A BAD IDEA
LORENZO ANZINI
San Giovanni in Marignano, Italy

WAR FLY
PABLO DI FIRMA
Rosario, Argentina

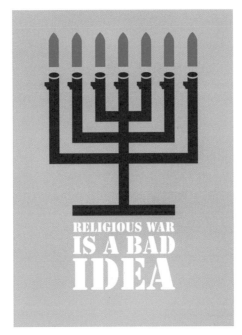
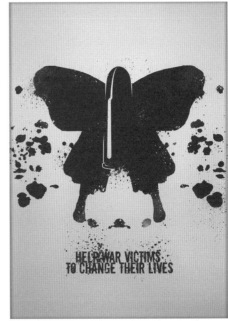

CHILD SOLDIERS
PABLO GRAND MOURCEL
Paris, France

TOYS ARE US
MANFREDI VITRANO
ERNESTO BONACCORSO
ROBERTO FERRANTE
Palermo, Italy

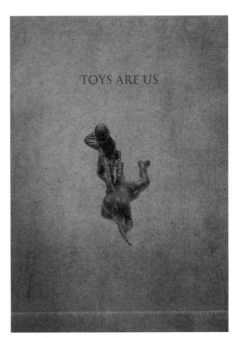

SOLDIER HERO
LUCIANO SALVATORE
Potenza, Italy

LABYRINTH
MUTSUMI WATANABE
Milano, Italy

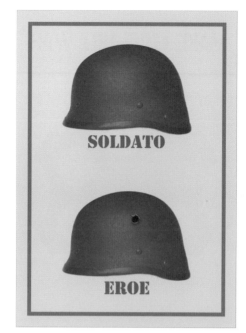 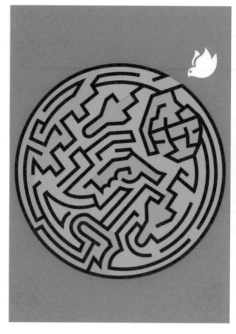

BEFORE/AFTER
JOE SCORSONE
ALICE DRUEDING
Jenkintown, USA

OUR AIM IS TO END THE SUFFERING
JEFFREY DAVIS
Wimberley, USA

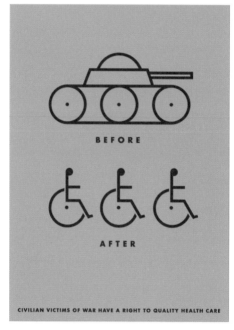

NO WAR
BAHAR KHALIFEH
Tehran, Iran

PEACE OR WAR
ALI JAVAHER
Tabriz, Iran

 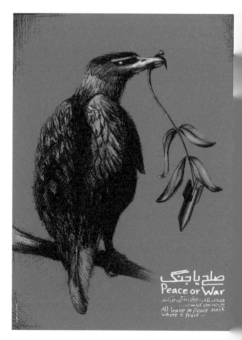

MAKE LOVE NOT WAR
MILÁN FARKAS
Oszkó, Hungary

WAR/PEACE
MAYBRITT RASMUSSEN
Milano, Italy

DAYS
FABRIZIO BONFIGLIO
Bologna, Italy

WAR VICTIMS
ATSUSHI NAKAZAWA
Osaka, Japan

GIVE HEALTH A CHANCE
BARAN GÜNDÜZALP
EYLEM ARBAK
Istanbul, Turkey

OIL WAR VICTIMS
SAJAD ASADI
Tabriz, Iran

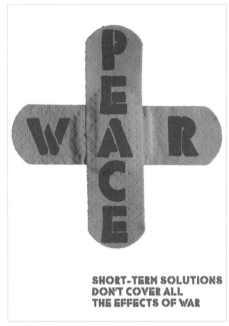
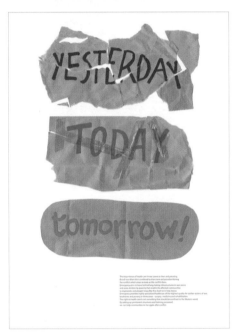
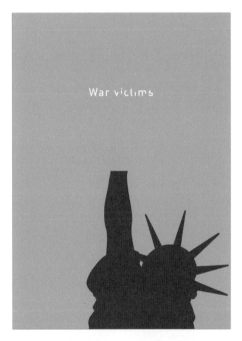
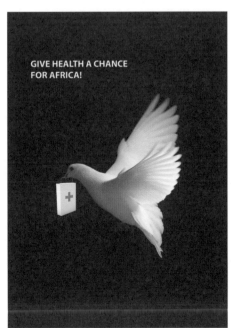
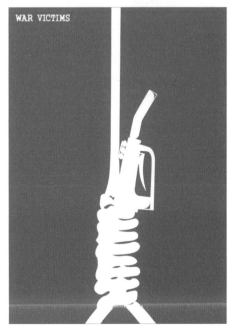

111

WAR
SAVAS CEKIC
Istanbul, Turkey

LAUNDRY
FRANCESCA BALBO
Venezia, Italy

MARMALADE
RICCARDO GIACOMIN
Samarate, Italy

CHAIR
ECE ELDEK
Kadikoy, Turkey

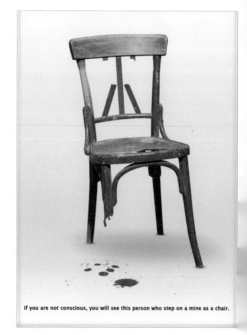

HUMANITY FREEDOM, WAR VICTIMS
AMIR FARSIJANI
Tehran, Iran

WHAT ELSE?
HAIYA LIU
Cambrai, France

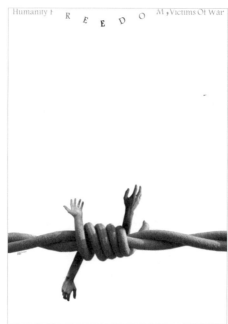

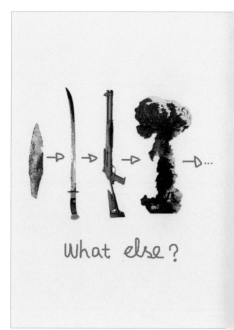

IL MIO PIEDE SINISTRO
RINO SORRENTINO
Pozzuoli, Italy

IT TAKES MORE TO CLEAR UP WAR THAN A PLASTER
SOFIJA OMELKOVICA
Waterford, Ireland

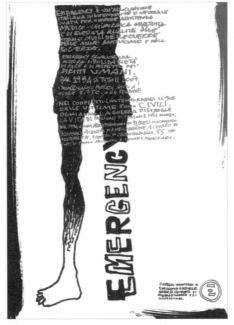

**HELP BUILD PERMANENT MEDICAL FACILITIES
IN WAR-TORN COUNTRIES**
ELIZABETH LAWRENCE
Duxbury, USA

WELCOME HOME
DANIEL COHEN
Pittsburg, USA

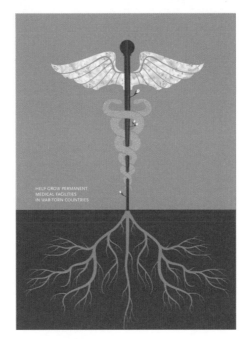
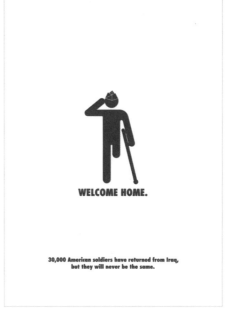

SHOT
JULIAN CLARK
Twyford, UK

REAL VICTORY
P. RAMESH
Thanjavur, India

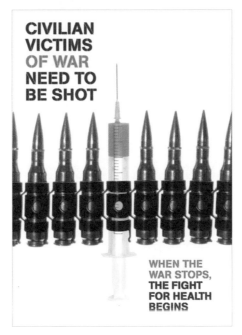

WATER SCARCITY

MESSAGE

TO MAKE PEOPLE IN THE REST OF THE WORLD MORE AWARE OF HOW MUCH WATER IS LACKING IN AFRICA.

BACKGROUND

Fresh, clean water is one of the most precious resources in Africa. More than a billion Africans do not have access to it. They are the ones who have 20 litres a day for drinking, cooking, washing, watering their animals and cultivating their land. In the Western world we each use more than 300 litres of water every day. There is such a desperate shortage of water in Africa that 2 million children die every year just because they are given polluted water to drink.

In Africa, clean drinking water means health, prosperity and development.

In the West, it's just something that comes out of the tap.

ABSOLUTE AFRICA
SERHIY CHEBOTAREV
Kharkiv, Ukraine

POCO/TROPPO
FEDERICO NAVARRA
Rimini, Italy

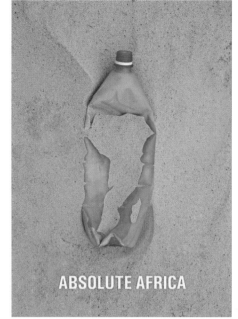

RIVERS FLOW FREE
AHMET ERDEM ŞENTÜRK
Istanbul, Turkey

CHEERS!
ALESSANDRO TUNNO
Milano, Italy

AFRICA CRIES OUT FOR WATER
ORIOL GAYÁN
Barcelona, Spain

GOT WATER?
ANDREA LO VETERE
Barcelona, Spain

115

JUST ADD WATER
KELLY HANNER
San Marcos, USA

DOMINO
ISTVÁN SZUGYICZKY
Budapest, Hungary

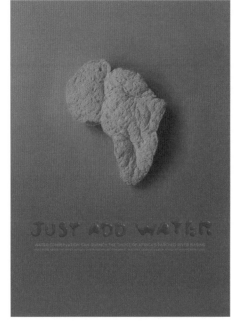 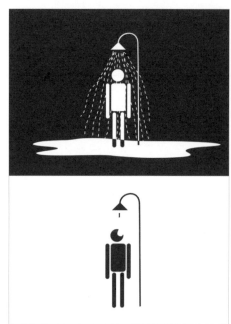

CHAM'EAU
MAXIME FEDRICK
Noyelles Sur Selle, France

**AFRICAN PEOPLE DO NOT HAVE
ENOUGH WATER EVEN FOR LIFE**
TOSHIFUMI KAWAGUCHI
Tokyo, Japan

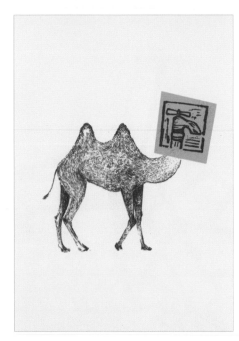 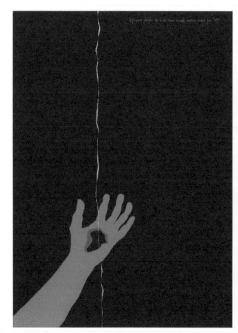

WATER ARE DECREASING
RAMAZAN SIMSEK
Çorum, Turkey

EVERY SINGLE DROP
BARTOSZ KOSOWSKI
Lodz, Poland

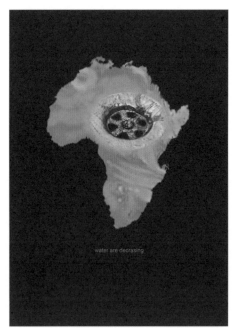 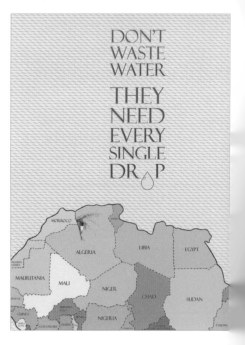

WATER IS LIFE
JULIANA ESTRELLA
LEANDRO OLIVEIRA
Rio de Janeiro, Brazil

CANNUCCIA INUTILE
FEDERICO NAVARRA
Rimini, Italy

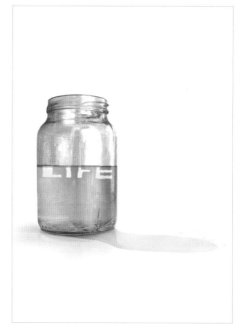
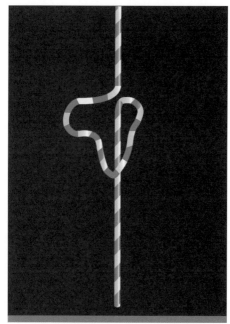

GIVE ME WATER, PLEASE!
NICOLA JAIME GRANDI
Milano, Italy

WATER FOR AFRICA
GREGORY PAONE
Philadelphia, USA

WATER
PIERO DI BIASE
Tolmezzo, Italy

WATER SCARCITY
HADIS RAZAGHI
Tehran, Iran

FACEDOWN
AHMET ERDEM ŞENTÜRK
Istanbul, Turkey

L'EAU DIVINE
LÉO CARBONNET
Lille, France

GIVE AFRICA, CLEAN WATER NOW!
GUAN HONG YEOH
Shanghai, China

I CONSUME YOU
DARYOUSH TAHMASEBI
Lulea, Sweden

AFRICA DRY
MATTIA RUBINO
Novi Ligure, Italy

THIRSTY
BENONI CERATTI ZORZI
Porto Alegre, Brazil

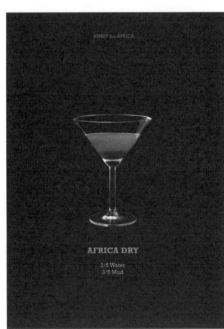
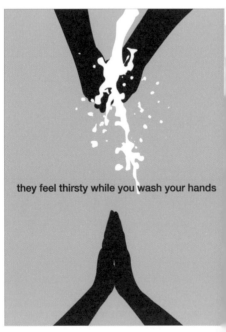

118

FISHBONE
ARGUN SEYHAN
Istanbul, Turkey

UNTITLED
RÉMY LE RUMEUR
Franconvile, France

CIERRALE
ANGEL ANASTACIO FERNANDEZ
Gonzalo Bautista, Mexico

NO MORE WORDS
EZIO BURANI
PAOLO ARTONI
New York, USA

THIRSTY AFRICA
ABHAY SALVE
Ahmedabad, India

THIRST
ORSI NAGY
Székesfehérvár, Hungary

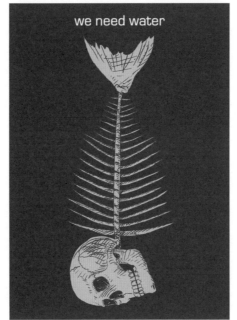
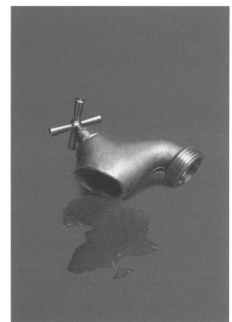
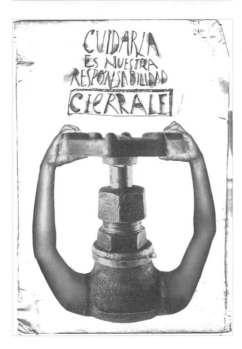

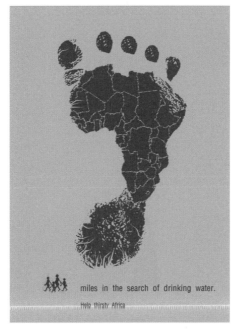
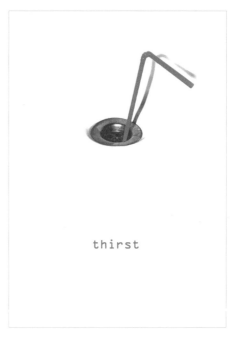

2009

3

MASSIMO VIGNELLI

New York, USA

This year the *Good50x70* competition has shown a higher quality level of entries. It is remarkable how strong and positive the general approach to poster design is. Many of the posters seem to master the space by placing the image at the centre of it to achieve greater impact. Better control of type and typography add to the overall quality and help the message to come across more powerfully.

In total, and in every category, the results are showing an active interest in the poster as a medium to convey awareness and emotions in a powerful manner.

I think that this edition of *50x70* proves, once again, that everywhere around the world the basic issues of our time are felt with intensity and a determination to make a change for the better, and that responsible design can help to achieve that goal.

Massimo

CHAZ MAVIYANE DAVIES

Harare, Zimbabwe

[…] The design process is not an accidental or indiscriminate exercise. It is a fundamental process we hone throughout our lives to imbue our expression with thought, skill and emotion. It is the most vital component of our toolbox. Until we realize this, we will crawl in the desert of mediocrity towards the pixelated mirage that computers promise those not willing to understand the ethos instilled in good communication and design.

The function of the *Good50x70* posters is to raise awareness, to call to action, to enlighten, to promote or to inform, and to do that effectively we need to be astute, informed and diligent in our approach and creativity so as to be representative of the messages they are meant to convey. With this in mind, there were more examples of strong intelligent work this year that stuck to the brief and used design more effectively to address the issues in a meaningful way. Hopefully entrants for future *Good50x70s* will learn from these and apply this to their work.

Chaz

TIMO BERRY

Helsinki, Finland

This was my third year on the *Good50x70* jury team. I am very happy to see the event grow and evolve every year. I was especially happy to see a considerable rise in not just the quantity of posters entered but the quality of the posters we jurors went through. Social posters are often a medium for the young and angry, but this time around they seem to be a medium for not just the angry, but also the young, wise and skilful.

Personally, as a somewhat socially concerned designer, I get strength from seeing how *Good50x70* does not grow old easily. There is new will to do something every year, and it gets bigger. We designers have souls, and that's comforting.

Timo

RUTH KLOTZEL

São Paulo, Brazil

Our model of development, based on the rampant growth of production and consumption, has caused catastrophic results: it has led to environmental degradation and the depletion of natural resources, social imbalances and the economic crisis we are witnessing today.

The distortions and misfortunes of this culture of super-productivity — hysterical consumption in a world where people still die from hunger — have made us wake up and question what kind of development we want. We know that to truly flourish as a society depends on our policy options. Self-reflection about what we are doing, what space we have, how we work, what we stand for and our desired path is essential.
We have many challenges but we also have a potential way forward: we can formulate new equations seeking healthier development models. And we need to assume that each one of us is responsible for making a better world.

Ruth

CAO FANG

Nanjing, China

I think the contest and the state of social communication is very important. In particular, competition can promote social progress.

Good50x70's aim is to raise awareness in the communications industry of the power we have to do meaningful work in the field of social communications.
The 7 themes for the posters are currently the subjects of greatest concern to the entire world. And they concern everyone.
The entries come mainly from students — and are both simple and strong in visual communication. I think that graphics that convey overly frightening or absurd images are not desirable. Creativity should be consistent with the unified form.
So I follow this principle: posters are impressive. Posters convey the spirit of creativity. Posters convey the visual aesthetic of information.

I am glad to have taken part in these activities and I am proud of the other *Good50x70* judges. I believe that successful communication and exchanges are a powerful force for the community.

Cao

LEONARDO SONNOLI

Trieste, Italy

But what are they doing, all these posters that we see in cities all over the world?
I thought the poster was dead? Perhaps we're witnessing the "Night of the Living Posters"? Or maybe we should update an old Italian saying to say, "There's no one more blind than someone who doesn't want to see (posters)."

Apart from jokes (easy ones, because it's easy to be right in this case), it's evident that the poster isn't just a tool that might be cast aside because of technological advances. Because one thing that will never end is the need for visual communication to deliver messages in one hit. Just like that arrow hitting an eye drawn by Cassandre to promote his MoMA exhibition in 1936.

Then it is the ability to summarize, the communicative strength, the ability to imagine, that makes a poster. The rest is useless banter. However, just as I said one year ago, I'm still confused about the purpose of contests like this one.

Leonardo

YOSSI
LEMEL

Tel Aviv, Israel

It is more and more difficult to be creative, original, punctual and to hit the target. More and more designers fall into the traps of cliché, and it is harder to create a surprising effect. It seems that although almost everything has been said and done, there is still the possibility of coming up with an unexpectedly good idea, and a good idea is the most important issue here. [...] Basically, either the concept does the job or not. The problem with these global issues is the fact that a lot [of the designers] are emotionally detached and they work more with their brains and less with their hearts, bringing too many flat shapes instead of using real photography, using ready-made icons instead of trying to develop a personal language, their own handwriting.

The key is to find a personal or local way to get connected to the issue. Instead of looking global and anonymous, one should look to the details, to characteristic qualities and the best unique selling proposition of the idea, or the unique emotional proposition (as a metaphor from the advertising world). [...]

Yossi

WOODY
PIRTLE

New Paltz, USA

Once again, the organizers of this annual poster competition focused on global social issues have outdone themselves! The staggering number of entries (4,000) has yielded a truly unparalleled collection of 210 winners.

Although last year's winners were very impressive, I feel this year the bar has been raised. It could be the result of a larger number of entries, and/or perhaps a more diverse representation of global cultures.
At any rate, it is encouraging to be a part of this annual effort and bear witness to the growing number of designers embracing subjects that are fundamental to the future of our very existence as civilized human beings.

Woody

SVETLANA
FALDINA

Saint Petersburg, Russia

If instincts are becoming important and morals less so, socially important problems should be shown. People prefer to close their eyes to the negative sides of human beings, as long as they are not directly affected. The contest *Good50x70* appeals to these problems and that makes it significant.

Svetlana

124

LIZA
RAMALHO

Oporto, Portugal

Projects such as *Good50x70* play a key role in raising social and ecological awareness. This event will contribute towards reviving the social and political involvement of design students and designers and affirm posters as a privileged means of achieving such a goal. While on the one hand the level of proposals is not generally very high – recurring solutions proliferate regardless of the respective subjects of the briefs – on the other hand there are several interesting proposals that stand out from the rest. This is an essential journey and I'm quite confident that as we consolidate this initiative, fostering greater involvement of professors, students and participants, the quality of the set of works will rise exponentially.

[…] This is an opportunity for designers to use their skills on behalf of good causes, and it will also inculcate a sense of responsibility. […] A truly effective poster is capable of altering people's consciousness, and this is the first decisive step.

Liza

ARMANDO
MILANI

Milan, Italy

The ever-growing number of participants, and the constant improvement of the quality of the entries, is proof that *Good50x70* works. Three years ago there were 1,659 entries; this year a staggering 4,210.
While the (Italian) focus might rest on the big opening exhibition of the best posters at Milan's Triennale gallery, it's important to remember that it's followed by many international exhibitions and projects.

[…] Personally I very much like *Good50x70* because it shares the intentions of my Human Design Collection. The objective in both cases is to make young people more aware of what's going on in the world, to transform their creativity into communication and create a constructive dialogue to build a better world. As the world grows a little bit gloomier every day, there's more need for more ethics in our lives, and to fight to preserve rather than to produce and sell.

[…] In my selection I always look for an immediate form of communication that is appropriate and uses as few words as possible. Many of the participants managed to pull this off with great results. […]
Long live *Good50x70*!

Armando

ALAIN
LE QUERNEC

Quimper, France

Good50x70 has one striking particularity: the huge volume of responses to its briefs. […] At first glance, the posters look poor and repetitive. They always use the same symbols to say the same things, and are usually inspired by famous images. Whose fault is this? We, the judges, are more or less guilty of this, as we have created the models… […] That is why I don't want to judge the posters immediately; I need to come back after a few days so I can view this repetitive effect less negatively, and even in a positive light.

[…] Because I am a designer, I suppose that my eye is sharper than the eyes of non-designers…
We all agree – the organizers, the participants and the jurors.
But sometimes I have real doubts. Are the images we select the best posters?
Yes, certainly, if we consider what we believe as designers.

[…] The increasing success of *Good50x70* in collecting so many images remains unique, and gives rise to these new questions.
There is no doubt that it is an instructive experience for me.

Alain

Unicef

CHILD LABOUR
ISN'T WORKING

MESSAGE

CHILDREN ARE NOT A SHORT-TERM RESOURCE FOR IMMEDIATE ECONOMIC RELIEF,
AND THEIR EDUCATION IS AN INVESTMENT IN THEIR COUNTRY'S (AND FAMILY'S) FUTURE.

BACKGROUND

All too often in developing countries child labour is the short-term solution to poverty. But this only reinforces the vicious circle of poverty: child labour – illiteracy – poverty. This cycle has to be broken if we are to protect children and lead developing countries out of poverty.
To do this we must communicate to their leaders and governments that only via education and long-term solutions can the economic condition of their countries be improved. Child labour is too complicated an issue to be simply abolished, and snap reactions like boycotts can make the situation worse.

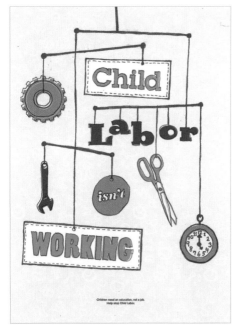

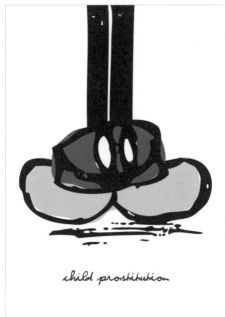

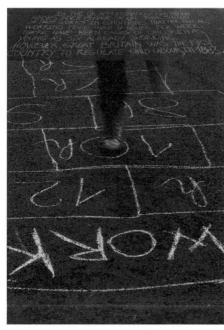

I'M NOT A WORKER
ANGEL ANASTACIO FERNÁNDEZ
Puebla, Mexico

GARMENT HANGER
JERZY TCHÓRZEWSKI
Kraków, Poland

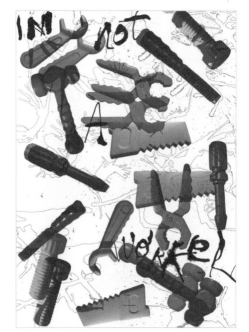 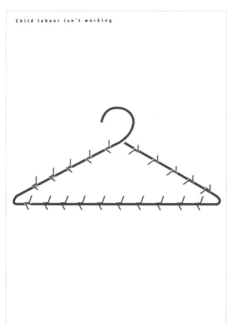

INCOMPATIBILITY
MASSIMO DEZZANI
Candiolo, Italy

CHILD LABOUR ISN'T WORKING
ANA CAROLINA DA SILVA ARAÚJO ROCHA
Lisbon, Portugal

ONE IN SIX
ANA CRISTINA ABREU JESUS
Lisbon, Portugal

SWING
SELCUK OZIS
London, United Kingdom

WEIGHT LIMIT
ERHUARDT MUCHEMWA
Johannesburg, South Africa

KIDS MEANS PLAY NOT WORK
ARIEF RACHMAN RAMEN
Jakarta, Indonesia

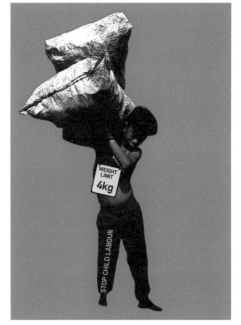

A WORKING CHILD DREAM
MAYSAM KHAZAEI
Karaj, Iran

NO EDUCATION. NO FREEDOM.
OLGA BUKHALOVA
Milan, Italy

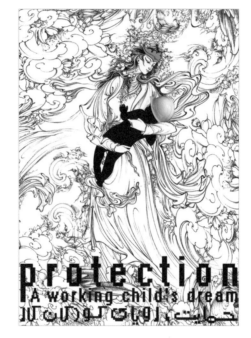

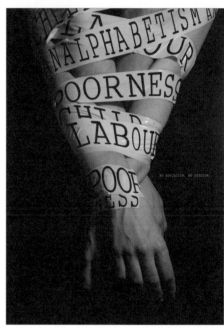

SKULL & CROSSBONES
KELLEY NIXON
San Marcos, USA

CHILD LABOUR
CAROLINA RIBEIRO
São paolo, Brazil

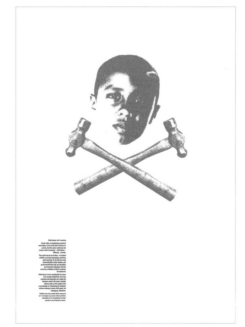

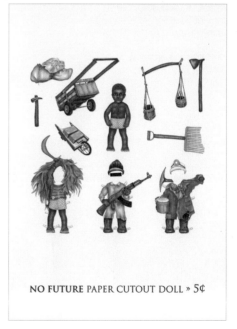

GROWING LABOUR
SAMEERA KAPILA
Curaçao, Netherlands Antilles

FACTORY CHLID
ANGELO STAMERRA GRASSI
Milan, Italy

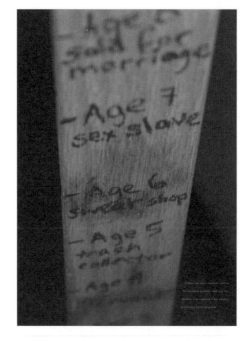

LITTLE HANDS
FARUK TERZI
Istanbul, Turkey

CHILD LABOUR 1
VINAY JOIS
Ahmedabad, India

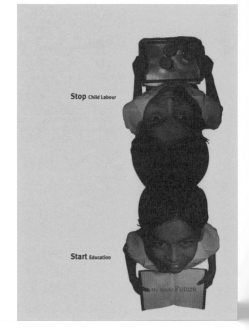

A CHILD'S DAILY ABC
JULIANA DUQUE
Lisbon, Portugal

TYPE FOR ONE OF THEM
SARAH-LOUISE BARBETT
Meudon, France

CHILDREN NEED EDUCATION
BARAN GUNDUZALP
SERKAN ISTANBULLU
Istanbul, Turkey

ONE DOLLAR BABY
SHIN JEONG CHUL
Seoul, Korea (South)

MICKEY AT WORK
FABRIZIO PIUMATTO
Cuneo, Italy

LET THEM GROW
JULIEN CARLIER
Colmar, France

STOP THE LABOUR FORCE
JEREMY HONEA
San Marcos, USA

WORKING ON
PABLO DI FIRMA
Rosario, Argentina

MESSAGE

EUROPE'S LEADERS MUST APPROVE A LAW TO GUARANTEE A 30% REDUCTION
IN GREENHOUSE GASES EMISSIONS BY 2020 THIS DECEMBER IN COPENHAGEN,
OR RISK ONE THIRD OF ALL ANIMALS BEING THREATENED WITH EXTINCTION BY 2050.

BACKGROUND

At current levels, unless we contain global warming under 2 °C, by 2050 one third of all animal species will be at risk of extinction and two billion people will be left without drinking water.
The good news is that in 2009 we can do something about it. On 11 December 2009 Europe's leaders are meeting to decide on the post-Kyoto environmental policy. There can only be one outcome – a genuine and unanimous commitment to a reduction of 30% in CO_2 emissions by 2020. Otherwise there will only be one outcome for humanity and all the other animal species on earth: extinction.

SAVE ENERGY – SAVE ANIMALS (2)
VIKTORIYA GADOMSKA
Poznan, Poland

DON'T LET IT GO UP IN SMOKE!
CAFLISCH NOTTA
Chur, Switzerland

IT'S HIGH TIME
PAMELA CAMPAGNA
THOMAS SCHEIDERBAUER
Sevilla, Spain

LOVE THY NEIGHBOR
PRAVIN SEVAK
Vincennes, USA

CLIMATE CHANGES
HECTOR IVAN DOMINGUEZ PINO
Puebla, Mexico

EXTINCTION
HABIB FARAJABADI
Tehran, Iran

133

HELP
ULAS UGUR
PINAR AKKURT
Istanbul, Turkey

EXTINCTION
MARCO VALENTINI
Lonigo, Italy

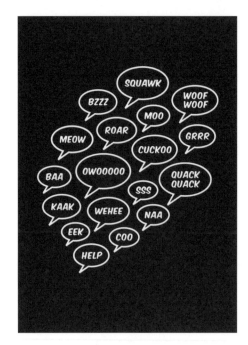

SWITCH TO COMPACT FLUORESCENT LIGHT BULBS
TAKANORI MATSUMOTO
Saitama-ken, Japan

2050
SAMEERA KAPILA
Curaçao, Netherlands Antilles

**CLIMATE CHANGE
AND ANIMAL DISTICTION**
HONG WANG
Hangzhou, China

ALERT CO2
ABHAY SALVE
Ahmedabad, India

EXTINCTION
MARVIN JASTILLANA
Austin, Usa

LIFE CLOCK
CAI SHI WEI
Beijing, China

DELETE ALL NOW?
RICCARDO PERELLO
Strambino, Italy

ANIMAL EXTINCTION
NATALIA DELGADO
Tijuana, Mexico

PROECT ANIMAL
TIANTIAN ZHANG
Hangzhou, China

THE CONSEQUENCES OF CO2 EMISSIONS
JOE SCORSONE
ALICE DRUEDING
Jenkintown, USA

CONFESSIONS OF LEAVES
YI MAO
Hangzhou, China

PLUS IS THE NEW MINUS
ANTOINE CORBINEAU
LAURIE MOGARRA
Paris, France

OUR TIME IS RUNNING OUT
SCOTT LASEROW
Wyncote, USA

GRADIENT
YANG ZHOU
Hangzhou, China

Help reverse climate change before it's too late.

SMOKE
ZHIXIANG DA
Huaibei Anhui, China

GLOBAL WARMING
MALGORZATA BEDOWSKA
Gdansk, Poland

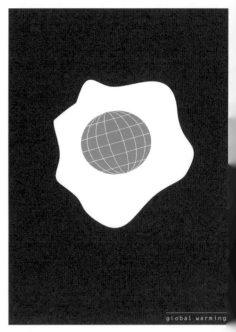

LIVE AND LET LIVE
JENS MITTELSDORF
Mönchengladbach, Germany

A NEED FOR WATER
VIKTORIYA GADOMSKA
Poznan, Poland

SAVE ENERGY AND EMISSIONS REDUCTION-1
MINGLIANG LI
Guangzhou, China

GLOBAL WARMING MAKES THEM DISAPPEAR
JU-HWAN LEE
SEUNG-HOON NAM
Seoul, Korea (South)

DEAD LEAF
CHRISTOPHER SCOTT
Dungannon, United Kingdom

"WRONG WAY"
FABIO LUPOLI
Turriaco, Italy

Emergency

MEDICAL TREATMENT
IS A RIGHT FOR ALL

MESSAGE

NO ONE SHOULD DIE BECAUSE THEY CAN'T AFFORD, OR CAN'T GET, HEALTH CARE.
THAT'S SO LAST-CENTURY.

BACKGROUND

In 2008, EMERGENCY established a manifesto for free universal health care on the following principles:

Equality: for everyone, regardless of economic or social conditions, gender, race, language or religion, delivered without discrimination.

Quality: health care based on the local community's needs – not the health industry's.

Social responsibility: governments must address the health and well-being of their citizens as a priority.

EMERGENCY wants national health authorities and humanitarian groups to sign this manifesto and the international aid community to fund, support and help implement EQS programmes.

HARD WAY
JOANA COUTO
Amadora, Portugal

**YOU CAN'R BOIL WATER
AND CALL IT SOUP**
DANIELE POLITINI
Milan, Italy

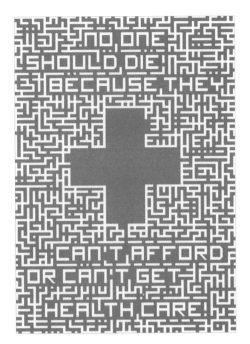

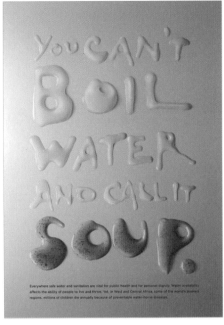

REFILL/RIGHT
CHRIS CAO
Houston, USA

CROSS
DAVIDE GALBUSERA
Lecco, Italy

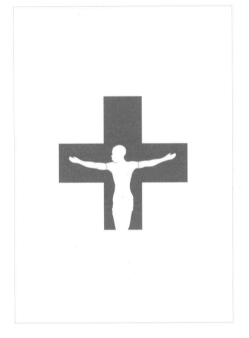

MEDICALL
KAILEY THIRLWELL
Vancouver, Canada

STETHOSCOPE
YAEL GAVISH
Haifa, Israel

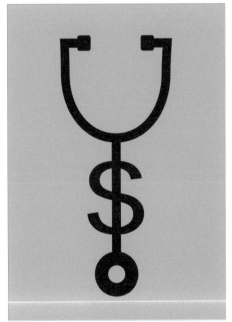

HEALTCARE DEPRIVATION
ANGEL ANASTACIO FERNÁNDEZ
Puebla, Mexico

JUST ANOTHER NUMBER
DAWN HOUSER
San Marcos, Usa

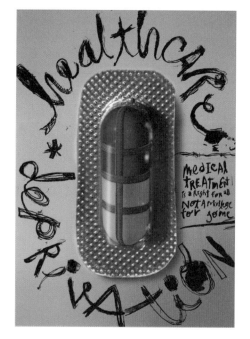 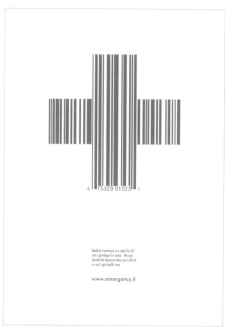

EQUALITY
FUNDA AKMAN
Eskisehir, Turkey

FACTS
YAEL GAVISH
Haifa, Israel

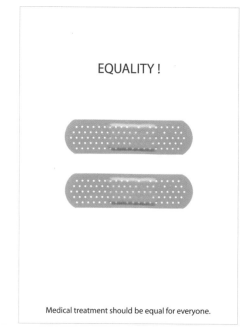 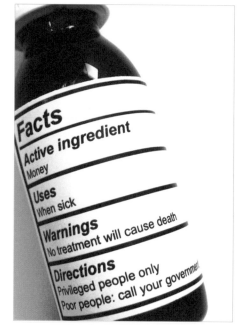

SHOT
BURAK TIGLI
Istanbul, Turkey

WE CAN HEAL OURSELVES
KHODABANDEH BIZHAN
Richmond, Usa

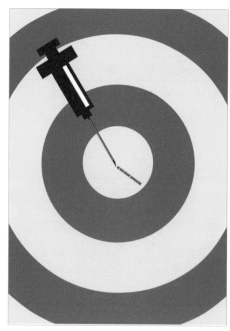 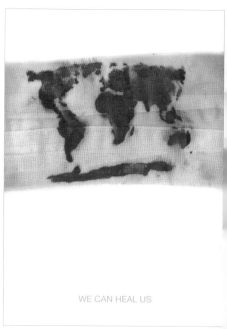

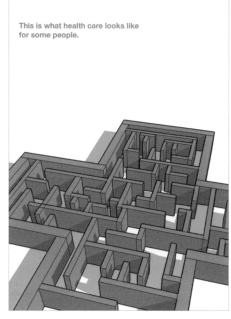

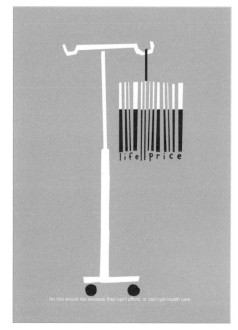

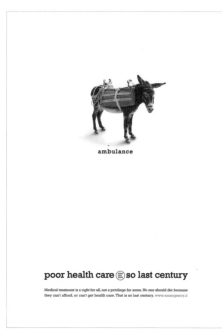

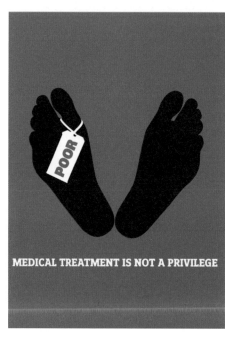

141

WEALTH CARE (DOLLARS)
GIACOMO BRIVIO
Lissone, Italy

YOUR MONEY OR YOUR LIFE
ANITA WASIK
Gdansk, Poland

COEXISTENCE
GUOWEI WU
Shenzhen, China

THE MEDICINE INDUSTRY
NATALIA DELGADO
Tijuana, Mexico

**WHAT A DIFFERENCE
45° MAKES!**
RICH MELCHER
San Diego, USA

RICH&POOR
SALOME KOSHKADZE
Tbilisi, Georgia

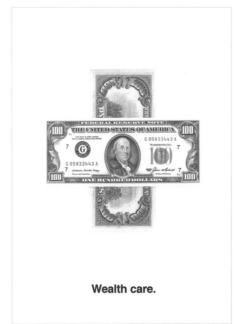

Wealth care.

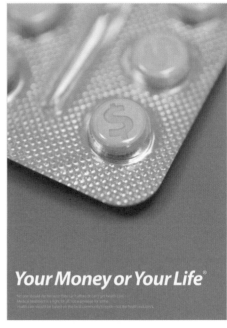

Your Money or Your Life®

THE MEDICAL INDUSTRY

Medical treatment is a right for all,

not a privilege for some.

+ Rich

No one should die because of poverty

† Poor

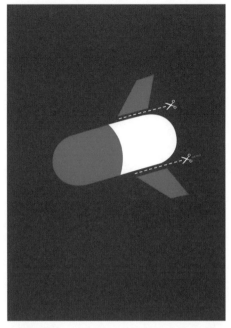

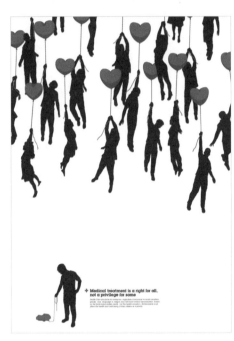

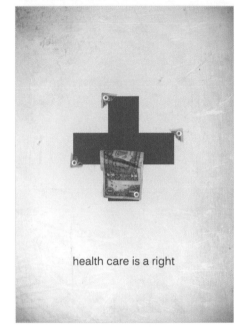

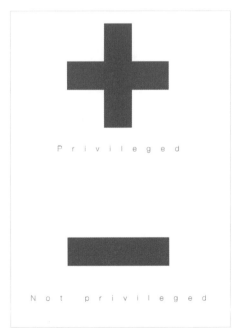

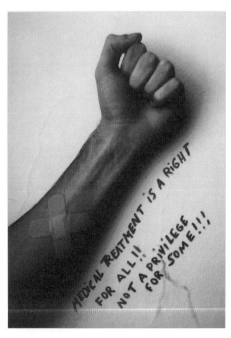

Lila
Italian League
for the Fight against AIDS

HIV ISN'T A SENTENCE

MESSAGE

BEING HIV POSITIVE IS NOT A CRIMINAL OFFENCE. GOVERNMENTS MUST FOCUS ON EDUCATION AND PREVENTION OF THE DISEASE RATHER THAN REPRESSION.

BACKGROUND

Despite evidence to the contrary, being HIV positive isn't a criminal offence. Yet AIDS sufferers are legally and socially discriminated against every day. In some countries being HIV positive is even judged under criminal, not civil, law. Governments must be convinced that making laws against HIV and its sufferers won't stop the spread of the disease. Instead of focusing on repression and punishing people who contract the disease, efforts should be concentrated on preventing it via education.

DON'T USE CONDOM
STEFANO LIONETTI
Parabiago, Italy

CONE-DOM
HANDOKO TJUNG
Jakarta, Indonesia

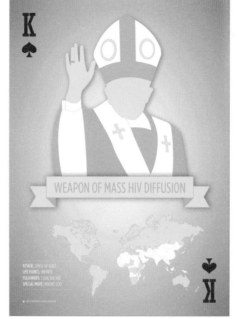

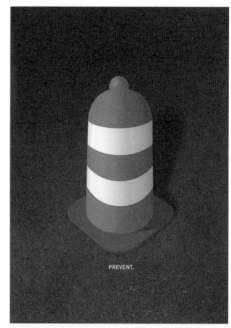

FIGHT AIDS, NOT PEOPLE WITH AIDS
SARA GAMA
Lisbon, Portugal

BELIEVE
ROBERTO TJON-A-MEEUW
Paramaribo, Suriname

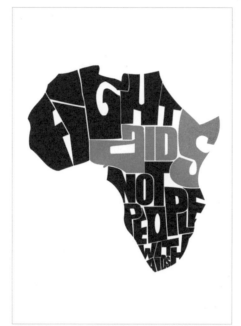

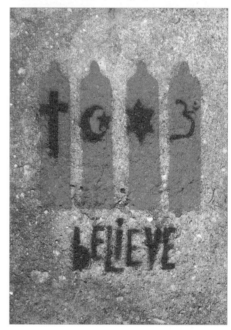

HIV IS NOT A CRIME
MARVIN JASTILLANA
Austin, USA

HIV IS A VIRUS NOT A CRIME
ALEXANDER NIKANPOUR
New York, USA

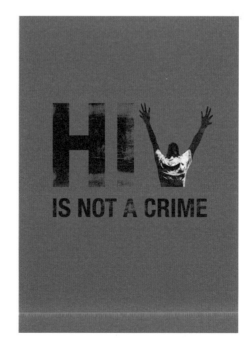

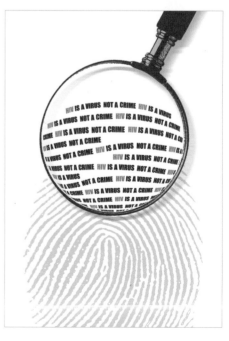

BE SINCERE AND FATHFUL
LEONIE MOSSEL
Paramaribo, Suriname

BE CAREFUL WITH YOUR CONNECTIONS
PAULO MELO
Urrô, Portugal

DO NOT PUNISH
ISMAIL ANIL GUZELIS
Eskisehir, Turkey

EDUCATION, NOT REPRESSION
YAEL GAVISH
Haifa, Israel

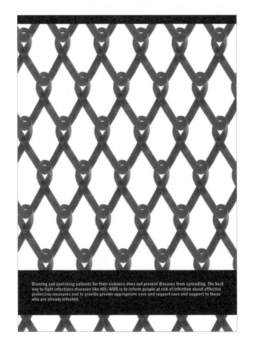

EDUCATION, NOT REPRESSION

DOUBLE SENTENCE
DAVIDE CALLUORI
MASSIMO PATERNOSTER
GABRIELE CAETI
Milan, Italy

HIV POSITIVE
GIOVANNI MASTROENI
Milan, Italy

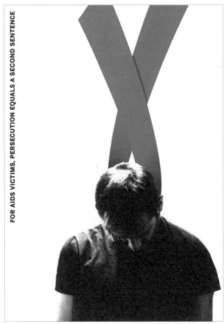

FOR AIDS VICTIMS, PERSECUTION EQUALS A SECOND SENTENCE

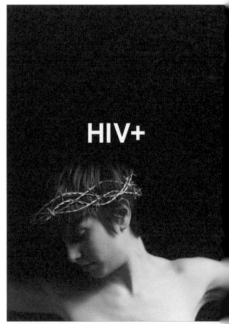

HIV+

HIV
JIE FANG
Hangzhou, China

CRIME SCENE
SELCUK OZIS
London, United Kingdom

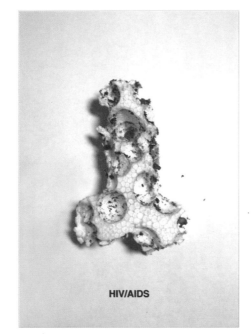

HIV/AIDS

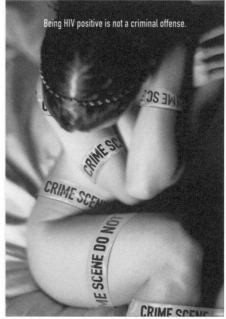

Being HIV positive is not a criminal offense.

CRIME SCENE DO NOT CROSS

ILLUSION
ÁGATA VENTURA
Lisbon, Portugal

HIV
SIMONE GIARA
Vercelli, Italy

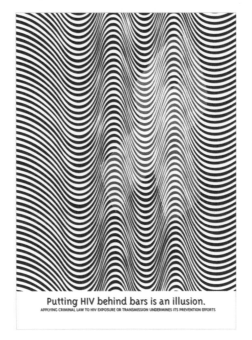

Putting HIV behind bars is an illusion.
APPLYING CRIMINAL LAW TO HIV EXPOSURE OR TRANSMISSION UNDERMINES ITS PREVENTION EFFORTS

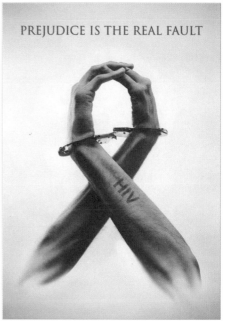

PREJUDICE IS THE REAL FAULT

HIV/AIDS
CATARINA MONTEIRO
Almargem do Bispo, Portugal

**TALK ABOUT IT,
IS NOT A CRIME**
MARCHE ALINE ALINE
Cambrai, France

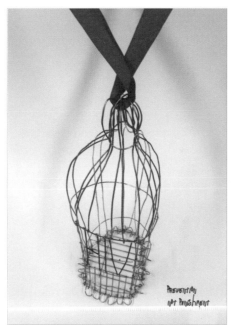

Prevention not punishment

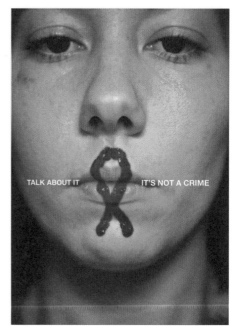

TALK ABOUT IT IT'S NOT A CRIME

USE YOUR HEAD
TAKANORI MATSUMOTO
Saitama, Japan

BRING ME FLOWERS!
ELENA MORA
Milan, Italy

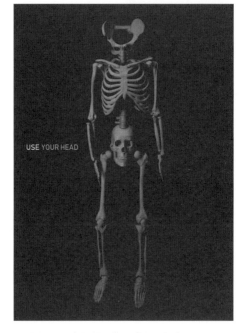 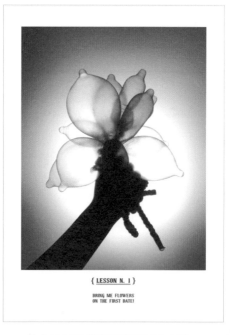

CLEAN LOVE – CLEAN BLOOD
LENA STARANCHUK
Kiev, Ukraine

**PRACTICE EDUCATION,
NOT SUPPRESSION**
MICHAL JANICKI
Chicago, USA

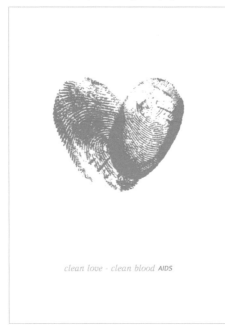 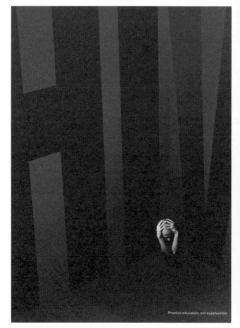

**AIDS PATIENTS
ARE'T CRIMINALS**
GUOWEI WU WU
Shenzhen, China

HIV IS NOT A CRIME
SIMONLUCA DEFINIS
Milan, Italy

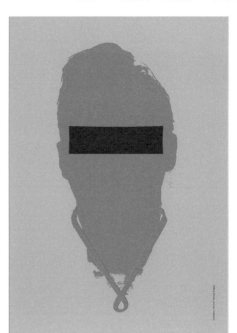 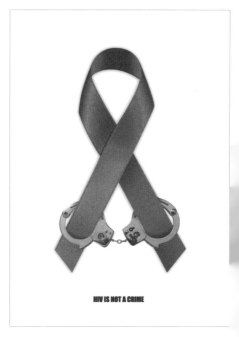

148

PERSIST
MAURIZIO CASALE
Aosta, Italy

CRIME!
SELCUK OZIS
London, United Kingdom

TOGETHER
RÉMI FOUQUET
Rousies, France

PRISON WALL
JAN SABACH
Prague, Czech Republic

DON'T DICRIMINATE.
ANDREA CASTELLETTI
Milan, Italy

**USE THEM NO MATTER
WHAT THEY SAY**
KRESIMIR GRANCARIC
Zagreb, Croatia

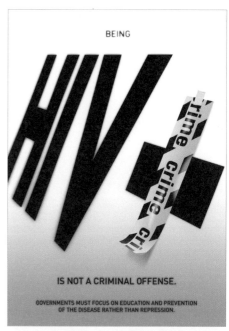
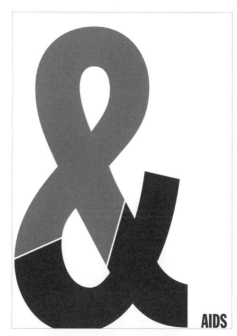

Greenpeace

NUCLEAR POWER
IS GOING TO BLOW UP

MESSAGE

NUCLEAR POWER IS NOT SAFE OR GOOD ENOUGH FOR OUR PLANET.
RATHER THAN PURSUE A DANGEROUS PATH THAT CAN OFFER LITTLE
TO THE ENVIRONMENT, WE MUST PURSUE CHEAPER, CLEANER, MORE SUSTAINABLE
FORMS OF ENERGY.

BACKGROUND

Despite being declared a non-sustainable technology by the UN as recently as 2001, plans
are gathering apace for the reintroduction of nuclear power. The basis for this is that it's clean,
CO_2-neutral power. But the reality is sadly different. Even ignoring the exorbitant costs, the safety
issues and the unresolved question of nuclear waste, it's impossible to implement nuclear power
before 2020, leading to a maximum 4% cut in CO_2 by 2050.

NUCLEAR EVOLUTION
HANDOKO TJUNG
Jakarta, Indonesia

WHITE ALTERNATIVE
SELCUK OZIS
London, United Kingdom

EMPTY CALORIES.
META NEWHOUSE
Bozeman, USA

GAME OVER
PHIL JONES
RYAN COLEMAN
Charlotte, USA

NUCLEAR TERROR
MICHELLE TROTTER
JASON KELLY
London, United Kingdom

NUCLEAR POWER IS UNREAL
ROBERTO ANZANI
Como, Italy

YOU'RE NOT PERSUADING ME
LUCA ANTOLINI
Cornate d'Adda, Italy

**THE PROBLEM
AND THE SOLUTION**
FLAVIO CARVALHO
Sao Paulo, Brazil

CUTE
SILVIA SCUTTARI
Sarre, Italy

THIS IS NOT A SOAP BUBBLE
VALENTINA FUMAGALLI
Milan, Italy

PIN
NIKOLAY KOVALENKO
Kiev, Ukraine

I'M YOUR BEST CHOICE
MARIO ISRAEL PRADO JIMÉNEZ
CLAUDIA LIBETH ARANA CORONADO
Mexico City, Mexico

END IT NOW.
SIAN RICHARDSON
Morrinsville, New Zealand

RUSSIAN ROULETTE
AHMET ERDOGAN
FIRDEVS CANDIL ERDOGAN
Istanbul, Turkey

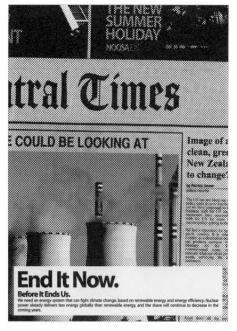 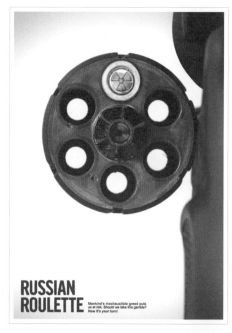

**NUCLEAR POWER IS GOING
TO BLOW UP THE PLANET.**
ANATOLIY OMELCHENKO
NATALIIA LYZENKO
New york, USA

NUCLEAR POWER IS NOT SAFE
SARAH HARTWIG
Berlin, Germany

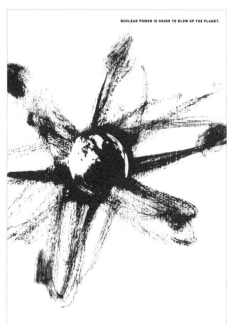 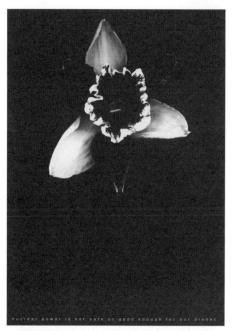

NUCLEAR
GUOWEI WU
Shenzhen, China

KABOOM
DANIEL NEVES
Parede, Portugal

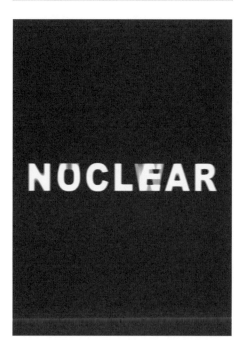

UNTITLED
ANDERSON GOMES
São Bernardo Do Campo, Brazil

TO OUR GRANDCHILDREN
AHMET ERDEM SENTÜRK
Istanbul, Turkey

READY TO BLOW UP
GÖKHAN APAYDIN
Istanbul, Turkey

DANGER!
ANITA LUKÁCSI
Budapest, Hungary

BLOWING UP THE PLANET
DILEK NUR POLAT
Ankara, Turkey

PAROLE... PAROLE
TOMASO MARCOLLA
Trento, Italy

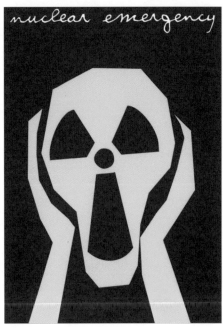

Amnesty International

CLOSE GUANTANAMO?
YES WE CAN

MESSAGE

IF THE USA, AND BARACK OBAMA, WANT TO MAKE A GENUINE COMMITMENT TO HUMAN RIGHTS, THEY MUST FOLLOW THE GOOD START TO HIS PRESIDENCY AND CLOSE GUANTANAMO BAY AS QUICKLY AS POSSIBLE.

BACKGROUND

Since opening its doors seven years ago, Guantanamo Bay has become a symbol for the USA's abuses of justice and disdain for freedom. Nearly 800 prisoners have been held there (250 at the time of writing), but just 26 detainees have gone on trial and only 3 have been convicted of crimes. On the very first day of his presidency, Barack Obama announced his intention to close Guantanamo Bay and invoke a suspension of the controversial military tribunals held there. Amnesty wants to make sure he follows this up with decisive action and a swift closure of Guantanamo Bay.

REQUIEM
MILEN GEORGIEV GELISHEV
Sofia, Bulgaria

THE CRY OF GUANTANAMO
ERICA TACCONI
Milan, Italy

SPIRAL OF VIOLENCE
VINCENZO VALERIO FAGNANI
Caserta, Italy

REPUBLICAN FLAG
DELPHINE MICHAUX
Fouquières Les Lens, France

WAR ON TEROR
AEL GAVISH
Haifa, Israel

EEL THE DARKNESS... FIGHT FOR FREEDOM
RZU BODUR
ocaeli, Turkey

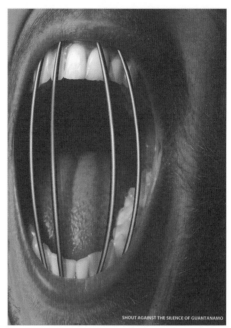

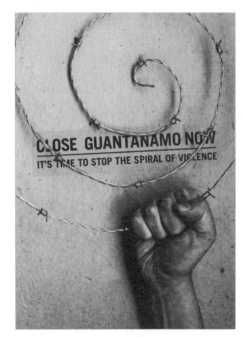

CHANGE THIS!
EMRAH GÜZEL
Istanbul, Turkey

TERRORISM
STEPHAN AZARYAN
Yerevan, Armenia

SPRING
LEE BANG WON
Seoul, Korea (South)

CLOSE GUANTANAMO BAY
ANITA WASIK
Gdansk, Poland

GUANTANAMO CRUCIFIXION
LUCA SERGIO MACI
Carlentini, Italy

BETWEEN LIFE AND DEATH
ERHAN OZDEN
UGUR KAPLAN
SELCKUK DANYILDIZ
Izmir, Turkey

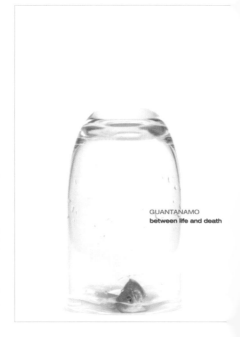

HOPE
FABRIZIO PUZZILLI
Rome, Italy

VICIOUS CIRCLE
SZYMON SZYMANKIEWICZ
Lodz, Poland

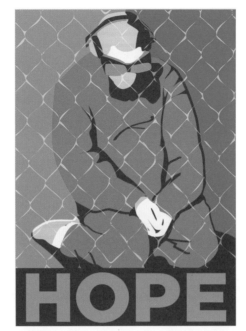

THE STATUE OF TORTURE
BARAN GUNDUZALP
SERKAN ISTANBULLU
Istanbul, Turkey

HOW MUCH NOISE
CAN YOUR SILENCE LISTEN? CLOSE GUANTANAMO
SIMONLUCA DEFINIS
Milan, Italy

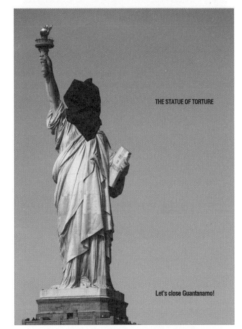

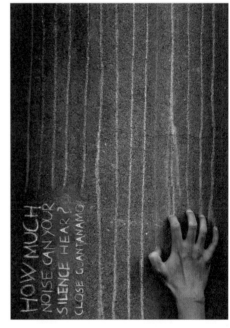

CORPORATE WARFARE
HOYT HAFFELDER
Buda, USA

I LOVE IRAQ
SAJAD ASADI
Tabriz, Iran

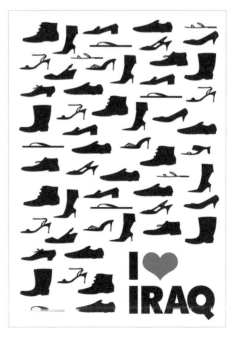

GUANTÁNAMO
JOSE RUBIO MALAGÓN
Madrid, Spain

CLOSE
RAPHAEL BERTSCHINGER
Wetzikon, Switzerland

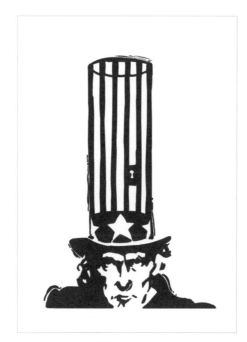 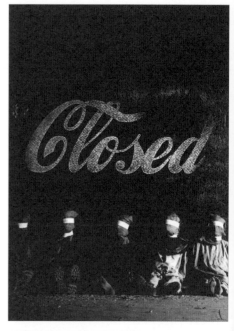

PEACE
OMID (MOJTABA) KESHTKAR
Tehran, Iran

SACK
AHMET ERDOGAN
FIRDEVS CANDIL ERDOGAN
Istanbul, Turkey

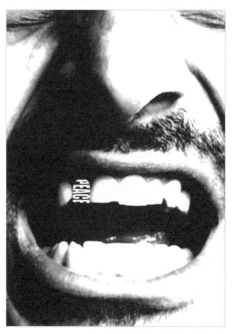 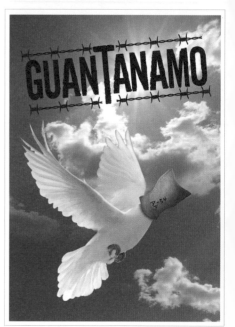

NO GUNS!
SISI REN
Shenzhen, China

TERRORISM
SUNG JAE KIM
Yeongju, Korea (South)

CLOSE GUANTANAMO
RAMAZAN SIMSE
Gaziantep, Turkey

HOPE!
SELCUK OZIS
London, United Kingdom

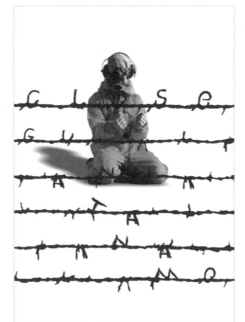

FOR PEACE
ERDEM ÖZIL
Erzurum, Turkey

UNTITLED
REZA SHERI
Tabriz, Iran

WAR ON TERROR = WAR ON PEACE
DAVID GARCIA
Miami, USA

AFTER
MINGLIANG LI
Guangzhou, China

WOMEN GIVE LIFE TO AFRICA

MESSAGE

WOMEN IN AFRICA ARE THE PILLARS OF THEIR COMMUNITIES. THEY MUST BE PROVIDED WITH MEANS TO HELP THEM GAIN THE RESPECT THEY DESERVE AND BE ALLOWED TO SPEAK WITH THEIR OWN VOICE.

BACKGROUND

Communities are the core of life. And the heart of every community is the woman. Yet every year in developing countries 82 million adolescent girls become wives, 14 million give birth to a child, 83 million cannot read and write, while an unknown number of young women are forced to drop out of school, thereby jeopardizing their future. Action must be taken to give women in Sub-Saharan Africa, where 74% of Africa's urban population is concentrated, the respect they deserve and therefore the hope that Africa needs.

AMREF runs schemes in the slums of Nairobi that help raise women out of their difficult everyday situations by giving them the support and confidence they need through art and education.

BOMBREAST
SILVIO MICHELE LORUSSO
Altamura, Italy

NO WOMAN NO RIGHT
EREN ARSLAN
Samsun, Turkey

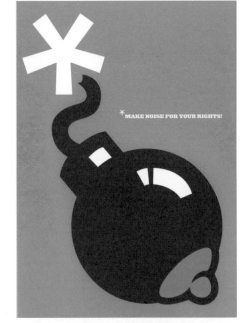

EGALITE
FLORIAN FISCHER
Berlin, Germany

WOMAN'S RIGHT LEFT BEHIND
DARYOUSH TAHMASEBI
Lulea, Sweden

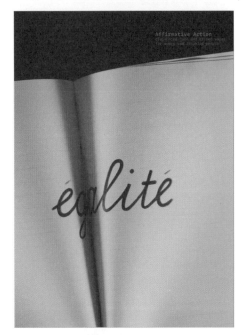

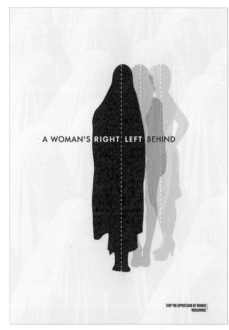

TORTURE AGAINST WOMAN
SÜYÜMBIKE GÜVENÇ
Istanbul, Turkey

MALE DOMINANCY
DEMET ATINÇ
ELVIN EVREN
Izmir, Turkey

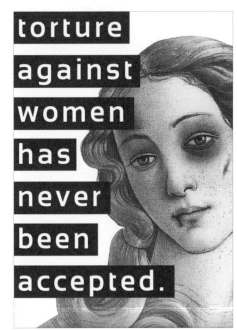

WOMAN IN BLACK
SELCUK OZIS
London, United Kingdom

SPEAK UP
WERONIKA KOWALSKA
Bytom, Poland

MACHITO
CESAR ALI HERNANDEZ TORRALBA
Puebla, Mexico

**THE AFRICAN WOMAN
IS THE PILLAR
OF HER COMMUNITY**
JOLY MELANIE
Paris, France

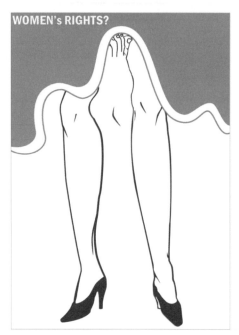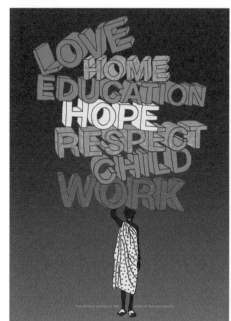

RAZOR BLADE
NATHALIE CARN
Cangas del Morrazo, Spain

THEY ARE ALREADY CARRYING TOO MUCH
CAMILA JAIMES
La Paz, Bolivia

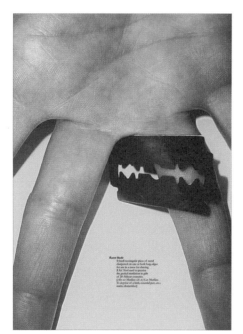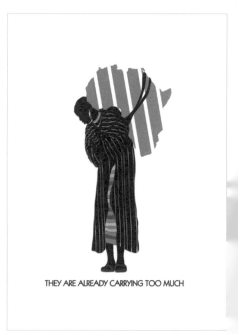

AFRICA
MARCO DUGO
Bologna, Italy

RIGHT TO HEALTH
EVA CHUDOMELOVA
Prague, Czech Republic

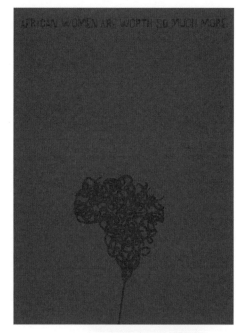
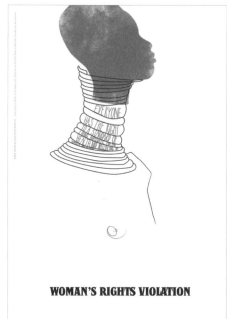

TRY IT
WERONIKA KOWALSKA
Bytom, Poland

FASHION: SHUT YOUR MOUTH
VAHE ABED
Tehran, Iran

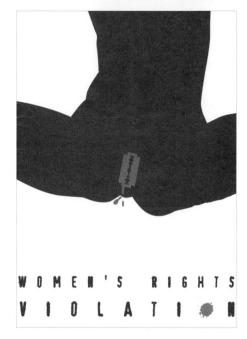

DIGNITY
ANNA GRAZIA DI RONZA
Caserta, Italy

WOMEN'S RIGHTS VIOLATIONS
FANG YI LIU
Hangzhou, China

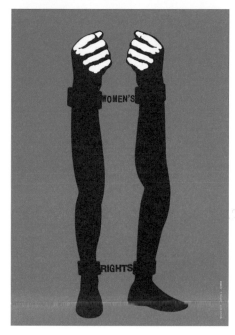

BREAST MOSQUES
EKIN KILIC
Ankara, Turkey

LET ME SPEAK
VARSHA MEHTA
Ahmedabad, India

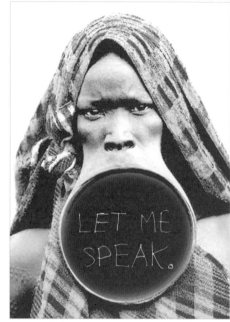

THE UNITED COLORS OF IRANIAN WOMEN.
PAYAM ABDOLSAMADI
Tehran, Iran

LISTEN
FULVIO VIGNAPIANO
Latina, Italy

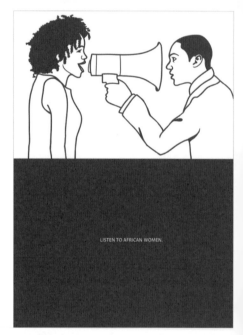

WOMEN PROTESTING AGAINST HUMAN RIGHTS VIOLATIONS
ANATOLIY OMELCHENKO
NATALIIA LYZENKO
New York, USA

CUT IT OFF
DANIELA GUMIEL GANTIER
La Paz, Bolivia

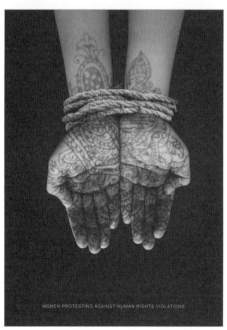
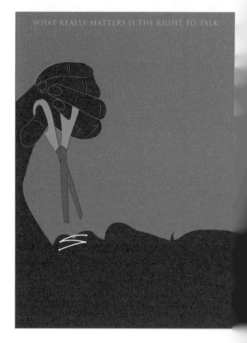

SEE-THINK-SAY
MARIKA MODZELEWSKA
Wroclaw, Poland

AFRICAN WOMEN
TODD STOILOV
Burlington, Usa

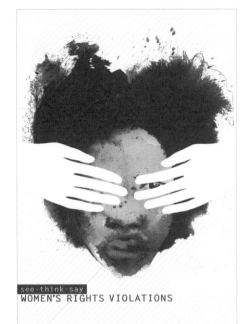
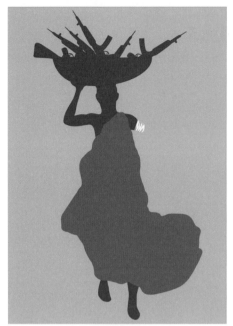

WOMEN'S RIGHTS VIOLATIONS
JING ZHOU
Long Branch, USA

" I "
FABIO CASELLI
Coldrerio, Switzerland

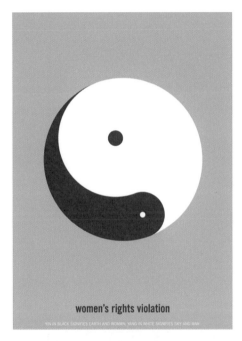

WOMEN AREN'T COMMODITIES
GUOWEI WU
Shenzhen, China

EDUCATE AFRICA.
CHARUTHA REGHUNATH
Ahmedabad, India

2010

4TH EDITION

YOSSI LEMEL

Tel Aviv, Israel

After clearing the fence of creating a great poster, the question is: what's next?

You participated in an exhibition, got a lot of compliments, professional publicity and media coverage. What is beyond the creation of a good work? Is this the limit of what you can do as a responsible, involved designer, or is there a way to expand further and really try to make change in people's minds and behaviour?
For almost ten years I worked with Amnesty International, Israel Chapter. The works I designed, mainly posters, were part of a series of poster biennials and international exhibitions, which was all very nice, but the real impact took place in the streets, on billboards, in bus stations, where you could feel the change in people's opinions: out in the field you get the legitimization to promote your ideology, and to attract attention even more, sometimes, than via the usual commercial route.

Through the street campaign, which was a rare collaboration between Amnesty, the posters and media power, we achieved impressive results, getting more financial support, recruiting more people and involving more members, and through this contribution we created change in some persecuted people's lives in other countries.

What I mean to say by this is that the main goal of *Good50x70*, from my point of view now, is to try to recruit NGOs to adopt the best selected posters and make a commitment with the media in a concentrated effort to develop a whole language for each campaign that will communicate an effective message and successfully convey the concept in order to create the desired change.

This has happened in the past. As far as I can remember, more than one of the posters from *Good 50x70* have been taken up for public use. Now this should be the aim in each category, followed up during the ensuing year so we learn more about the consequences and achievements that a good work can bring about! [...]

Yossi

CHAZ MAVIYANE-DAVIES

Harare, Zimbabwe

[...] The work was generally stronger and it was refreshing to see that, unlike previous years, many posters attempted to answer the briefs as their specifics required, as opposed to using broad representational responses and obvious clichés as their solutions. [...] In terms of the process of creating posters, there are some comments I feel I should share with respondents:

1. Don't just interpret the problem, make a point or opinion about it. This point will also be more original and meaningful if you dig deep and research into your own culture and the ways that your societies discuss and express their views on the problem, instead of merely scratching the surface of the subject and relying on well-worn stereotypes and clichés to render your work. [...]

2. Don't speak only to a captive audience. Expressing a problem is easy when your audience understands it. Most of your viewers need hints and guidance through your creativity and narrative to lay the ground for their understanding. In short, some things need to be explained. [...]

3. Don't label what we see. Images and words work together, and when one works off the other or questions or ignites the other, we can create visual friction and a third meaning through the fusing of visual and spoken language in cases where those two elements would not normally be used together. Accept that your audience is intelligent and that you might leave a stronger impression on them if they feel they have worked out your creative subtlety themselves. [...]

Chaz

MASSIMO VIGNELLI

New York, USA

I must say that the qualitative level of the posters is generally quite high when you consider the difficulty of the themes, so I find it interesting and meaningful that both conceptual quality and graphic talent have reached an even higher level. The poster is finally in a symbolic phase, having come out of a narrative one: now the sign becomes the important bearer of the message. I think this represents the results of a better education in design.

The work of many young people reflects a professional seriousness and a positive and constructive engagement with social responsibility that are far different from the hippie movement of the 70s and the post-modern deformations of the 80s.
The fundamental lesson of modernist culture, which sought to simplify its expressive means while enriching them with greater intellectual complexity, has resulted in a language of greater cultural depth which is reflected in the work of many designers chosen for this competition. This, I think, is a positive aspect of the competition, which is capable of catalysing the creative capacities of a new generation, year after year, through a series of works which keep getting better and better.

Many are the works that struck me, both for their intellectual elegance and for their graphic talent. Among these, one of my favourites is an all black poster with the word Tiger on it; the T is a cross. Perfect, concise, truly elegant. A real masterpiece. [...]

Massimo

DAVID BERMAN

Ottawa, Canada

"We can't solve problems by using the same kind of thinking we used when we created them".
Albert Einstein (1879-1955)

It's like this:
The world's tiger population today is 20% of what it was the day I was born. That makes me cry.

On the other hand, I know that designers have the creative power, through social communication, to create significant global change in our world. That makes me hope.

I hope that by the day I die there will be as many tigers alive as there were on the day I was born. Maybe one more. However, I don't know when I am going to die. Thus the urgency.

Across all the topics, the typography and the colour and the cleverness come together to create messages that motivate and educate. These designs reassure us that our tigers and our hopes and our dreams for a just society are safe in the hands of the next generation of designers: a generation who don't just do good design: they do good!

David

ALAIN LE QUERNEC

Quimper, France

Good50x70 is getting better.

When a new concept appears, it is not easy to guess whether it will work or not, even if you support it from the beginning.

It is easy to criticize this kind of initiative: one could say that the average graphic level is rather poor, that it is not elitist enough and so on. Some graphic star designers will not allow their name to be associated with this popular initiative, and that is a pity for them because they are missing something. *Good* is a unique opportunity for designers all over the world to present and confront their work. Often, responses come from countries where these messages cannot be expressed, usually for political reasons, sometimes for economic reasons. The low quality of many of the works received is not a problem – this is an open competition and the number of entries constitutes its strength. It is open and must remain open. The final selection of these works makes for a high-quality exhibition, with strong and original messages supported by accurate design.

Year after year, the concept is getting stronger and stronger. It works, and the best homage is to see that it has become a model for similar events.
Of course *Good50x70* will evolve, but its success depends on the support it receives to develop on a larger scale. It needs it, and it deserves it.

Alain

WOODY PIRTLE

New Paltz, USA

I have been a juror for this social communication project since its inception in 2007, and must say that it has been truly rewarding to be part of an effort that has seen such astounding exponential growth – attracting more entrants, patrons, endorsements and charities to the global effort each year. The 2010 competition resulted in 2,357 entries from 81 countries, once again expanding the reach of social consciousness even further around the world.

The most recent competition, judged this past July, resulted in 210 winners across 7 categories. The best of these are succinct, simple and direct in execution, universally communicative and truly inspirational. The judging process is always very interesting in that while often laborious, the moment that one discovers a jewel, or obvious winner, is the moment of stimulation needed to face the next several hundred posters that need to be carefully considered.

[…] Thanks to all who have participated in the competition and related events. Each of you has helped, and will continue to help make an effort that was very good from its beginning in 2007… even better.

Woody

JONATHAN BARNBROOK

London, United Kingdom

There is a question I am often asked when I give a lecture and show my more political work, which is, "Can you give me an example of a poster you have done that has changed anything?" My answer is a very clear "No". An uncomfortable moment follows. The more idealistic people in the audience are disappointed in this answer; the person who asked it looks smugly triumphant – after all, what is the point in doing this kind of work if you can't change anything? But they are missing the error in their question. Change does not happen with one poster; the poster is just one of many voices that bring an idea into the mainstream, and only then can change happen. So for one individual to claim they have changed anything with one piece of work, or another to expect them to prove it, is a silly idea. Changing people's minds is a much more complex process.

So is it pointless to design a poster with a social message if it can only be a small voice? On the contrary, it is confirmation that graphic design does have a vital role to play – it's just a much less important one than we think. Graphic designers focus too much on their own little world – on who does what and whether it's a "proper" piece of design or not. We need a bit of distance from our own profession to look at our role in society through history. Yes, graphic design is commercial, but it has also been one of the vital mediums used to disseminate political and social ideas. I firmly believe that if you express your voice or explain your idea clearly and simply in a visual form, it has a power that words do not: a power to change society as part of that larger voice of change.

So back to that original question. Usually it is asked by somebody who is desperate to prove that any socially-engaged work is "unrealistic", that in the "real world" such things make no difference. Why? Because it takes much less effort to be a designer when design is seen as something safe. The power to change involves responsibility to make change in the right way, and that brings up moral choices. As Gandhi said, "You must be the change you wish to see in the world." We need to keep doing socially-engaged design, we need to express what is in our soul, our discontent with the world. That one small, honest voice will help make change, and that is the reason I wholeheartedly support and value the work of *Good50x70*.

Jonathan

PADDY
HARRINGTON

Toronto, Canada

ANGELA
MORELLI

Lecce, Italy

[…] The power of design is that it allows us to visualize the potential of a better future and gives us many of the tools to make that future into reality.

The beauty of design is that it's democratic. Ideas with true value can come from anywhere. And the new connected world means that the best ideas rise up based on their own merit. Ideas, of course, come in many sizes and shapes. Some great ideas take the shape of government policy, others of products driven by major investment in research and development from some of the world's largest corporations. But some ideas start small, yet have a huge impact.

[…] The posters in this year's *50x70* competition are amazing in their diversity. In their numbers, they offer a window into how people are interpreting some of the major issues of today. Yet seeing them all together makes something clear: great design is not easy. […] It begins with a clear idea. And the best ideas stand out for their strength and originality.

[…] That's great design: the intersection of powerful concept and stunning execution. One without the other leaves an ineffectual vacuum.

And when thinking about a project aimed at increasing social good in the world, it helps to add optimism to the equation, to visualize a better and more exciting future. Because when we see a better future, we see a destination. And when we see a destination, we have a place to move to. That's the power of design.

Paddy

My first belief is that Good Design speaks the language of understanding; my second that when design speaks the language of understanding together with the language of empathy, it can drive the user to transform understanding into action.

Writer Jeremy Rifkin explains that the "pathy" in the word empathy suggests that we enter into the emotional state of another human being or living being. […]

Empathy can drive designers' commitment and motivate them to use design to empower understanding and raise awareness of important issues. As a consequence, design that raises awareness and facilitates understanding can trigger empathy in the end-users, enabling them to embrace the designer's commitment, passion and dedication, thereby motivating them to contribute to social change. From Empathy (in the designer) to Empathy (in the end-user), this is the journey I call Good Design.

Good Design lies in a systemic approach. It does not lie solely in designers' ability to masterfully use typography or colours, grid systems and visual principles. It lies in designers' ability to empathize with human beings and with nature, out of which we can find the strength for indefatigable dedication to support good causes. It lies in designers' actions and in their passion, in our beliefs and our attitude to life. […]

In the belief that our Earth relies on a balance in which every living being has a role to play, being a designer brings with it a responsibility and a mission: to enhance understanding, where understanding can contribute to changing habits and policies; to raise awareness, where awareness is essential in order to tackle issues we may not be able to witness with our own eyes; to explore new professional possibilities, where those possibilities can save lives and rescue nature.

Angela

Amref PLAY FOR AFRICA

MESSAGE

FOOTBALL CAN DO A LOT FOR AFRICA. A FOOTBALL MATCH CAN RECONCILE ETHNIC
GROUPS, SAVE YOUNG PEOPLE FROM DRUG USE AND BRING JOY
TO SUFFERING COMMUNITIES.
PLAY AND SPORT ARE EXCEPTIONAL INSTRUMENTS THROUGH WHICH YOUNGER
GENERATIONS MAY MEET, SOCIALIZE AND EVOLVE.

BACKGROUND

The World Cup in South Africa, the first hosted by an African country, is an extraordinary opportunity
to concentrate attention on a continent that is all too often ignored.
[…] The football is a constant feature of the African landscape: from the ghettoes of the large
metropolises to the more remote villages, there is always one around to run after, even if it is
made up of rags. As a sport, it is a common element among African populations and fans all over
the world: it draws the attention and the passions of all and knows no difference in skin-colour,
ethnicity, political or religious conviction. […]

PLAY FOR AFRICA
ANITA LAM
Austin, USA

PLAY FOR AFRICA
CRISTINA LANGELLA
Alatri, Italy

FOOTBALL FOR AFRICA
VALENTINA GIORGI
Monte San Giusto, Italy

PLAY FOR LIFE
LUCA SANNA
London, United Kingdom

POWER IN SIGHT
GIACOMO PENNICCHI
Milan, Italy

UNITED TO PLAY
NATASHIA PRIVETTE TASHIA
Durham, USA

BALL
FABIO DEMITRI
Urbino, Italy

GOAL!
ZIYA LEVENT AYBAY
Istanbul, Turkey

FIFA WORLD CUP
STEFANO CHIES
San Vendemiano, Italy

ONE BALL. ONE HOPE. ONE AFRICA.
OLGA BUKHALOVA
Milan, Italy

 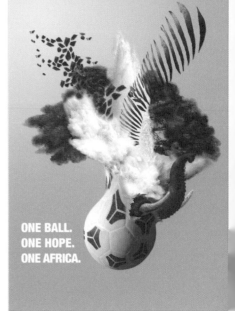

MASKS
GENARO SOLIS
San Antonio, USA

GREEN FIELDS OF HOPE
BRIAN HUEZO
Fullerton, USA

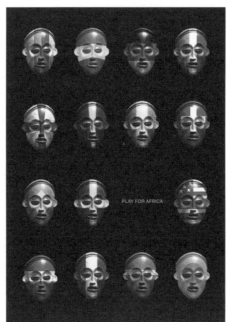 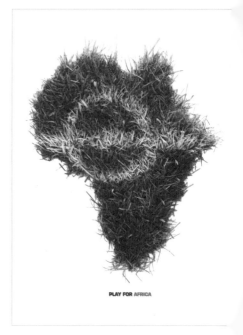

HOPE
DENIZ ÖZTÜRK
Eskişehir, Turkey

AFRICA AT PLAY
BENJAMIN MCVEY
San Marcos, USA

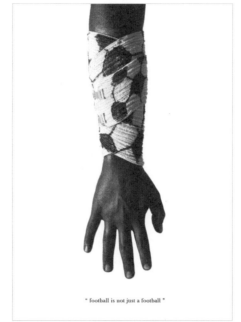

PLAY
TABER CALDERON
New York, USA

PLAY FOR AFRICA
ANNA GIZELLA VARGA
Budapest, Hungary

SHOOT
LUCIANO CROSSA
El Paso, USA

SOUTH AFRICA
GÖKHAN GÜÇLÜ
Eskişehir, Turkey

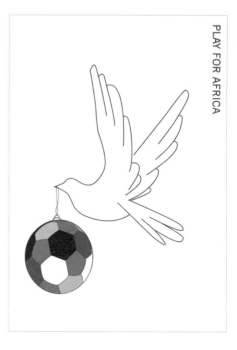

177

PLAY FOR AFRICA
CONOR CLARKE
Dublin, Ireland

PLAY
MURAT YÜKSEL
Istanbul, Turkey

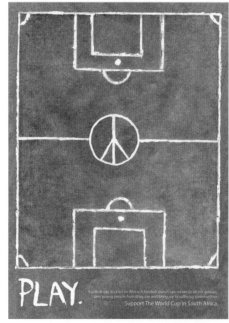

AFRICA IN THE HEART
ERIKA DORIA
Turriaco, Italy

PLAY THE GAME AFRICA
ANNA GIZELLA VARGA
Budapest, Hungary

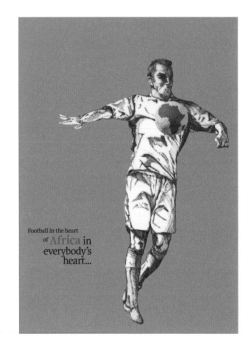

PLAY
MILEN GELISHEV
Sofia, Bulgaria

**THE FLAG & THE SYMBOL
OF FOOTBALL**
MEDEA CARAPETIAN
Tehran, Iran

CURE
MARCO GIRAUDO
Turin, Italy

PUT TOGETHER FOR AFRICA
ALI SEYLAN
Samsun, Turkey

PLAY FOR AFRICA
FABIO CASELLI
Coldrerio, Switzerland

PEACE FOR SOUTH AFRICA
VINCENZO CIANCIULLO
Campobasso, Italy

PLAY
WERONIKA LUIZA KOWALSKA
Wroclaw, Poland

ONE BALL FOR MANY LIVES
HERISSON REDI
Bauru, Brazil

Lila
Italian League
for the Fight against AIDS

FREEDOM TO TRAVEL

MESSAGE

THE BAN ON ENTRY AND PERMANENCE FOR FOREIGN NATIONALS WITH HIV
IS A VIOLATION OF HUMAN RIGHTS.
GOVERNMENTS MUST REVIEW THEIR DISCRIMINATORY LAWS WITH REGARD TO HIV
POSITIVE PEOPLE WHETHER THEY ARE RESIDENTS OR FOREIGNERS.

BACKGROUND

In China, Russia and many other countries, foreigners with HIV cannot enter, travel or reside for
brief or long periods of time. This ban is born out of fear as it has no rational or scientific basis.
It is an act of discrimination that forbids families from reuniting and hinders professional careers and
cultural growth. Often, individuals circumvent this by not claiming HIV status and hiding medication,
in the hope that they will never have to resort to medical care in the hosting country, for the penalty
would be deportation.
[…] All that is gained with these repressive measures is the increase in stigmatization, criminalization
and humiliation of HIV positive people; this situation does not foster security but only increases
damages and risks for all. [able …]

STOP HIV TRAVEL RESTRICTIONS
EDUARD HORN
Warburg, Germany

STOP DISCIMINATION
MATTIA TONO
Cadoneghe, Italy

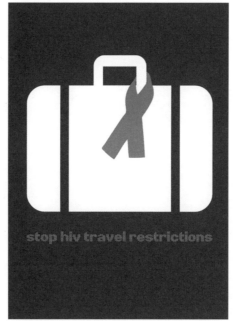

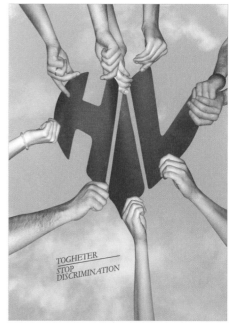

FREEDOM IN THE SKY
ARMANDO PINEDA CRUZ
Mexico City, Mexico

FREEDOM TO TRAVEL. EVERYWHERE.
SAM WARD
San Antonio, USA

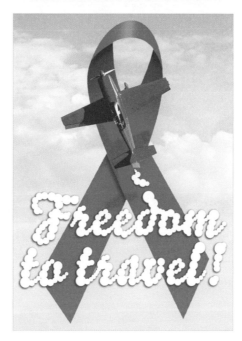

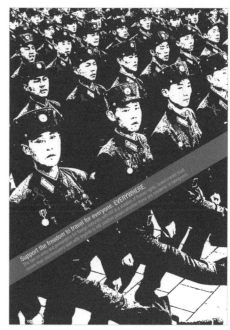

SUPPORT FREEDOM TO TRAVEL
MIGUEL MARTINEZ
Austin, USA

HIV CAN´T FLY!
CAROLA STURN
BENJAMIN BURGER
TYMON DABROWSKI
Zürich, Switzerland

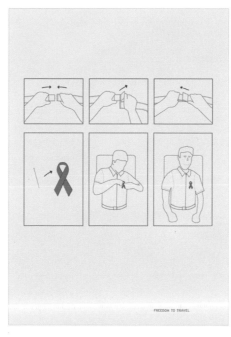

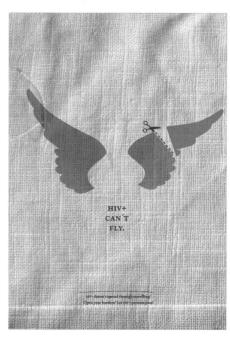

BIRDS
CESAR ALI HERNANDEZ TORRALBA
Puebla, Mexico

TURNING BACK
KAYA BARLAS
ECE EREN
Istanbul, Turkey

NO DISCRIMINATIONS
SOFIA OLIMPIA BERTOLDI
ERICA GONZATO
Padua, Italy

POSITIVE CHANGE
JULIAN CLARK
Twyford, United Kingdom

DO NOT BLOCK THE FREE PASSAGE
YUANHUA WU
Huazhou, China

FREE AS BIRD
SELCUK OZIS
London, United Kingdom

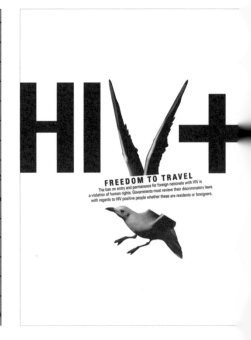

BORDER
SAURABH VYAS
Fords, USA

FREEDOM TO TRAVEL
ANGEL ANASTACIO FERNÁNDEZ ANGEL ANASTACIO
Puebla, Mexico

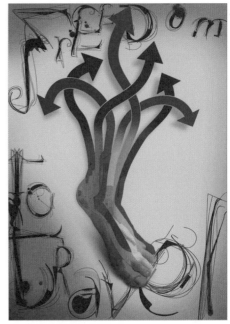

SYMBOLS
URIAH GRAY
Perth, Australia

POSITIVE STATUS. NEGATIVE TO TRAVEL.
ROB MEERMAN
ANDREAS SCHÖFL
DIANE PETERS
Amsterdam, Holland

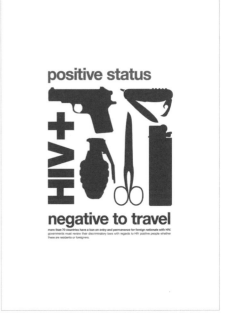

POSITIVE DESTINATION
MOISÉS ROMERO
Guadalajara, Mexico

DEPARTURES
DEBORA BINI
Castelbellino, Italy

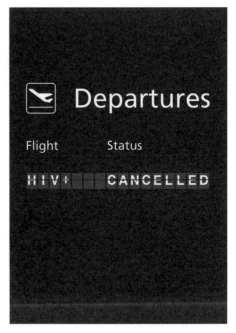

POSITIVE PASSPORT
RINO SORRENTINO
Naples, Italy

LIFT ENTRY BAN
PURSHOTHAM G
Hyderabad, India

THIS IS NOT A BORDER
MARCO ROMANI
Milan, Italy

STOP
GABRIELA SZIRELEM MONCADA FLORES
La Paz, Bolivia

UNTITLED
CHRIS MONROE
Raleigh, USA

TIED HANDS
FABRIZIO PIUMATTO
Cuneo, Italy

LISBOA
DARIA PACCAGNELLA
Sant'Angelo di Piove, Italy

FREE TO MOVE
SIMONE MANCA
Cagliari, Italy

FREEDOM TO TRAVEL
VICTOR MANUEL SANTOS GALLY
Mexico City, Mexico

FLY BEYOND COSTRICTIONS
SARA PELLERINO
Alba, Italy

HIV PASSPORT
KIND MANUELA KATHARINA
St.Gallen, Switzerland

STUPIDITY IS MORE CONTAGIOUS
ELISA BALDISSERA
Turin, Italy

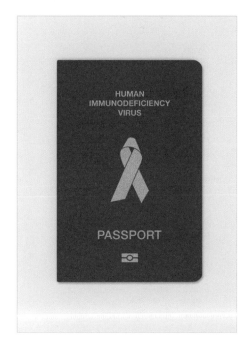

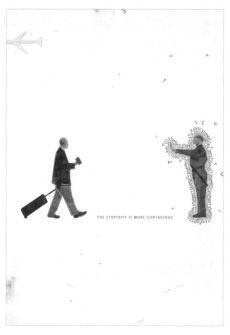

185

MESSAGE

MAFIAS OPERATE THROUGH FAVOURS AND THROUGH LAUNDERING MONEY.
THEY PRACTISE EXTORTION AND ENGAGE IN THE ILLEGAL TRAFFIC OF WEAPONS, DRUGS,
COUNTERFEIT PRODUCTS, TOXIC WASTE AND HUMAN BEINGS.
IT IS NECESSARY TO "BE AGAINST" ALL MAFIAS, BUT IN ORDER TO BEAT THEM IT IS MORE
IMPORTANT TO "BE FOR" THE CREATION OF PHYSICAL SPACES FOR FREEDOM, AWARENESS
AND LEGALITY. IT IS A CALL EACH AND EVERY ONE OF US SHOULD HEED.

BACKGROUND

Organized crime means absence of rights, employment, democracy and co-responsibility. It means
a broken social fibre, corroded by personal interests and by the pursuit of profit and consumption.
It means lack of social justice and legality, equality and dignity.
Libera works in those areas that seek to prevent and counteract mafias, albeit with the awareness
that these repressive measures, though necessary, do not suffice. The only really effective response
to mafia control is the practice of citizenship and participation, which individuals, associations and
social groups of every kind are urged to develop and live by. One of Libera's principal objectives is
"building an alternative community to mafia", where rights rather than favours are granted to each
human being, as opposed to what happens within the mafia system.

BLOCK THE BLACK!
ANDREA PALERMO
Savona, Italy

NEW LIFE FROM A BAD TRADITION
VADYM TKACHUK
Chernivtsi, Ukraine

SHOOT AGAINST SHOOT
DONATELLO CEDDIA
Palagiano, Italy

SILENCE IS THE LOUDEST CRIME
MARIA CHIRCO
MARIA GIOVANNA TITONE
PAOLO TEDESCO
VINCENZO INGRALDO
Marsala, Italy

I SPEAK
DANILO GIRASOLE
GENNARO GIRASOLE
Aversa, Italy

DRAIN OUT OR FIGHT IN!
DARIO ANTONIO ROMANO
Laterza, Italy

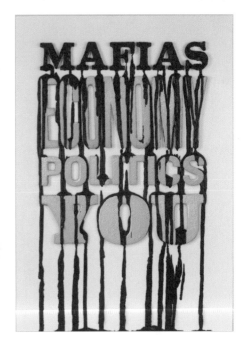

GOD FORGIVES EVERYONE
STEFANO MACCARELLI
MANUELA RONCON
Turin, Italy

NO MERCY
PAOLO WOLF
Cerro al Lambro, Italy

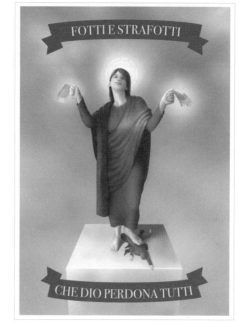

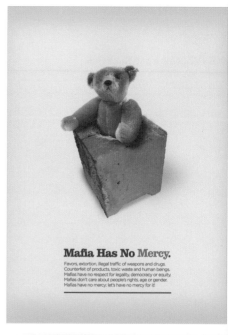

MAI PIÙ (NEVER AGAIN)
GABRIELE FALLETTO
Bruino, Italy

THE ONLY GOOD WEAPON
ROSARIO NOCERA
Grumo Nevano, Italy

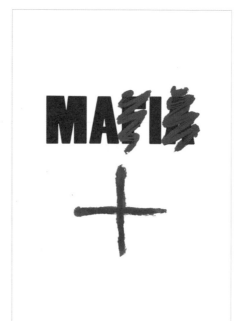

HEAR, SEE, SPEAK
LORENZO FISCHETTI
Milan, Italy

**LEGALITY IS SLEEPING
WITH THE FISHES**
EMRE ÜLÜS
Istanbul, Turkey

BREAK THE CODE OF SILENCE
DAVIDE ALOISIO
Rome, Italy

NO TO MAFIA
MARCIN DUBINIEC
RAFAL NAGIECKI
Komorow, Poland

BUILD UP LEGALITY
FABRIZIO CANTONI
Milan, Italy

BLUNTLY
RINO SORRENTINO
Naples, Italy

HORSES MOURN THEIR VICTIMS. FIGHT MAFIA
ENRICO MASSONE
Camogli, Italy

MAFIA CAUSES TROUBLE
TAHE ABED
Tehran, Iran

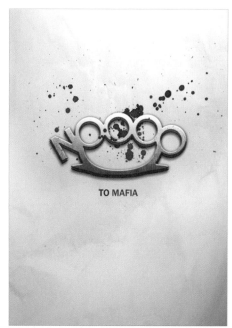

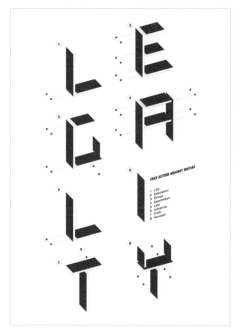

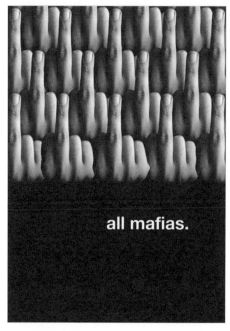

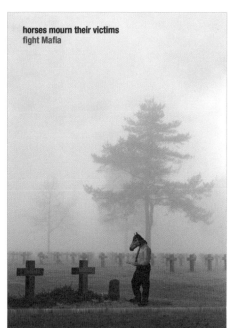

DONE
MIGUEL MARTINEZ
Austin, USA

MAFIA HIDES AMONG US
FRANCESCA LEONESCHI
LAURA DAL MASO
Milan, Italy

LET'S CUT IT OUT
FLAVIO MARRONE
DANILA CATALANO
Milan, Italy

RESPONSABILITY
FEDERICO NAVARRA
MATTEO PIANA
MATTIA RUBINO
Milan, Italy

TEASING THE MAFIA
GONZALO PEREZ OTERO
Montevideo, Uruguay

CHAOS
SELCUK OZIS
London, United Kingdom

MAFIA S.P.A. // HUMAN TRAFFICKIG
FEDERICO NAVARRA
Rimini, Italy

THE FAILURE OF CONTROL
ALESSANDRO ALBANESE
Palermo, Italy

LITTLE DIFFERENCE
MARGHERITA MAGNETTI
DANIELA BRUNO
ELENA CENTARO
Turin, Italy

THE PROMISE (TAKE ACTION AGAINST MAFIAS)
TIEN LE
Durham, USA

WITH A LOUD VOICE WE KEEP AWAY MAFIA
MATTIA RUBINO
FEDERICO NAVARRA
MATTEO PIANA
Milan, Italy

MAFIA: CUT IT OUT
ROBERTO NECCO
ROBERTO BALOCCO
Turin, Italy

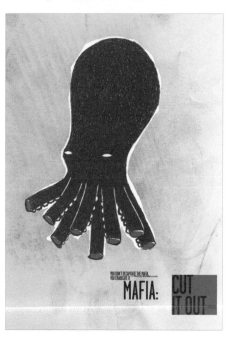

Greenpeace

WHALE SHORTAGE:
A SANCTUARY EMPTIES
BY THE DAY

MESSAGE

[…] THE FIN WHALE, THE WORLD'S SECOND LARGEST ANIMAL, LIVES
IN THE MEDITERRANEAN SEA. TODAY THERE IS A PROGRESSIVE DECREASE
IN POPULATION OF THESE CETACEANS.
IN ORDER TO PROTECT THE SEA AND ITS ECOSYSTEM, THERE IS NO ALTERNATIVE
BUT TO BUILD A NETWORK OF MARINE RESERVES AND OF LARGE AREAS
TO BE PRESERVED RIGOROUSLY.

BACKGROUND

The Sanctuary of Cetaceans, which was born in 2002 as an agreement between Italy, France and Monaco, protects 87,000 square kilometres of the Mar Ligure in the Mediterranean Sea.
[…] The scandalous data gathered by Greenpeace on the Sanctuary of the Cetaceans reveals a dramatic situation: striped dolphins have decreased by 50%, and the fin whales have been reduced by a quarter in ten years. This area of sea is now an open-air sewer without rules or regulations.
[…] Unregulated traffic (ferries travel at 70 km/h), pollution by faecal bacteria and dangerous whale-watching activity conducted by aeroplane or motorboat are some of the causes for the vertical decline of cetaceans.
Greenpeace demands that the Sanctuary of the Cetaceans of the Mediterranean be regimented immediately by appropriate tutelage and that a marine reserve be created within it – with bans on fishing and emission of toxic or hazardous waste – so as to protect a unique ecosystem of which the cetaceans are an integral part.

I WANT YOU!
IGOR PLAC
Osijek, Croatia

FIN
GENARO SOLIS
San Antonio, USA

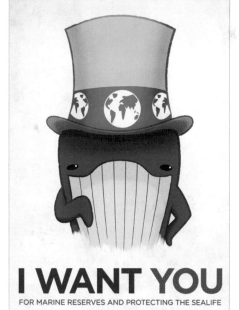

ONCE UPON A TIME...
GIORGIA BIMBATTI
Milan, Italy

DO YOU WANT TO EAT FISH TOMORROW?
ROCIO ALBA HIERREZUELO
London, United Kingdom

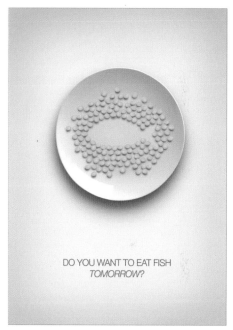

PROTECT THE WHALES
ELENA MEDVEDEVA
EVGENIYA RIGHINI-BRAND
DOMINIC RIGHINI-BRAND
Moscow, Russian Federation

WHALE RESCUE
XIAOJUN WANG
Nanjing, China

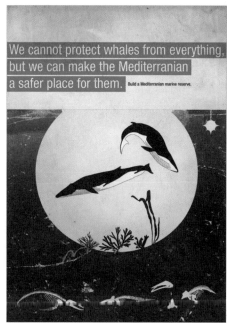

193

**THEY WERE PROMISED
A SANCTUARY, THEY GOT A GRAVE**
STEPHEN KAVANAGH
Dublin, Ireland

TURN HOPES INTO REALITY
ALI SEYLAN
Samsun, Turkey

WHERE ARE THE WHALES?
GABRIELE BARROCU
PAOLA DEALEXANDRIS
Strevi, Italy

WHALE PROGRESSIVE DECREASE.
TOMASO PERINO
Giugliano in Campania, Italy

DO SOMETHING BEFORE EXTINCTION
ALI SEYLAN
Samsun, Turkey

A SANCTUARY WITHOUT SAINTS.
SIMONE PAOLI
Finale Ligure, Italy

 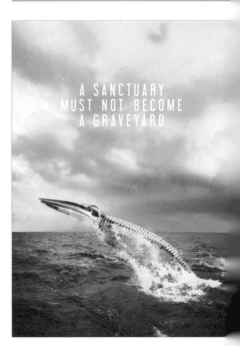

EXTINCTION
SUNG JAE KIM
Yeongju-si, South Korea

BEGINNING AND END
SIMON TUMLER
Schlanders, Italy

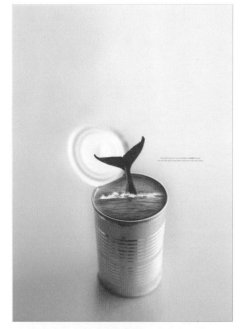
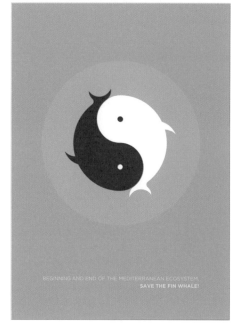

LIVE WITH WHALE
CURTIS WONG
Kowloon Bay, Hong Kong

DON'T FOLD IT
ALI SEYLAN
Samsun, Turkey

WHALE SANCTUARY
MATTEO BENCINI
Florence, Italy

SANCTUARY
GABRIEL MARTINEZ
SONIA DIAZ
Madrid, Spain

FIN-ISHED WHALE
BARIS BASARAN
Ankara, Turkey

MEDITERRANEAN SEA
FRANCESCA BALDUCCI
Rome, Italy

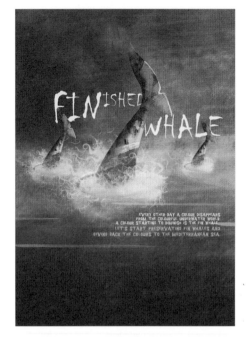

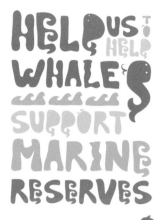

**THE SANCTUARY
OF THE CETACEANS – 2**
SIMONE MANCA
Cagliari, Italy

"ONCE UPON A TIME THERE WAS A PIECE OF WOOD"
ELISABETTA POZZO
Oviglio, Italy

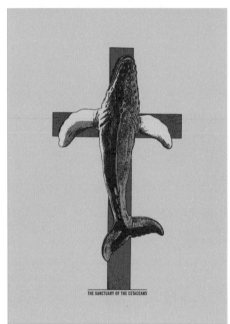

LOOK THE WHALE
CATERINA DEAMBROGIO
Lamporo, Italy

WE BEG YOU TO STOP
FABRIZIO FRASCA
Nova Milanese, Italy

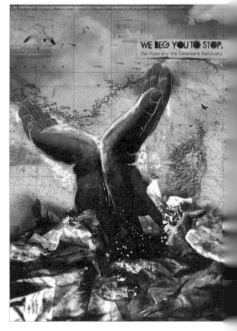

PROTECT WHALES AS YOU PROTECT YOUR EYES
YIYUN ZHANG
Hangzhou, China

SANCTUARY?
STEVE RAND
Reading, USA

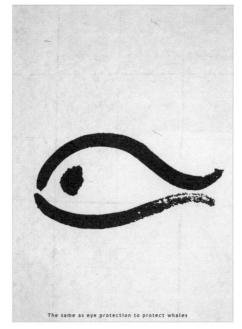

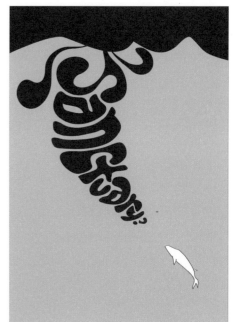

EMPTY SANCTUARY
CAROLINA MONTES RIBEIRO
São Paulo, Brazil

REPLICATE
RINO SORRENTINO
Naples, Italy

**THE SANCTUARY
OF THE CETACEANS**
SIMONE MANCA
Cagliari, Italy

SINKING POPULATION
LAUREN HANSON
Ellicott City, USA

197

THE UNCERTAINTY OF THE CURE

MESSAGE

THE RIGHT OF MIGRANTS TO HEALTH CARE, INDEPENDENT OF THEIR LEGAL STATUS, IS AN ISSUE THAT CONCERNS THE HUMAN RIGHTS OF EACH INDIVIDUAL. IN ORDER TO PREVENT THE INEQUALITY THAT MIGRANTS FACE WHEN IT COMES TO ACCESSING APPROPRIATE CARE, EMERGENCY HAS OPENED AN OUTPATIENT CLINIC IN ITALY TO GUARANTEE FREE HEALTH ASSISTANCE TO MIGRANTS (WITH OR WITHOUT PERMITS) AND TO RESIDENTS IN NEED.

BACKGROUND

[…] The barrier which separates migrants without papers from health care is [a] violation and endangers the universal principle of a right to a cure.
It is from this awareness, and from the will to grant people access to these rights, that EMERGENCY's intervention in the arena of "immigration" springs.
Migrants with health issues have a right to proper care, even if they lack papers.
[…] EMERGENCY demands that the Italian law guarantee and maintain the principle of not signalling migrants who seek medical attention and are without papers to the authorities, in order to raise the barrier that hinders access to a cure by people at risk of dangerous sanitary marginalization.

MIGRANT CARE
SILVIA GALIMBERTI
Fara Gera d'Adda, Italy

X-RAY
GABRIEL MANUSSAKIS MELLO
Mogi das Cruzes, Brazil

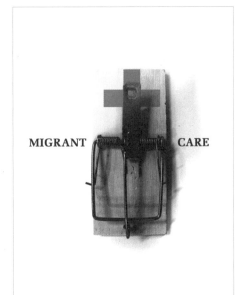

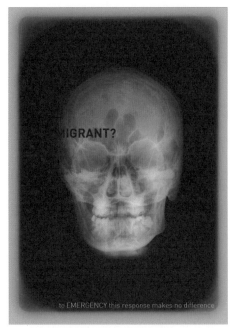

NO "BUT", ONLY "AND"….
MARIA SHIRSHOVA
Tbilisi, Georgia

MIGRANTS FUTURE
ERIKA BONEZZI
Cavriago, Italy

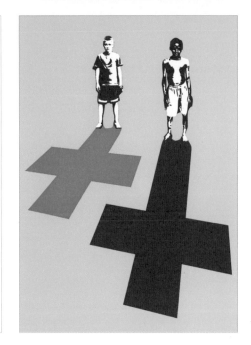

LADY (NURSE) JUSTICE
HANDOKO TJUNG
Jakarta, Indonesia

BORDER FOR HEALTH
ISMAIL ANIL GUZELIS
Eskişehir, Turkey

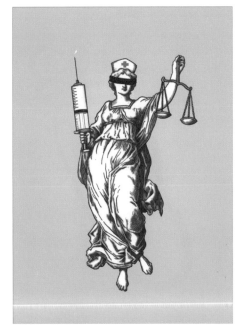

MAKE IT EQUAL
HANDOKO TJUNG
Jakarta, Indonesia

APPROVED
SELCUK OZIS
London, United Kingdom

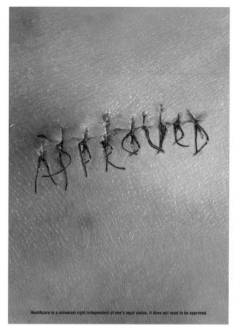

HEALTH CARE FOR MIGRANTS
ANITA WASIK
Gdańsk, Poland

BASIC HEALTHCARE IS A HUMAN RIGHT
GUILLAUME DRISCOLL
Berkley, USA

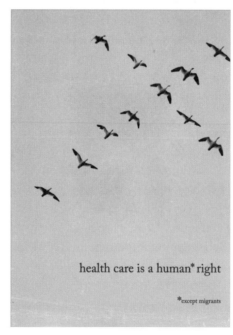

HEALTH CARE FOR ALL IMMIGRANTS!
VICTOR MANUEL SANTOS GALLY
Mexico City, Mexico

WE DO MORE THAN THAT
KATARZYNA JACKOWSKA
Zürich, Switzerland

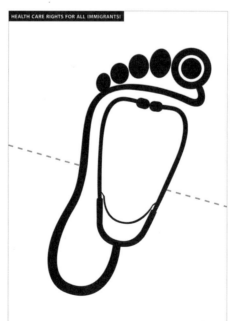

WITHOUT CURES I STAY INVISIBLE
CLAUDIO CHIANGONE
Vinovo, Italy

DENAID
ALBIAN GAGICA
Pristina, Albania

ILLEGAL IS NOT LETHAL
KATARZYNA JACKOWSKA
Zürich, Switzerland

IMMIGRANT HEALTHCARE
FABIO CARRETTI
Reggio Emilia, Italy

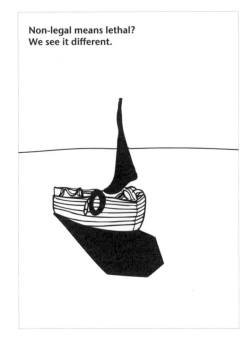

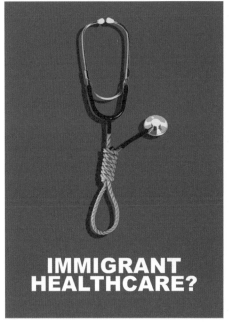

IRRESPECTIVE OF RACE, NATIONALITY, RELIGION.
VINCENZO VALERIO FAGNANI
Fano, Italy

HOSTEL
RINO SORRENTINO
Naples, Italy

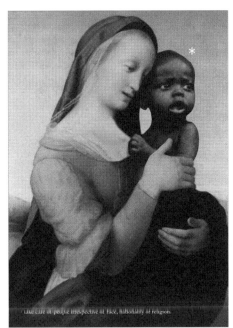

HEALTH AND JUSTICE
CARLOS FERNANDO
LARROTA ARDILA
Mérida, Venezuela

MIGRATION: SHARE DREAM
OSVALDO GAONA
Puebla, Mexico

HEALTH?
DAVIDE DAL COLLE
Treviso, Italy

MIGRANTS HEALTHCARE
TOMMASO GENTILE
Mestre, Italy

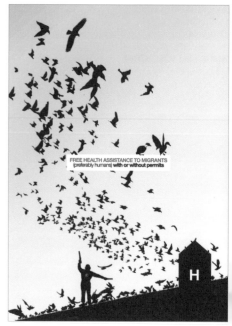

IMMIGRANT
DENIZ KARAGÜL
Ankara, Turkey

GRANT HEALTHCARE
COURTNEY SAMPSON
Los Angeles, USA

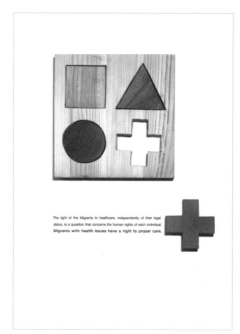

HOWEVER, WE CARE.
LUCA SANFELICI
Rivarolo Mantovano, Italy

CARE FOR EVERYBODY
BARBARA MENIETTI
Moncalieri, Italy

ACCESS
ERIN BURNS
Florida, USA

OPERATION
LINDA TASIN
Trento, Italy

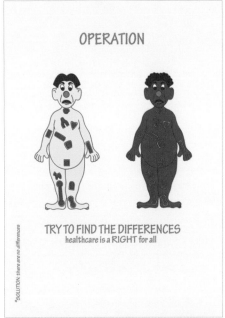

STRUGGLE WITH NO END
MIGUEL MARTINEZ
Austin, USA

TO HEAR
KAYA BARLAS
ECE EREN
Istanbul, Turkey

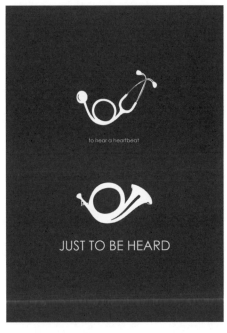

203

Amnesty International

FOR A PATH OUT OF POVERTY, TAKE THE HUMAN RIGHTS ROUTE

MESSAGE

ALL OVER THE WORLD, PEOPLE IN POVERTY ARE DEMANDING DIGNITY.
THEY WANT AN END TO THE INJUSTICE AND EXCLUSION THAT KEEP THEM TRAPPED.
IN DEPRIVATION, THEY WANT TO HAVE CONTROL OVER THE DECISIONS THAT AFFECT
THEIR LIVES. THEY WANT THEIR RIGHTS TO BE RESPECTED AND THEIR VOICES TO COUNT.

BACKGROUND

The global economic crisis is driving millions of people into poverty and placing them at increased risk of human rights violations such as food insecurity or forced eviction.
The world urgently needs a different kind of response and a different kind of leadership if we are to reverse this dramatic escalation of human misery.
Amnesty International's Demand Dignity campaign aims to end global poverty by working to strengthen recognition and protection of the rights of the poor.
This is a campaign about all rights. It is the combined abuse of civil, cultural, economic, political and social rights that drives and deepens poverty.
[...] Participation and involvement in the decisions that impact our lives are essential to human rights. By including all rights holders in policymaking, governments are at once creating a framework for accountability, transparency, inclusion and empowerment. These are the prerequisites to end poverty.

POVERTY IS EVERYWHERE
TANIA DALLAIRE
ELENA VILTOVSKAIA
Montreal, Canada

FACEPOOR
MARIADELE DEL GIUDICE
San Polo d'Enza, Italy

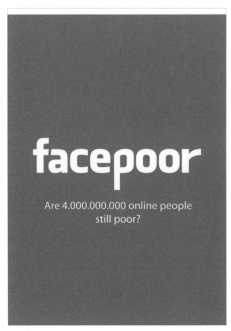

**TO BE LISTENED JUST
A MINUTE**
DANIELE GASPARI
Monzambano, Italy

METAMORPHOSIS
PETER ST JAMES
Vancouver, Canada

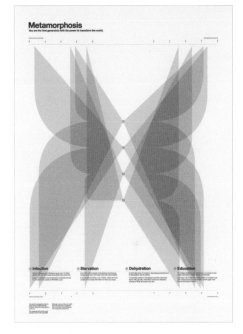

POVERTY IS OVER
META NEWHOUSE
Bozeman, USA

LET THEM BE HEARD
ANITA LAM
Austin, USA

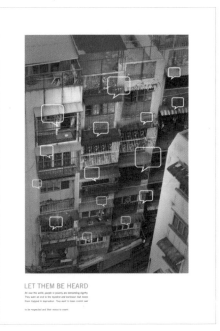

HELP!
MAURICIO RAMÍREZ GARCÍA
Huejotzingo, Mexico

SNATCH FOOD
QI CHEN
Hangzhou, China

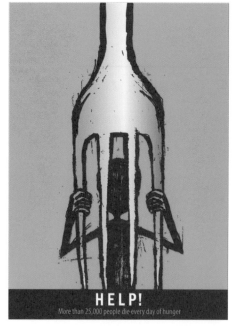

POVERTY TRAPPED
MARY ANNE PENNINGTON
Humble, USA

POVERTY
ANGEL ANASTACIO FERNÁNDEZ
Puebla, Mexico

STOP POVERTY
JAKUB HAREMZA
Mosina, Poland

ABUSE OF DOMESTIC WORKERS IS ENSLAVEMENT
MARIANNE SCHOUCAIR
Lexington, USA

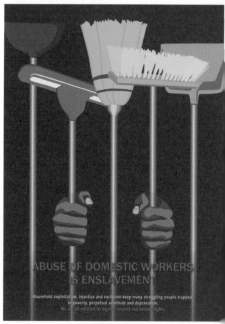

206

A WOMAN'S LIFE
MEHDI RAHIMI
Tehran, Iran

I WANT MY RIGHTS
DAVIDE ZENNARO
Martellago, Italy

LIGHTER THAN PAPER
YE ZI LEE
Suwon, South Korea

BUSY BEE
SELCUK OZIS
London, United Kingdom

 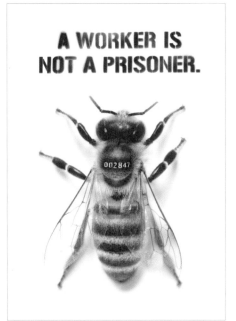

HUNGER
LUKASZ JANKOWSKI
Chelm, Poland

EQUALITY?
ARTURO BOTELLO
Puebla, Mexico

 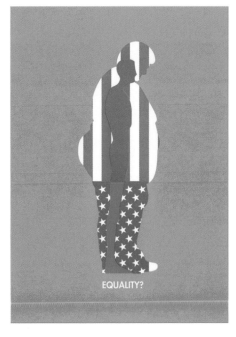

**PAY THE PRICE TO HAVE
YOUR VOICE**
ISMAIL ANIL GUZELIS
Eskişehir, Turkey

DAILY DEFICIENCY
MAURICIO RAMÍREZ GARCÍA
Huejotzingo, Mexico

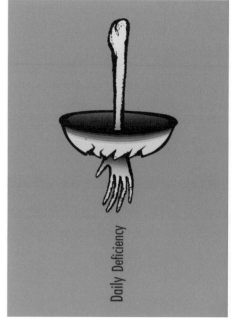

**NOT MORE VIOLENCE
AGAINST WOMEN**
CARLOS ANDRADE
Coro, Venezuela

**PROPORTION
VS. DISPROPORTION**
MICHAL TADEUSZ GOLANSKI
Rome, Italy

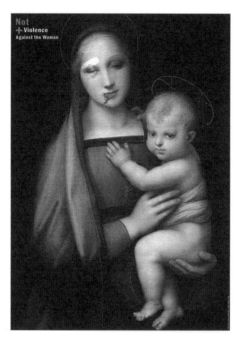
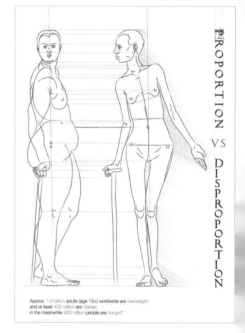

FOOD OR WAR
DARYOUSH TAHMASEBI
Luleå, Sweden

INTERNATIONAL COOPERATION
MOISÉS ROMERO
Guadalajara, Mexico

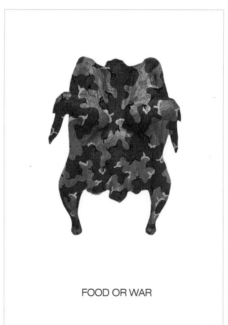

POVERTY!
VAHE ABED
Tehran, Iran

HER PUBLIC BATH
MYISH ENDONILA
Makati City, Philippines

STOP HUNGER
CESAR ALI HERNANDEZ TORRALBA
Puebla, Mexico

SHOUT
MARCELO SILVEIRA LEITE RIBEIRO
Curitiba, Mexico

 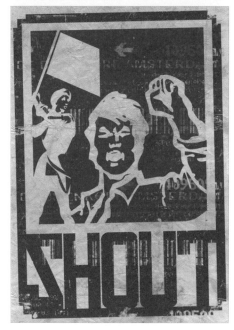

WILL WORK FOR DIGNITY
JEE-EUN LEE
Astoria, USA

I DEMAND DIGNITY
BARBARA DOUX
HITOMI KAI YODA
DENNY BAROLESCU
London, United Kingdom

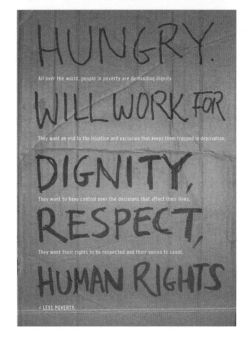

THE YEAR OF THE TIGER

MESSAGE

2010 IS THE YEAR OF THE TIGER IN THE CHINESE CALENDAR - WHAT BETTER ...
OPPORTUNITY TO DRAW ATTENTION TO THE DECLINE OF WILD TIGER POPULATIONS.
GIVEN THE CHANCE – ENOUGH SPACE, PREY AND PROTECTION – TIGERS,
ONE OF THE GREATEST ICONS OF CONSERVATION, CAN RECOVER.

BACKGROUND

Tigers are one of the greatest icons of conservation and have been the focus for much of WWF's work for over 40 years.
There is an urgent need for a renewed, focused, collaborative effort to halt their decline and begin the process of restoring their numbers in the wild. 2010, the Year of the Tiger in the Chinese lunar calendar, is an unprecedented opportunity to bring tigers back from the brink.
We have to act now or we risk facing the extinction of tigers in the wild by the next Year of the Tiger in 2022. Wild tigers are an evocative symbol of nature, a valuable and irreplaceable asset for people (employment, preservation of food sources, and cultural heritage) and a powerful guardian of nature: protecting tigers in the wild means protecting some of the most spectacular places on Earth, including critically important forests and watersheds, and therefore many other species. [. . .]

TIGERS NEED BIGGER FORESTS
DONGJUN KANG
Seoul, South Korea

DISAPPEARING TIGER
JACEK TOFIL
Warsaw, Poland

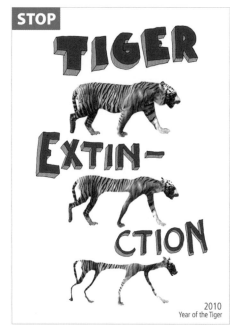

LIFE OF THE TIGER
SHANE ALLBRITTON
Houston, USA

YEAR OF EXTINCTION
DOMINIC RIGHINI-BRAND
EVGENIYA RIGHINI-BRAND
ELENA MEDVEDEVA
Moscow, Russian Federation

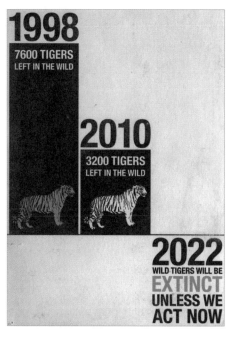

SAVE THE TIGER'S FOREST
TOMOKO MIYAGAWA
Gifu, Japan

SAVE THE TIGER
ADRIENN KOVACS
Györ, Hungary

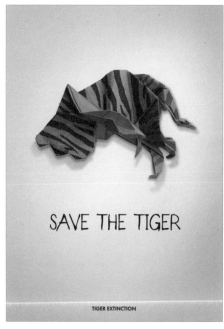

FUTURE LINES
Zhaoming Chua
Singapore, Republic of Singapore

EDUCATIONAL CHART
Jan Sabach
Brooklyn, USA

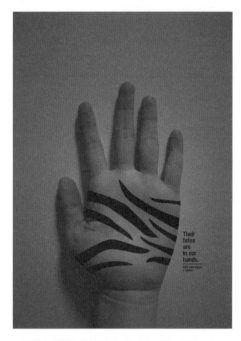

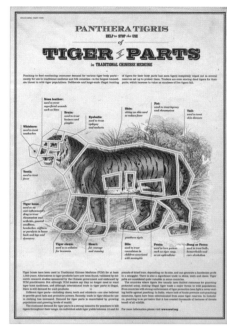

SAVE THE TIGERS
MASSIMO DEZZANI
Candiolo, Italy

TIGERS WERE BIG CATS WITH STRIPES
KATARZYNA JACKOWSKA
Zürich, Switzerland

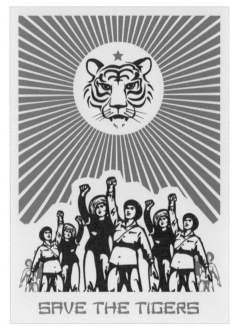

HAPPY NEW YEAR MEANING THE DEATH OF TIGER
TIEN VO
Ho Chi Minh City, Vietnam

CONNECTING THE DOTS
KOK CHEOW YEOH
Singapore, Republic of Singapore

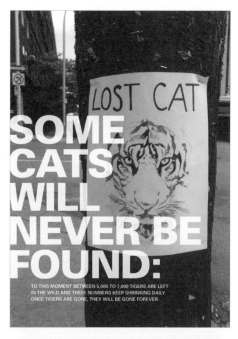

THE DEATH OF THE TIGER
ARNAUD ROUSSEL
Vincennes, France

TIGER GLOBAL WARMING
MAGALY PLATA RAMOS
ABEL DAVID ORTIZ MENDEZ
Puebla, Mexico

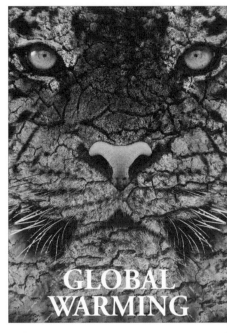

YEAR OF THE TIGER
JARRIK MULLER
Amsterdam, Netherlands

BUNNY LOVER
PEDRO SARMIENTO
LUIS PUERTA
Miami, USA

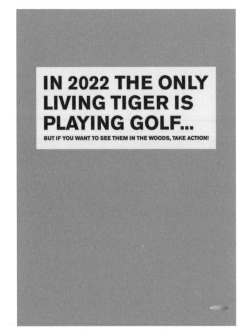

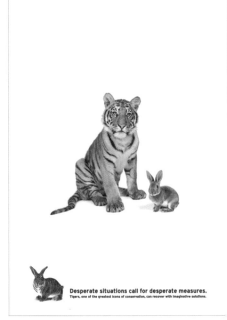

THE NEXT YEAR OF THE TIGER
BARBARA LONGIARDI
PATRICIA DE CROCE
ALESSANDRO NIGRO
Forlì, Italy

END TIGER TRADE NOW
GABRIEL RIVERA
Mexico City, Mexico

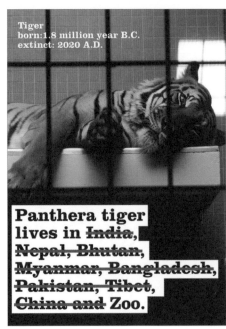

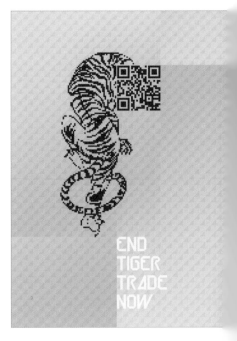

**2010 CHINESE YEAR
OF THE TIGER!**
ONUR ASKIN
Istanbul, Turkey

CRIME SCENE
RODRIGO ZENTENO
La Paz, Bolivia

DON'T WEAR TAKE CARE.
PEDRO MENDES
Marco de Canaveses, Portugal

EXTINCTION
GENEVIÈVE RAICHE-SAVOIE
Vancouver, Canada

WWF TIGER
COURTNEY SAMPSON
Los Angeles, USA

ALL TIGERS OF THE WORLD
CHRISTOPH SCHMID
Berlin, Germany

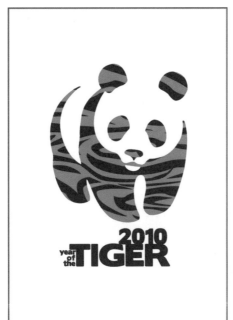

2011

5TH EDITION

PADDY
HARRINGTON

Toronto, Canada

This year's crop of posters shows the breadth of the challenge because the task becomes even more so when we're asked to deliver a message with a strong social purpose. We have to be clear in our expression of the message while, at the same time, somehow telling our story in a way that stops people in their tracks. That makes them wonder. That shocks them into awareness of something they may not have otherwise considered.

We can create a wonderful illustration. We can offer a minimalist take. We can play with iconography. But without "the idea", we are destined to remain caged behind the bars of graphic design.

So how do we get "the idea"? There are many ways, and no "way". It's the curse and magic of design. We sketch and sketch and sketch. We spend late nights talking in whispers with a friend. We stare at the moon. We pick up a book that we've ignored for months. We go to a museum. We sketch some more. And, if we're lucky, we're hit with it. It's OK that it doesn't always happen, but it usually comes with sustained effort and sporadic daydreaming. The amazing thing is that once we are hit with "the idea" (and there's no other way to describe it than "hit"), we are energized. The work then flows. The decisions are easy.

And if we take a minute to consider what we've just done, we realize that, despite it seeming painful at the time, all the worry leading up to the breakthrough was worth it. We've had an experience that has improved our life. And if our work is the outcome of that kind of process, the chances are good that we will have also changed the world.

Paddy

YOSSI
LEMEL

Tel Aviv, Israel

This is my fifth time as a jury member for *Good50x70*. Beside the honour of being a part of such a laudable initiative, I have gained a lot of satisfaction from being involved in an inspiring project like this.

Every time I am taken by surprise by the endless variety of new designs on the same subject. Every time I think everything has already been done, said, drawn, and every time I find myself in front of new concepts that possess the quality to pass over higher and higher boundaries; and in this age of fast technological change, when we are exposed to so many ideas, visuals, texts, it is not at all easy to find an original solution to corny or trivial subjects such as "saving the panda", or an exceptional solution to themes like "peace".

Last year was a very special year globally, in terms of uprisings in countries, nations and societies. The movements that were created through the social networks are the first of their kind, defining a new era. I guess the beginning was in 2009, in Tehran. The whole world followed Twitter and, later, Facebook... The rest is history. The role of the poster has become more tangible and, for the first time in decades, we have a chance to take part in leading change through visual concepts, so the cliché that "a poster can change the world" is becoming more and more within reach. Take the protest in Wall Street as an example: the poster of today has recaptured its glory, the spirit of the revolutions of the 60s, and is once again proud to be the king of the streets; at the same time it has the potential to be powerful as a concept in every media, from the largest scale to the smallest.

Yossi

SVETLANA
FALDINA

Saint Petersburg, Russia

Good50×70 is one of the few projects that focuses on the social poster – a complex and significant form of art. The entries for the 5th edition are diverse and interesting. They speak about problems, ecology, relations and the whole world. They make people worry about these themes. In my opinion, the best poster is an image reduced down to a sign, a symbol in which the idea is concentrated and its message clear to a viewer without explanation. That is the power of the poster. There are many such works in this year's edition, and *Good50x70* is a great opportunity to see how many people are not indifferent! I admire the enthusiasm of the *Good50x70* organizers and wish them success in the future editions.

Svetlana

DAVID
BERMAN

Ottawa, Canada

What becomes possible when two million designers spend some of their unlimited creativity each week on efforts that will help design a better world together? We don't know yet.

However, if the quality of design and passion seen in this year's *Good50x70* is any indication of what 600 designers can do, then I have no doubt that there isn't a problem on Earth that we can't tackle with the power of design thinking.
The future of civilization is indeed our common design project, and as long as we keep our priorities straight and our beliefs alive, then there's never been more hope for what humanity can achieve.

Some days I'm discouraged by all the challenges that surround us. Today is not one of those days: having just finished judging 600 posters packed with caring creativity, I feel blessed to be a part of the *Good50x70* project. I am shaking with excitement, awash with hope. A few of the pieces were so strong, I'd love to have them enlarged and put up in my studio. Congratulations again to everyone who participated.

I'm the first to admit that in some ways things have never been so fragile. But at the same time there has never been more that is possible. It's a great time to be alive. Here's looking to the day that all of Earth's inhabitants share that feeling. Don't just do good design, do good!

David

MASSIMO
VIGNELLI

New York, USA

The good news is that, since the first edition, the design of the posters in the *Good50x70* competition has markedly improved, in terms of both form and concept. There's been a shift from pictorial representations to absolute simplicity, although this transition does not always have positive values, so one needs to be careful. We love complexity and cannot stand complication. In the iconographic simplification of many posters, the simplification in itself often risks leading to greater unoriginality rather than greater clarity. In any case, that risk is worth taking, if compared with the alternatives.

But even in this sense I've seen a huge improvement in the most recent edition. And that, I feel, is precisely the value of this competition: the fact that the entries improve as a result of a collective refinement of visual language and of ways of expressing content. Nothing is more damaging than a lack of comparison, cultural isolation, lack of stimuli and the impossibility of discussing different ideas. *Good50x70* performs a cultural task with a wide-ranging significance, not just due to the importance of the themes which are developed, but as a platform for debate on the very form of the poster and its relevance or otherwise as a communication tool.

For that, we have the competition's organizers to thank: for the extent of their commitment, for their contribution to banishing provincialism, and for the disinterested hard work behind this project. My wholehearted respect goes out to them and to all of the entrants.

Massimo

CAO
FANG

Nanjing, China

I am honoured to be, once again, a judge for *Good50x70*.
These are my thoughts:

1. Today, even in the context of such fanatical pursuit of digital media, people are still using photography, graffito, handcraft, texture rendering etc. – the intrinsic charm of the performance of the print media – to bring fresh blood to posters in this "new media" era.

2. The increasing quantity of work by Chinese students shows their concern about international themes, and demonstrates that *Good50x70* has had a broad impact in the world.

3. The size limitation of the poster demands concise and refined graphics which are simple but profound. The simple yet meaningful expression, distinctive graphics and fonts and the vivid colours cause me to enjoy the artistic visual communication of poster design I see during the judging process!

Cao

THERE ARE NO RESTRICTIONS ABOUT THE TOPIC, BUT NATURALLY A SOCIAL FOCUS IS MANDATORY.

BACKGROUND

Good50x70 is an annual social poster competition. For four years we have presented briefs proposed by the most important charities in the world. This year there are no restrictions on the topic, but naturally a social focus is mandatory.

Non-profit organizations are often disadvantaged in publishing an effective campaign to support their causes and raise awareness about what they fight and work for. There are also many issues that are not represented by an accredited charity or a non-governmental organization.
We believe that a poster is the appropriate medium for giving a visual for a cause, a key concept for starting a campaign and for reducing the distance between charities and creativity.

In order to raise awareness about as many different social issues as possible and to offer every charity a potential poster for a campaign or an event, free of charge, *Good50x70* is reaching out to everyone. Designers, art directors, illustrators, students, professionals or any interested individuals are invited to create a *50X70* poster (or more than one).

What we ask for is engaging visuals and a message that is as simple and clear as possible, aiming for the widest target. The competition provides the participants with the chance to share their interest about social issues that affect the world or a particular community. It also creates an opportunity to discuss and investigate new briefs and to learn about the society and the environment.

POSITIVE THINKING
MANUEL PONCE CONTRERAS
Ribera del Fresno, Spain

IN $ WE TRUSTED
DAVIDE MISERENDINO
Palermo, Italy

AFRICA
HEE-KU KIM
Incheon, South Korea

PAECE NOT WAR
ALI MASUMBEYGI
Mashhad, Iran

3% TIGER
LEANNE BELCHER
Spring, USA

CANNIBAL ECONOMY
VICTOR MANUEL SANTOS GALLY
Mexico D F, Mexico

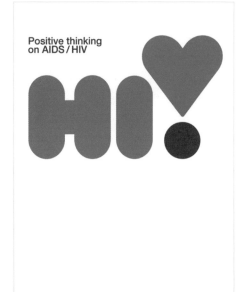

SOLIDARITY
FABRIZIO (TEAM: GRADOSEI)
MISTRETTA GISONE
CHIARA PELLICANO
DANIELE BARBIERO
EDOARDO GIAMMARIOLI
Roma, Italy

**DIFFERENCES MAKE
THE WORLD BEAUTIFUL**
CHIARA SCAVINO
Genova, Italy

AFRICAN WOMAN\'S RIGHTS
GLORIA TESEI
Roma, Italy

KEY TO THE FUTURE
ANITA LAM
Austin, USA

STOP VIOLENCE
SASHA VIDAKOVIC
London, United Kingdom

RADIATION IS INVISIBLE
TOSHIFUMI KAWAGUCHI
Tokyo, Japan

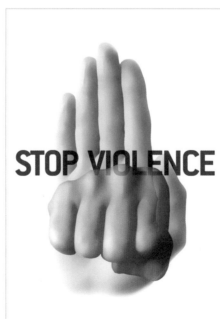

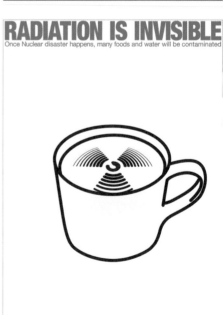

EDUCATION FOR ALL
MARIANO CERRELLA
Caba, Argentina

IS DIET HEALTHY?
DESIREE KANDOU
Jakarta, Indonesia

SAVE AFRICA SAVE WATER
XIE JIAN XIE
SUN CHENG SUN
Nan jing, China

WAR IS NOT FOR MEN BUT CLOWNS.
LUKASZ JANKOWSKI
Chelm, Poland

FOOD IN EUROPE & AFRICA
TOURAJ SABERIVAND
Tehran, Iran

NEW BEGINNIG TO LYBIA
BENONI CERATTI ZORZI
Porto Alegre, Brazil

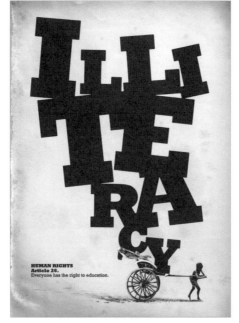

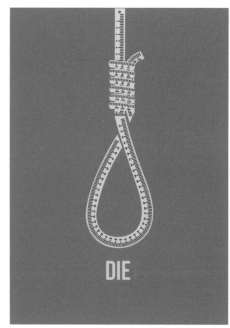

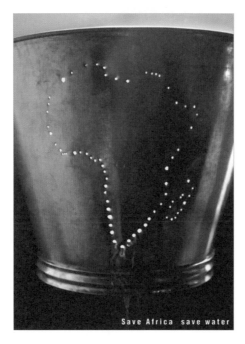

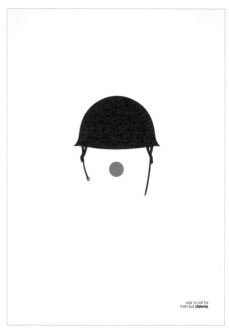

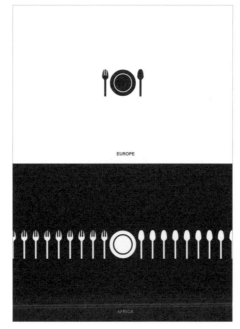

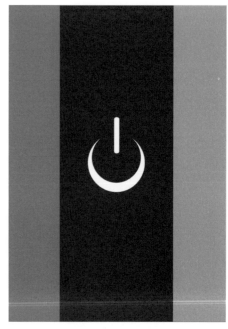

PASTA
LEI YUE LEI YUE
Tai zhou, China

THERE IS NO RIGHT WAY TO MAKE WAR!
MICHELE MANENTI
Arco, Italy

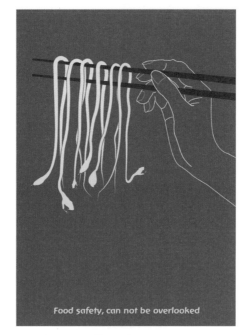

EDUCATION
ANITA WASIK
Gdansk, Poland

SILENCE HIDES VIOLENCE
LEANNE BELCHER
Spring, USA

THREE WERE KILLED ONLY FOR ONE COAT
FAN CAO
Nanjing City, China

WOMAN AGAINST WAR
ANITA WASIK
Gdansk, Poland

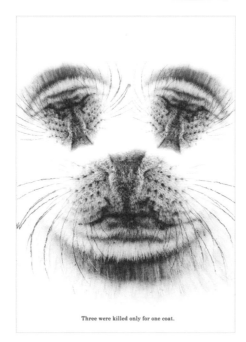

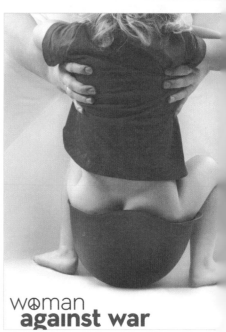

STOP GLOBAL WARMING
ASHRAF REFAAT
Cairo, Egypt

THE NATURAL MOTIF
MOHAMMADQASIM HUSSAINI
Qom, Afghanistan

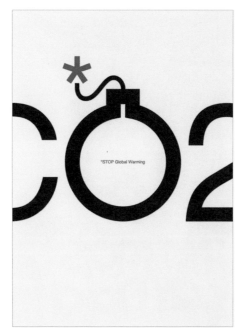

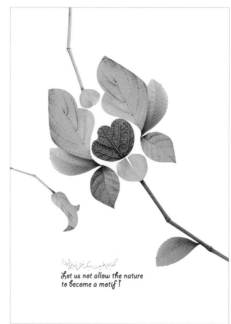

CUT EDUCATION
XIOMARA CRESPO
Guayaquil, Ecuador

INTERCONNECTED WORLD
ALI SEYLAN
Samsun, Turkey

SAVE WATER
SZYMON SZYMANKIEWICZ
Poznan, Poland

DON'T LET THEM COLORLESS
ESTEFANY GARIBAY GARITOS
Queretaro, Mexico

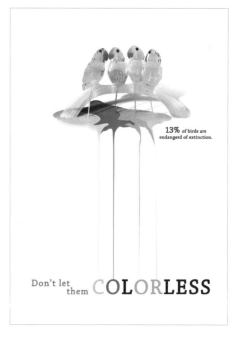

225

STOP BULLFIGHTING!
ANITA WASIK
Gdansk, Poland

PLEASE...GIVE ME A HELP
JAVIER PEREZ
Guayaquil, Ecuador

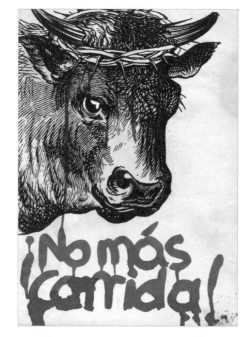

R.I.P. TREES
GÁBOR OLÁH
Budapest, Hungary

G(R)IFT
TAUDIN LAURENT
Paris, France

FREE CHILDREN FROM SLAVERY
ADOLFO BOTTA
SARA POLI
Venezia, Italy

EFFECTS OF DOMESTIC VIOLENCE IN ITALY
ADOLFO BOTTA
SARA POLI
Venezia, Italy

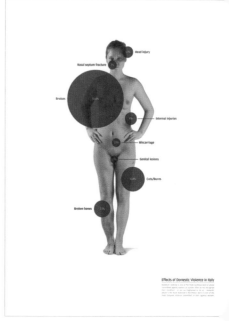

226

COEXISTENCE
ELMER SOSA
Puebla, Mexico

POVERT
ANITA WASIK
Gdansk, Poland

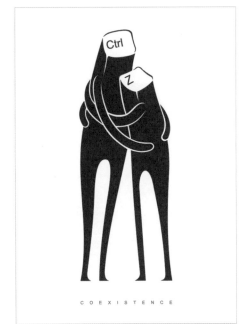

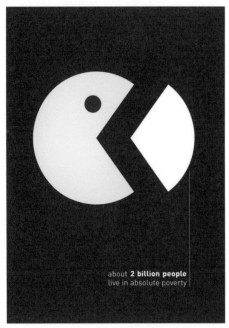

WOMEN'S RIGHTS
SZYMON SZYMANKIEWICZ
Poznan, Poland

THE PERFECT SWARM
EZRAH KHAN
San Antonio, USA

WATER DEPLETION
TONG ZHANG
Beijing, China

**YOU CAN'T SEE
THEM ANYMORE**
JANGHYUN RYU
Chungcheongnamdo,
Republic of Korea

227

BOOKS FOR AFRICA
BETSEY MARCUS
San Marcos, USA

GOOD BOY
JÚLIA GHUN HOHMANN
Barcelona, Spain

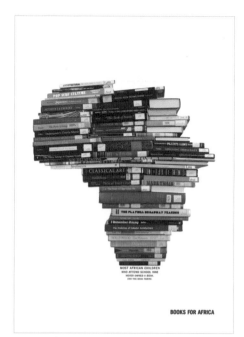

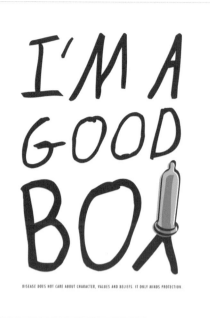

STICKS AND STONES MAY BREAK MY BONES...
MEGAN RYLANDER
Boerne, USA

ROYAL TREATMENT
JONATHAN BENSON
Lafayette, USA

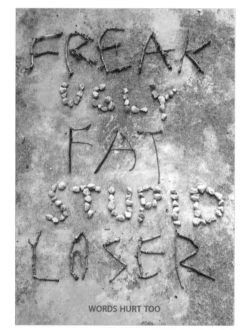

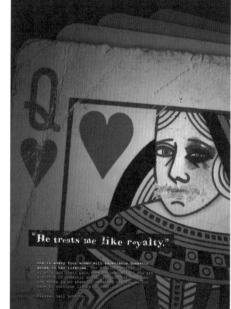

SAFE LOVE
ZHOU ZUOLI
NanTong, China

OIL AND WAR
CARLOS ANDRADE
Coro, Venezuela

SUNSHINE FOR JAPAN.
SEICHU SAKAI
Hyogo, Japan

WORDS HURT
MARY ANNE PENNINGTON
Humble, USA

NOT CONSUMERISM
JOSE RUBIO MALAGON
Alicante, Espana

PROTECT THE TRUTH
MICHELLE FLUNGER
Dortmund, Germany

DOMESTIC VIOLENCE
BENONI CERATTI ZORZI
Porto Alegre, Brazil

STOP CHILD LABOUR
HAKKI EROL
Istanbul, Turkey

STREETS IS NOT A HOME
KEVIN FRANCO
Guarujá, Brazil

WE ARE THE SAME, PLEASE SAVE THE ANIMALS
ZHIHONG CHEN
NanJing, China

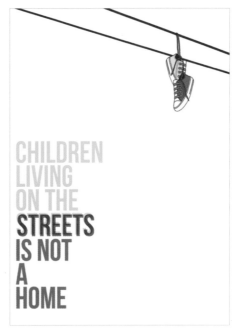

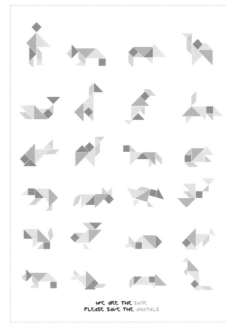

TARGET BOARD
ALI TOMAK
Samsun, Turkey

-CONSUMERISM + OCEANS
FRANK GUZMÁN
Caracas, Venezuela

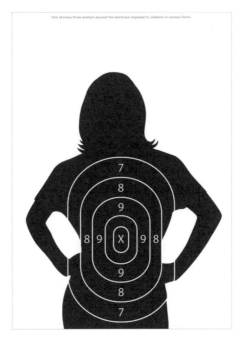

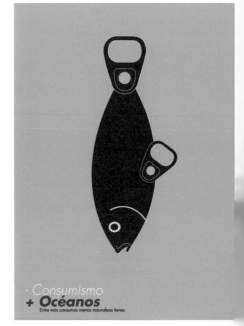

LOVE KNITTING
XINLU SUN
Nanjing, China

DEATH IS ALREADY IN
DANIEL FERNANDEZ
Rovereto, Italy

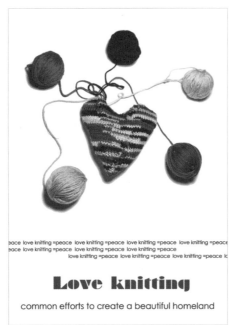

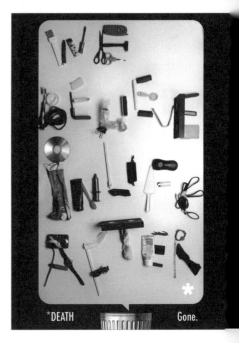

MAKE PEACE IT'S EASY!!
ALEJANDRO AYALA
Florida, USA

HAPPY BIRTHDAY
CALLIE TEPPER
Chagrin Falls, USA

YOU NEED TO KNOW
BETHANY ARMSTRONG
Wisconsin, USA

OCCUPY
ALEXANDRA CLOTFELTER
Savannah, USA

POSTER CAN CHANGE THE WORLD
ELENA TARAN
Saint Petersburg, Russia

CHIMNEYS
WEI LI
HeFei, China

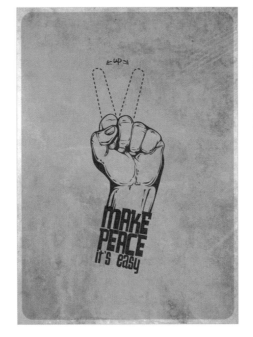

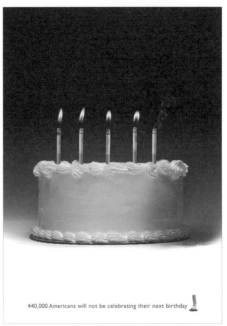

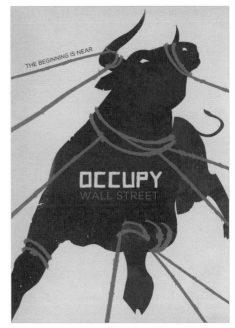

NO PROSTITUTION
GIORGIA NEGRO
Subiaco, Italy

END POVERTY
ANITA WASIK
Gdansk, Poland

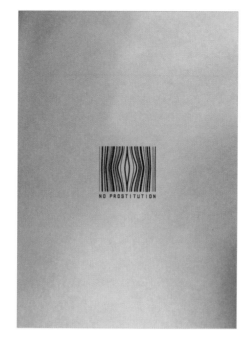

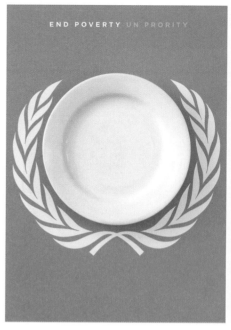

STOP CHILD RECRUITMENT 1
KANG YU MI
Seoul, Korea (South)

COW POWER
ALICE DRUEDING
JOE SCORSONE
Jenkintown, USA

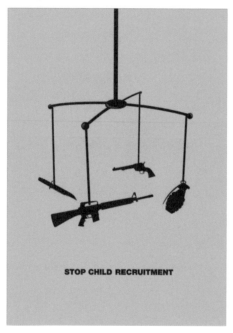

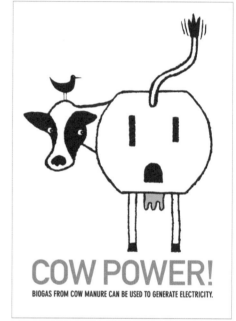

H2OURGLASS
SCOTT LASEROW
Pennsylvania, USA

WAR FOR WATER
ALICE DRUEDING
JOE SCORSONE
Jenkintown, USA

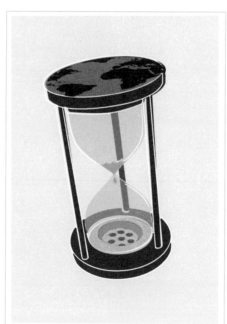

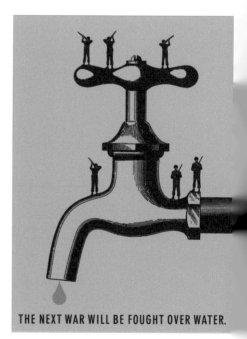

ALCOMORTALE-GUN
YURY AMBROS
ALEXANDRA AMBROS
Chisinau, Moldovia

FOOD WASTE
VICTOR MANUEL SANTOS GALLY
Mexico D F, Mexico

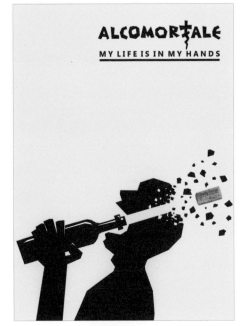
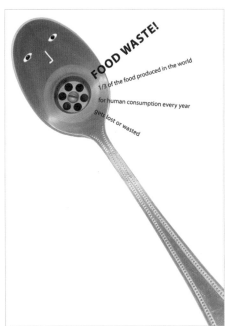

IT IS TIME TO HELP ELEPHANTS
VANESA MERULLA
Norwalk, USA

POLLUTED WATER KILLS.
MARIA THOMPSON
New York, USA

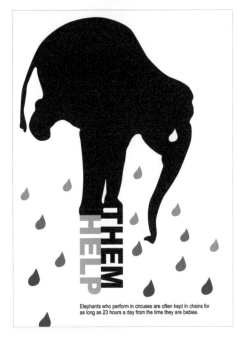
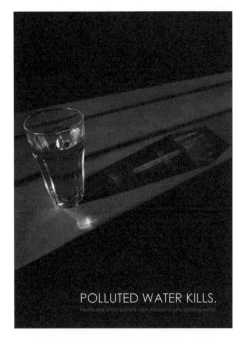

CHILDREN ARE
ALI MASUMBEYGI
Mashhad, Iran

PEACE
ALI TOMAK
Samsun, Turkey

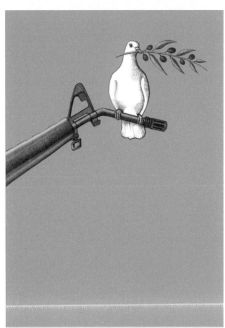

233

ONE DREAM—NO WAR
HAO ZHU
Hubei, China

SOS
YUQIAN JIA
Nanjing, China

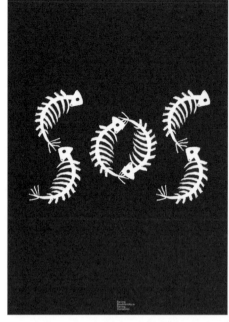

HOPE
FENG SHA
NanChang, China

IN OIL WE TRUST
ASHRAF REFAAT
Cairo, Egypt

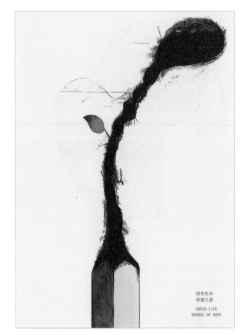

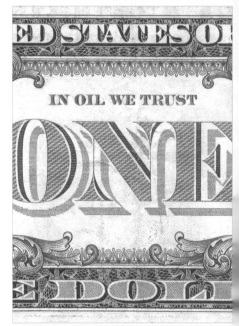

GIANT PANDA CONSERVATION
EVGENIYA RIGHINI-BRAND
DOMINIC RIGHINI-BRAND
Moscow, Russian Federation

INVISIBILI
MATEUSZ SINIAKIEWICZ
Falerone, Italy

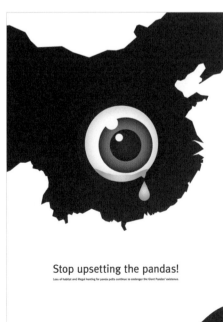

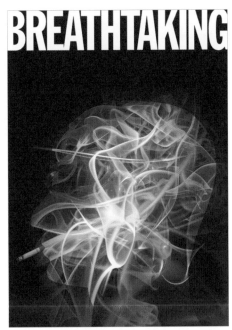
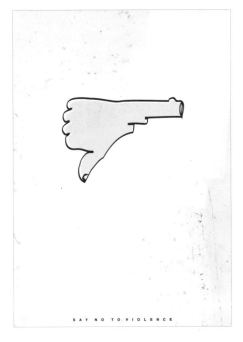

CONSUMPTION
SARA GIRONI CARNEVALE
Caserta, Italy

FOOD RIGHTS
ANITA WASIK
Gdansk, Poland

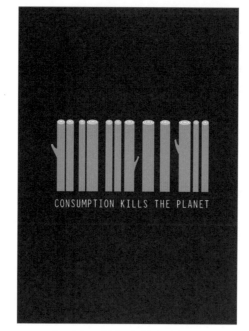
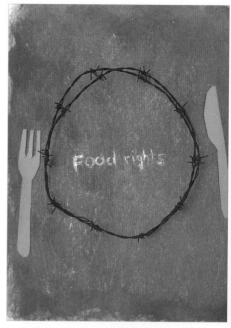

**SAVE WATER
(PRESERVE WATER)**
PRAVIN SEVAK
Vincennes, USA

**PROTECTION
OF THE ECOLOGICAL**
WU ZHONGHAO WU
LI ZHUANG LI
Beijing, China

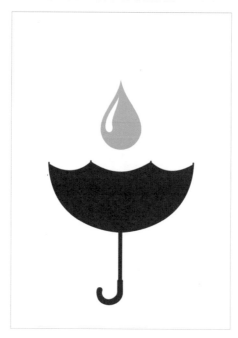
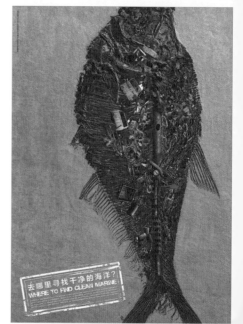

WOMEN'S RIGHTS VIOLATION
GHENWA EL SOUKI
Beirut, Lebanon

HOT EARTH
SUNG-JAE KIM
Busan, Korea (South)

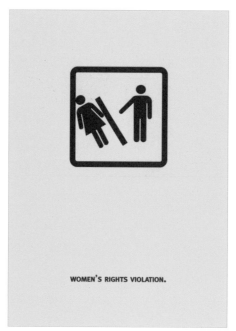
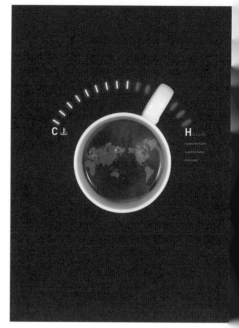

**THE DEATH PENALTY
IS NOT A GAME**
CARLOS ANDRADE
Coro, Venezuela

NO NAME
YUQIAN JIA
Nanjing, China

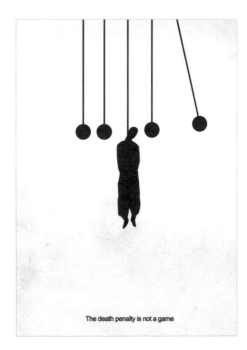

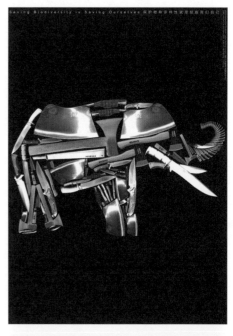

THE ROOTS
ALESSANDRO DI SESSA
Nocera Inferiore, Italy

RIGHTS TO EDUCATION
ANITA LAM
Austin, USA

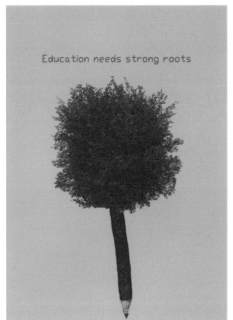

DEAS FIRST

I would like to conclude these thoughts on the exemplary initiative that was *Good50x70*, and the potentially stimulating new life of the poster (from analogue to something else, why not?) in the digital age, with a story that would have brought a smile to the lips of Mies van der Rohe, the last director of the Bauhaus and the man behind the famous motto "Less is more".

As a graphic designer who is now among the older generation, when I was young I was struck by scenes of the Sandinistas' tumultuous invasion of Managua on the day that Nicaragua was liberated. Naturally, the rebels had neither the time nor the money to print official posters announcing the dictator's downfall, so what the Sandinistas did was take all the official pro-Somoza posters they could find in the government buildings and institutions around the capital. Deft communicators, they knew they could use the posters just as they found them, pasting them up quickly and cheerfully in streets all over the country. How? Upside down.

Without a single change having been made, that poster escaped being pulped (an excellent example of intelligent recycling), and with a stroke of semantic genius and creative simplification became an instant sign of the change that had taken place: merely by the way in which it was stuck on the wall, the printed image which until a few days earlier had represented the violent gaze of power had become the symbol of revolutionary triumph.

"There's zero graphic design in that story" you might object. But that is only partially true. A poster (and thus an artefact) already existed, but it was the way it was used that changed its meaning. A presumably ugly poster required a brilliant, light-hearted idea for it to become useful and, in some way, beautiful. And, I would add, is a perfect lesson in *Less is more*: here, the theory of reduction worked extremely effectively. The Sandinistas got their message across excellently without even having to print it. Almost a work of contemporary art.

So what would graphic design be without those sudden, crucial, bright ideas which give back a dramatic, progressive, marvellous sense to its existence? An empty, banal (and fundamentally reactionary) stylistic exercise.

Franco Achilli
March 2013

GOOD50X70 ANTHOLOGY
THE SOCIAL
COMMUNICATION PROJECT
www.good50x70.org

Published by
Moleskine SpA

Project coordinator
Pasquale Volpe

Editor
Franco Achilli

Texts by
Franco Achilli

Excepts by
Jonathan Barnbrook
David Berman
Timo Berry
Bulent Erkmen
Svetlana Faldina
Cao Fang
Paddy Harrington
Ruth Klotzel
Yossi Lemel
Alain Le Quernec
Luba Lukova
Chaz Maviyanne-Davies
Armando Milani
Angela Morelli
Woody Pirtle
Liza Ramalho
Leonardo Sonnoli
Massimo Vignelli
Lourdes Zolezzi

Graphic design
Pvolpedesign.com
Liviana Loiudice

Publishing Coordinator
Igor Salmi

ISBN 9788866138976

Good50x70 is an initiative promoted
by Associazione Culturale Good Design
www.agooddesign.org

First edition December 2013 – Printed by
Dongguan Taifai in China

Acknowledgments
We would like to thank all the members
of the jury.

Last but not least, we would like to thank
all of the individuals, companies, institutions,
schools and non-governmental associations
that have supported this initiative and have
helped to make every aspect of it possible
during these 5 years.